SOCIAL DISSONANCE

SOCIAL DISSONANCE

MATTIN

URBANOMIC

Published in 2022 by
URBANOMIC MEDIA LTD,
THE OLD LEMONADE FACTORY,
WINDSOR QUARRY,
FALMOUTH TR11 3EX,
UNITED KINGDOM

BRITISH LIBRARY CATALOGUING-IN-PUBLICATION DATA

A full catalogue record of this book is available
from the British Library

ISBN 978-1-913029-81-4

Distributed by The MIT Press, Cambridge, Massachusetts
and London, England

Type by Norm, Zurich
Printed and bound in the UK
by TJ Books, Padstow

www.urbanomic.com

CONTENTS

FOREWORD:
SCORING CONTRADICTION

RAY BRASSIER

[O]ur most intense approach to what is 'new' about the old involves a sudden intuition of taboos and constraints, negatives, restrictions, prohibitions, reluctances and aversions. But these are not inherited dogma or aesthetic moralism, and have nothing to do with the respectable tastes and unexamined aesthetic good conduct of the conventional public sphere. They are new taboos; indeed, what is new about the *Novum* is less the work itself (whose most spankingly new innovations, in all their self-conscious Sunday pride, may well come to seem the most pitiably antiquated thing about it) than these new prohibitions, about which it would therefore be better to say, not that they tell you what not to do, but rather that they spell out what is no longer to be done; what you cannot do any more; what it would be corny to do again; or about which something (Socrates' *Daimon*) warns you that it is somehow not quite right and ought to be avoided, for reasons you yourself do not quite understand and may never fully grasp.

Fredric Jameson[1]

If, as Mattin proposes, the movement from Schoenberg to Cage was the step from equality of tone to equality of sounds, what is the next threshold of equalisation? Or in terms borrowed from Jameson: What is no longer to be done in the realms of noise and free improvisation? Mattin's response is uncompromising. Since structures of tone and sound cannot be abstracted from social structures, the gestures, codes, and

1. F. Jameson, *Late Marxism: Adorno, or, the Persistence of the Dialectic* (London and New York: Verso, 1990), 192.

conventions that have turned noise and free improvisation into recognisable genres are no longer to be done because they prevent us from seeing that the aesthetic liberation of tone and sound ultimately entails the social liberation of humanity. Mattin's Marxism compels him to connect improvisation's staging of freedom to freedom's social realisation. Yet while Marxism may rightly be seen as the most radical of egalitarian visions, it also suggests that legal 'equality' and social 'equivalence' mask the inequality of the capitalist class relation and the abstract domination of exchange value. Against this, communist freedom would realise equality as the society of nonequivalents, or the sociality of inexchangeables. Dissonance and noise are its negative prefiguration within a society where inequality remains the necessary condition of equivalence. The atonal and the aleatory index negative freedoms whose positive obverse can only be realised by abolishing the fundamental inequality of class together with the false equivalence of value. Thus, it is not just tone and score that are no longer to be done, but 'performer' and 'performance' as well. The concert form (staged or impromptu) and the performance venue (theatre, club, hall, gallery, cinema, warehouse) belong to an apparatus of commodification that cannot but reify whatever parcel of freedom or subversion might be experienced by participating individuals. The point however is not to seek a purer elsewhere, some space uncontaminated by commodification, but to turn commodified experience into an experience of commodification, or the experience of unfreedom. What is required, in Mattin's words, is 'a suspension of clear-cut roles where people experience and explore their own conditioning, their unfreedom'. This suspension permits the construction of the space of social dissonance, conceived as the contradiction between the commodified experience of the individual spectator or performer

and the system of social relations enforcing this commodification. The articulation of this contradiction requires collaboration, but a collaboration whose principles must be collectively forged. Thus social dissonance must be *scored,* precisely because it does not sound like anything. This very unlikeness indexes hearing's inextricable sociality: Mattin wants us to hear what the commodity form renders inaudible; what is inaudible in commodified experience. His wager is that the scoring of social dissonance rehearses an experience of unfreedom from whence the prospect of collective freedom might begin to be orchestrated, however dimly.

What does 'experience' mean here? How does it relate to subjectivity? Mattin distinguishes three distinct but superposed strata of experience and subjectivity. First, subjective experience as neurobiological phenomenon, the embedding of a self-model within a representational system's world-model (following the work of Thomas Metzinger). Second, subjective experience as sapience or cognition: the subject as locus of apperceptive spontaneity in which representations are combined according to a rule or concept (following Kant and Sellars). Third, subjective experience as social self-consciousness, comprising an entire system of practices, beliefs, and norms in a contradictory totality (following Hegel and Marx). The first is the domain of the self as individual 'I' or owner of experiences; the second, the realm of intersubjectivity, the space of dialogical exchange mutually implicating first- and third-person standpoints (as indexed by Kant's 'I or he or she or it, the thing that thinks'); the third, the dimension of collective social agency, wherein individual and collective are no longer opposed or even reciprocally implicating, but interpenetrating: Hegel's 'I that is We and We that is I'. (The subject of the unconscious traverses these three strata, but its workings defy any quick

summary here.) However, where Hegel sought the reconciliation of personal and impersonal, individual and collective, in the institutions of bourgeois society (property, marriage, work, state, etc.), Marx exposes these as false conciliations masking the fundamental contradiction between the social production of wealth (cognitive as well as material) and its private accumulation. Capitalism tethers subjectivity to the property relation: to be a social subject is to be a proprietor, either of capital or of labour-power. The realisation of freedom, individual and collective, is stymied by this basic antagonism, locked between its poles. The construction of social dissonance ties this antagonism to the dynamic of alienation traversing the superposed strata of subjectivity: alienation from below, attributable to the dysfunction of the subpersonal mechanisms conforming awareness into the shape of the self; and alienation from above, imposed by the suprapersonal structures constantly personifying us. Personification interpellates the self as a proprietor of experience. By exposing this complicity between naturally mandated selfhood and socially mandated personhood, social dissonance aims to alienate us from the proprietary relation to the experience we call our own. Sandwiched between the sub- and supra-personal levels, cognitive subjectivity is constrained from below (by neurobiology) and conditioned from above (by ideology). But Mattin's gambit is that it is also the medium in which both vectors of alienation can come to be recognised—not because they are transparent to consciousness, but precisely because conception itself registers the symptoms of the process through which the machineries of selfhood and personhood (neurology and ideology) screen themselves from self-consciousness. Between self and person, the subject of social dissonance emerges as the symptom of estrangement

from socially mandated individuality. From this estrangement, something like class-consciousness becomes possible.

Thus, although the neurocomputational processes mapped by Metzinger (presentationality, globality, transparency) are no more conceptual in nature than the social forms anatomized by Marx (commodity, value, money, labour) they remain conceptually tractable. Conception gives us cognitive traction upon the forces shaping subjectivity, despite their nonconceptual character. Of course, this does not automatically endow us with the ability to act upon them. But it is a start, whereas ignoring them is surely a guarantee of practical impotence ('Ignorance never yet helped anyone!', as Marx thundered to Weitling). By exposing the screening mechanism through which these forms and processes hide themselves, social dissonance does not just aim to make us conscious of them, as though this were sufficient for us to change them. In this sense, the estrangement or *Ostranenie* (Shklovsky) sought for in social dissonance differs from standard interpretations of what Brecht called the 'estrangement effect [*Verfremdungseffekt*]'. The point is not just to present the machinery of representation or to integrate the conditions of presentation into what is presented. These once unsettling techniques of defamiliarisation have become overly familiar; they have become, in Jameson's terms, antiquated or even corny. Defamiliarisation presumes that becoming conscious of something motivates us to change it. But what is required is an estrangement of estrangement: a defamiliarisation that suspends the fixed positions from whence estrangement can be experienced as a spectacle because it exposes and indicts the social forms that underpin spectacle's social contract. It is in this regard that the idea of noise retains its pertinence for Mattin:

[N]oise is, in some regards, the most abstract yet the most con-
crete of cultural expressions [...] It is abstract because [...] it con-
stantly forces [...] complexity to reach another level which has
not yet been explored. Yet it is concrete because its specificity
has to do with the unacknowledged residue [...] that surfaces in
a precise sender-receiver situation.

Because it is at once the most abstract and the most concrete
cultural expression, noise conjoins the intelligible and the sen-
sible without fusing them in some mythical immediacy. Thus, it
conjoins conception and sensation in an unintuitable register.
This is its paradoxical aspect. Noise is successfully conceived
when it fails to sound like anything; it is successfully sensed as
the failure to sense meaningfully. It correlates thinking and
sensing, but without either corresponding to the other. Thus
it reveals their historical rift to be not eternal, but socially symp-
tomatic—and symptomatic not of our estrangement from
some originary integration of thinking and sensing, but of a
social contradiction whose overcoming is indissociable from a
revolutionary transformation that would rearticulate them, such
that each might spring the other from its limitations.

Social dissonance aims to turn noise against itself; not by
reinstating an aesthetics of tone and sound, but by turning
noise into a device capable of scrambling established codes for
interpreting it:

[W]hat would it mean to claim the possibility to use noise as a
device? It would mean incorporating and appropriating the very
deciphering of noise into this device.I propose that highlighting
the process of the deciphering of noise could be a way to socialise
its estrangement effect. Inevitably, this would mean the disap-
pearance of the immediate experience of estrangement for the

time being, but it would also allow us to explore how our social, cognitive, and sensory capacities work at resolving such experience.

Deciphering noise socialises the workings of its estrangement effect. This is a form of demystification, which works by exposing the social relations underlying what presents itself as alien—what is alien is made so by human social relations. To turn noise into a device that incorporates its own deciphering is to show that estrangement is man-made, not God-given, and that its abolition is not the reinstatement of some originary unalienated state of nature, but the estrangement of estrangement. Thus the problem is to convert the experience of estrangement into an estrangement of experience. While the individual's experience of unease or disturbance is required to render estrangement perceptible and cognitively tractable, it must also be grasped as the symptom of a more profound social estrangement, which the individual cannot directly perceive or experience. Noise becomes the mediating instance here in so far as it indexes a confusion that confounds us because we can't control or access what produces it. What could be gleaned from such confusion? Perhaps the recognition that alienation is a contradictory process in which freedom and unfreedom are bound together. Social dissonance is an attempt to articulate this process, and thereby an attempt to get individuals to collectively articulate the contradiction between individual and collective. It affirms the need to overcome this contradiction as the only non-mystificatory idea of freedom available, while acknowledging that this overcoming is congenitally blocked by capitalism. But capitalism is manmade, not God-given, so the question is whether this blockage is a symptom of what Mattin (following Samo Tomšič) calls 'constituted alienation' (the

transposition of relations between producers into relations between their products, or commodity fetishism), or whether it follows from a 'constitutive alienation' (Tomšič) intrinsic to being human. The danger of affirming the latter is the accusation of essentialising a historically contingent condition (the charge often levelled by Marxists at Lacan). One way to respond would be to say that it is externalisation (*Entäußerung*) that is constitutive of freedom, because it is at once what separates and unites subject and substance; their reified unity in the interdependence of capital and labour being the estrangement (*Entfremdung*) that reinstates unfreedom. What perpetuates this interdependence? In one sense, the commodification of consciousness is coterminous with capitalism: it is just reification in Lukács' original sense (the commodity as universal social form). In another sense, it would be the ultimate stage of real subsumption as the direct production (not just determination) of experience (the manufacturing of conscious states, as envisaged by Metzinger). But the complete integration of labour into capital (the reduction of worker to tool) threatens to compromise capital's self-reproduction. Tools are not compelled by vital needs to sell their labour-power to reproduce; capital requires labour to maintain a modicum of independence (as living labour) so that it can continue to depend on selling itself to capital for its reproduction (mortifying itself as dead labour precisely in order to maintain itself as living labour). As primary source of surplus-value, the wage relation is fundamental to this entire dynamic. It is the point of intersection for the two cycles of reproduction, capital and labour. Capital needs labour-power, but doesn't care whether or not it is attached to a self when buying and consuming it. Indeed, it promotes the notion of self in order to sell commodities back to labourers. If so, then communism as coincidence of singular 'I' and plural 'We' might

be envisaged as decoupling the interests of the subject from the socially enforced needs of the self and the person. What would arise then is a subject striving to realise social conditions under which humanity becomes free to develop and satisfy needs unconstrained by those of capital.

Communism will be the collective management of alienation.

Samo Tomšič

INTRODUCTION

MAYBE: Anti-syzgytic variables a nonsynthesis arnesologically appropriated e.g. "Jarrod Fowler" "Taku Unami" "Moe Kamura" {anonymous}, though {the object-phrase 'only'?} 'arnesologically' having been parapraxologically posited from Rhythm 'as' any automorphism identical to non-dramaturgic 'Scene VI Scene XI'. The latter may not in/consist 'in that identity' (morphism)? Thus, these aforementioned anti-syzgytic variables materially affixed, via rhythmics(?), the size 'nullpropriated' {to, with, from} a generalized phenology, which may 'also' noncausally or generically 'miss-'ticked' (skipped) praxis' via the contemporaneous strike {not} 'of this flier'. It may have missed praxis. Each non-conceptual variable (set?) given 'in this case': "Jarrod Fowler" "Taku Unami" "Moe Kamura" {anonymous} hypercontingent identical disaggregated posologies, horizontally idempotent? may irregular-pause itself 'up to' e.g. 42.327776, -72.532089, but even the aforementioned 'up to' already fractal-ticked off 'faux-bond' asequential, hence its {uncounted abeit negatively paused?} 'position' in the 'previously performed sentence' may be a cloning of 'asequentiality' performed-syntactically ordered. Any 'up to' has {already} from Rhythms (09/14, ??:??) identically supplanted 'as subsistence?' its intension only of the given-?-morphism (sequencer-period) with any other un/ticked antipraxis (i.e. count, quantity, Act (Pragmologic?) X, 44.801677, -68.774053 (K,D), architecture, climatology, ..., (—). cfr Information: No Theory (1970. CITATION)). Para-idiotic mistaken quasi-similar to any 'X' idiotics Scene X{I} Scene {V?}I MONOTONOUS

HAMPSHIRE COLLEGE CENTRUM GALLERY 14 SEPTEMBER 2011 4-11 P.M.

Arnold Schoenberg: All tones can be treated as equal.

John Cage: All sounds can be treated as equal.

Next logical step: Everyone can be treated as equal.

Why is it that we can accept that all musical notes can be treated as equal, or even that all sounds can be treated as equal, but find it extremely difficult to envisage the possibility of all people being treated as equal? We live under an economic system that makes social equality impossible. One might object that these are different types of register: the first two are aesthetic, while the last is socio-economic and political. However, today these registers are very much interrelated.

A couple of contemporary examples come to mind which blur the social with the aesthetic, the first in the field of music, the second that of art:

On 14 September 2011, the music improvisers Moe Kamura, Taku Unami, and Jarrod Fowler were invited for a concert at Hampshire College in Massachusetts. For their contribution, Unami and Fowler decided to hide from each other in the bushes outside the performance venue. The organiser Jack Callahan was looking for them for a long time and it was only at 11pm, after all of the audience had left the venue, that he managed to find them. The musicians explained that hiding was their contribution to the concert. Callahan did not understand this 'contribution' and became extremely angry. If it seems unclear as to where the sonic element comes from, one only has to think of

what Kamura, Unami, or Fowler, or the audience in the venue, might have been hearing while the concert was supposed to be happening. Their contribution radically questioned its own framing and the function of improvisation and music within a specific context. To this day an event organiser might have problems accepting this as a concert, but it is precisely in this sense that this gesture pushed the boundaries and produced thinking.

In another performative work that blurred the lines between art, life, and the social, as part of her residency at Iaspis (Stockholm) in 2010, under the title *What if, if I take your place?*, Lebanese artist Lina Issa placed ads in various places around the city asking people to let her take their place at work, at home, or elsewhere for an hour, a day, or a month. There were a number of responses to the ads, and Issa was able to take the place of people who wanted a break from their everyday life—either at their jobs or at home and in their relationships.

There can be no doubt that in the contemporary world, art has pushed its way into everyday life, while on the other hand capitalist relations have permeated the most intimate forms of communication (from your mobile phone to coaching and therapy) and our innermost feelings (through pills and chemicals) as well as the most abstract forms of economic relation (high-frequency trading, futures).

To claim some kind of autonomy for the aesthetic domain under these conditions is a highly questionable move. And yet within this situation, perhaps the aesthetic domain can allow for certain forms of experimentation which, at least, would expose and explore this very interrelation.

Moreover, in general, if one is looking to explore how we are produced as subjects by today's social conditions, the artist and the musician are good examples precisely because they are figures that are supposed to represent maximally 'free subjects' who retain a level of criticality standing in contrast to the general determination. On the one hand, the artist's subjectivity is paradigmatic of the freelance era, in the sense that they are obliged to be self motivated, adaptable, and opportunistic. On the other hand, the artistic realm is one in which autonomy and freedom of expression and speech are supposed to be explored without prescriptions (even if this seems to have begun to change over recent years). To put it simply: the artist displays strong individual will and agency (which of course has the additional connotation of their social adaptability in the labour relation).

Specifically, in relation to my own background and the context within which this book developed, I come from years of experience of making noise and improvised music with a computer. The usual understanding of improvisation and noise involves the possibility of an artist's maximally expressing freedom with their instrument, without any mediation such as a manuscript or score. But at a certain point it became clear to me that noise had become a genre of music with specific tropes— loud volume, aggressive frequencies, total movement or total stasis, etc.—and that it was gradually turning into a parody of itself. I then became interested in a different approach to noise, one that has to do with silences—but silences that are full of expectation, because one does not know what might happen next. These silences created effects that seemed to go beyond the purely sonic and bleed into the social situation of performance itself. This technique emerged out of, and helped to further, a shift in my understanding of improvisation: I began to

understand improvisation not as an interaction between musicians and their instruments, but as a collective social interaction happening in a given space where there is no neutral position (no audience, no spectators). Assuming, after John Cage's *4'33"*, that there is no such thing as silence in any given social situation, and that it may well be the audience who produce the sounds, I then began to incorporate a Marxist perspective into my work, trying to understand and expose how social relations are produced in a given space and context.

This book develops and accompanies that ongoing project, developed and reworked over a decade, addressing the relation between the cognitive and aesthetic expectations of the concert situation and the social totality—and social contradictions—of which it is a part, but which it also encapsulates. The book comprises two parts: the first part theoretically traces back the concept of alienation in different ways and develops the concept of 'social dissonance'. The second part presents and discusses *Social Dissonance*, an instructional score that explores these conceptual issues in practice.

SOCIAL DISSONANCE: IMPROVISATION AND ALIENATION

The *Social Dissonance* score was performed at documenta 14, in both Athens and Kassel, between April and September 2017. It involves four interpreters playing the audience as an instrument for one hour every day (except Mondays), over six months. The interpretations began first in Athens, continuing simultaneously in Athens and Kassel for some time, and finally only in Kassel.

Before each day's performance, the interpreters and I would decide on how to start the session, taking into consideration what had happened previously. The performances would begin

with an introduction reminding the audience that the performance was being streamed live via Periscope, and that the videos would be shown the following day in the documenta 14 exhibition space, and archived on YouTube and archive.org. We also explained to the audience that the rules of the score required them to remain in the space for the entire hour. If anybody wanted to leave they could do so, but they would be asked to give some feedback to the rest of the room, so that the interpreters could learn from their experience.

To improvise is to exercise one's freedom of expression through an instrument. But once you take away the instrument and become the instrument yourself, you begin to realise how instrumentalised you are and how you are embedded in many processes of mediation—economic, social, linguistic, and so on. The freedom that you thought you were expressing is inevitably unveiled as at best problematic, at worst a pernicious illusion. The *Social Dissonance* score attempts to engineer such moments of disillusion, in order to bring these deeper dissonances into the foreground and make them a disconcerting part of the concert.

Today we are entertained, informed, and brought together by technological systems that urge us to be strong individuals, each equally capable of expressing our freedom. But this is evidently a superficial appearance, since in reality our future seems to be dictated solely by the reproduction of capitalist social relations and thus the furthering of inequality. It is under these conditions of alienation that there emerges within our self-conception the discrepancy I call *social dissonance*: a form of cognitive dissonance at the structural level which stems from the contradiction between the social reality of what we do (which under capitalism means buying and selling commodities, including ourselves) and what we believe about ourselves as

non-commodified entities—the liberal myth that, as individuals, we are already subjects. In continuing to subscribe to this myth, we conflate selfhood with subjectivity.

Under liberalism, the notion of the individual is based on a supposedly mutual recognition between different persons with equal rights such as freedom of speech and the freedom to labour and to exchange the products of their labour. The individual is therefore assumed to be a subject, in the sense of being an agent with the capacity to act in a self-determined way. However this understanding of the individual based on the singularity of a person is nothing more than a metaphysical abstraction.[1] It assumes the possibility of conscious recognition, but disregards class struggle and the ways in which we are socially determined differently at the material level through economic conditions, gender, race, disability, and so on. Furthermore, this recognition presupposes that a person has a stable self with clear boundaries that need to be controlled and guarded. As we shall see, this is arguably problematic: selfhood is nothing more than a fragile brain-generated image, albeit one that in general cannot be experienced *as* an image.

This fiction of the individual as subject is only being accelerated by rightwing libertarian tendencies that can already smell the corpse of liberalism. In opposition to this, in paying attention to social dissonance, I seek to denaturalise this myth by demonstrating, through an exploration of alienation, how we are embedded within various different historical processes of mediation.

1. This issue will be discussed further throughout the book. See R. Brassier, 'Abolition and Aufhebung: Reply to Dimitra Kotouza', in A. Iles and Mattin (eds.), *Abolishing Capitalist Totality: What is To Be Done Under Real Subsumption?* (Berlin: Archive Books, forthcoming).

INDIVIDUAL, SELFHOOD, SUBJECT

The notions of the individual, selfhood, and subject are a product of different histories, and their meanings have changed over time. Although they are often confused with one another, the relationship between these terms is complex.

The term *individual*, often used with a colloquial sense of 'person' or 'single human being', emerged in the early fifteenth century and comes from the Latin *individuum* which as a noun means 'atom, indivisible particle'. Prior to the Enlightenment, however, a human individual was always understood as being part of a community with different relationships, dependent on feudal and religious ties, among others. It was with the development of the Enlightenment and especially that of liberalism that the individual began to be understood in terms of *separation*, as a person having the rational capacity to make their own decisions, implying an idea of autonomy in which the individual can act according to their own will without being coerced. A clear example of this is found in the ethics of Immanuel Kant: 'A rational being must always regard himself as giving laws either as member or as sovereign in a kingdom of ends which is rendered possible by the freedom of will.'[2] While for Kant a rational being did not necessarily mean an indvidual, his thought contributed enormously to the development of our current undestanding of the secular individual, supposedly able to establish herself or himself as a sovereign subject, leaving behind all theological tutelage. But liberal ideology tends to naturalise this sovereign autonomy and render it inseparable from consciousness as such, while identifying it with the identity and responsibility necessary for contractual transactions and property ownership.

2. I. Kant, 'The Good Will', *The Fundamental Principles of the Metaphysics of Morals* [1785], <http://fs2.american.edu/dfagel/www/Kantgoodwill.html>.

The concept of *selfhood* refers to the reflexive experience of having a first-person perspective; it names the phenomenon of a stable continuous presence that allows experiences to cohere or 'belong' to the same agent.

The concept of *subject* emerged in the fourteenth century and comes from Old French *sogit*, *suget*, *subget*, meaning 'a subject, person, or thing' or 'person under control or dominion of another'. It therefore implies a paradoxical combination of *subjecthood* and *subjection*, an articulation between an individual and an apparatus of power that precedes and exceeds them.

In *The Labour of Enjoyment*, Samo Tomšič explains how under the current neoliberal ideology, an individual must be an economic subject, and describes the role played by a personalised form of alienation in this type of subjectivation:

> [According to t]he understanding of subjectivity which prevailed in the last two centuries [...] [t]he social obligation of every individual was to become an ideal economic subject, social egoist or self-loving subject of private interest, capable of mastering and overcoming alienation in the social sphere. From the viewpoint of this presumably authentic and fundamental but actually fictitious image of subjectivity, alienation appears like a sign of the individual's failure to live up to the 'natural condition of man' as propagated by the liberal and neoliberal economic doctrines. Individuals are obliged to pull themselves out of the state of alienation, the latter being considered as their personal problem.[3]

As Tomšič points out, capitalism needs an exploitable understanding of subjectivity which simultaneously produces the

3. S. Tomšič, *The Labour of Enjoyment: Towards a Critique of Libidinal Economy* (Berlin: August Verlag, 2019), 127–28.

appearance of individual agency—although the twentieth century saw the emergence of numerous critiques of this naturalised understanding of the subject from different perspectives: structuralism, poststructuralism, psychoanalysis, feminism, decolonial thinking, afropessimism, queer theory, antihumanism, and posthumanism, to name but a few.

To avoid any misunderstandings, then, in what follows, by individual we mean an autonomous and separate person, but with the understanding that this is an ideological construct based on a conceptual abstraction. As for self, as discussed below we will follow Thomas Metzinger, for whom the phenomenal self is what gives an experiential perspective into one's own consciousness by *constructing* a point of view. Although we may experience the self as 'transparent' access to a substance or a thing, in fact it is the outcome of a process: the subjective experience of *being someone* emerges when a conscious information-processing system operates under a transparent self-model.

The notion of the subject is the most complex of these concepts and remains to be constructed. What we can say in advance is that the subject comprises the unconscious activities that we carry out in reproducing existing conditions, while in the process mystifying how the subject appears in the world. That it is why it is of such importance to demystify the fiction of the individual as subject.

MENTAL NOISE AND THE CATASTROPHIC REACTION

Needless to say, demystification is not enough. Short of a revolution, we will not overcome the forms of social dissonance under which we labour. Until then, there will still be noise in our heads. And when the noise gets too much, it is liable to cause a 'catastrophic reaction.'

In her recent book *An Epistemology of Noise*, the philosopher Cecile Malaspina analyses the notion of noise in different fields including cybernetics, information theory, economics, and psychology. Drawing on a 1986 text by Steven Sands and John J. Ratey, Malaspina refers to what they call 'the mental state of noise', which involves the loss of a reliable sense of self engendered by the disappearance of borders between the owners of experience. Such exposure, they claim, is likely to produce an 'internal chaos', delivering sensations of 'inner confusion and terror'.[4] But Malaspina goes further, claiming that this state of noise reveals itself at the very core of the rational subject. The resulting conception therefore goes beyond any observation about noise as an object of perception; rather, noise is understood as constitutive of the machinery of perception as such:

> Far from [...] a mere object of perception, [...] noise is also what un-conditions the capacity to discern and evaluate the object of perception. Not just a state of confusion and indecision, noise is also amplified by the panicked attempt to redraw the boundaries of the sense of self. To regain the sense of self as first object of cognition thereby becomes the precondition to reasserting its relation with other objects of cognition. At stake, in other words, are not the noises we perceive, but the noise of cognition constituting itself, against the always looming crisis of its dissolution.[5]

Sands and Ratey define the 'mental state of noise' in terms of a pathological openness: it is 'as if patients vulnerable to the

4. S. Sands and J.J. Ratey, 'The Concept of Noise', *Psychiatry* 49:4 (November 1986), 290–97.

5. C. Malaspina, *An Epistemology of Noise: From Information Entropy to Normative Uncertainty* (London: Bloomsbury, 2018), 173.

chaos of overloading that we are calling noise are always wide open'.[6] My claim is that, even though we may not be suffering a clinically pathological total loss of boundaries, under current conditions our sense of self is increasingly revealed to be based on this same unstable ground, disturbed by the low-level mental states of noise that I call social dissonance and which, if they get too much, can lead to a type of 'catastrophic reaction' where one is longer able to say who one is or where one stands, or to differentiate what is private from what is public:

> [T]he changes of external stimuli over time and the changes of internal disposition over time conjointly modulate the experience of 'the mental state of noise', potentially progressing from confusion and anxiety to [...] the 'catastrophic reaction'.[7]

Social dissonance can become a noise which one is no longer able to manage, and when this happens, the individual's self-perception as 'helpless' spirals out of control.

> The fear of disintegration of the sense of self is thus also a consequence of the inability to impose a critical limit. Loss of confidence furthermore implies the threat of losing a reliable sense of self.[8]

Given the expansion and intensification of technologically-enabled social interaction coupled with the increasing individualisation, fragmentation, and economisation of society, we may expect many more such 'catastrophic reactions'. If we add to this major climate and economic crises and an exponential

6. Ibid., 174.

7. Ibid.

8. Ibid.

growth in the distrust of authority and conspiracy theory, it is even likely that they may become the norm. We do not have the proper platforms to deal with this, because to do so would require a careful interweaving of care, psychological insight, and finally and most importantly political engagement with the class relation on an international level, within a long-term future horizon. The theoretical and practical exploration of social dissonance, however, aims at least to provide some resources for understanding and anticipating such breakdowns.

STRUCTURAL NOISE

The ongoing mental noise that is social dissonance, then, is not just passively received, but is co-produced, or at least amplified, by the continual effort to reconcile dissonant self-perceptions. Here the concept draws upon the work of Leon Festinger in his landmark 1957 book *A Theory of Cognitive Dissonance*. As Festinger writes, '[t]he basic background of the theory consists of the notion that the human organism tries to establish internal harmony, consistency, or congruity among his opinions, attitudes, knowledge, and values'.[9] He defines cognitive dissonance as the contradictory belief in two different values or incongruent sets of beliefs:

> In short I am proposing that dissonance, that is, the existence of non-fitting relations among cognitions, is a motivating factor in its own right. By the term [cognition] I mean any knowledge, option, or belief about the environment, about oneself, or about one's behaviour. Cognitive dissonance can be seen as the antecedent condition which leads to activity oriented towards dissonance

9. Ibid., 269.

reduction just as hunger leads to activity oriented toward hunger reduction.[10]

For Festinger, then, 'dissonance' is analogous to notions such as hunger, frustration, or disequilibrium.[11] In what could be read as a description of ideology, Festinger writes that 'the reality which impinges on a person will exert pressures in the direction of bringing the appropriate cognitive elements into correspondence with that reality'.[12] It can be difficult and stressful to cope with the contradictory character of these pressures, and this makes action necessary. In order to reduce cognitive dissonance, Festinger says, a person may believe without proper rational justification whatever they need to believe. Equally, they may avoid situations and information that could lead to an escalation of dissonance.[13] In short, in order to avoid cognitive dissonance they may either (1) change one or more of the elements involved in the dissonant relations, or (2) add new cognitive elements that are consonant with already existing cognition.

Now, if *cognitive dissonance* is the uncomfortable tension which results from holding two conflicting thoughts in the mind at the same time, *social dissonance* is the discrepancy and tension between the narcissistic individualism promoted by capitalism and our social determination. In the case of social dissonance, then, the first option outlined by Festinger, that of changing the dissonant relations themselves, would require a radical transformation of society, because the conditions that

10. L. Festinger, *A Theory of Cognitive Dissonance* (Stanford, CA: Stanford University Press, 1957), 3.

11. Ibid.

12. Ibid., 11.

13. Ibid., 3.

produce this dissonance exist at the level of capitalist social reproduction. Since this seems impossible to achieve, in order to cope with social dissonance we instead find ourselves obliged to add new cognitive elements that are consonant with the already existing cognition, doubling down on the narrative of the sovereign self.

SOCIOGENY: RACISM AND SOCIETY

Evidently, like cognitive dissonance, social dissonance has an effect on the psyche and calls for psychological compensations—yet it is not merely psychological in nature. A helpful concept here is that of *sociogeny*, as developed by Frantz Fanon and Sylvia Wynter. As opposed to cognitive dissonance, where contradictory beliefs are generally analysed at the level of the individual, Fanon carried out a much deeper analysis at the societal level in relation to the racial processes of colonisation, the state of mental noise produced by its *structural* cognitive dissonance in both black and white people and the ensuing neurotic symptoms, which result in the absence of any capacity to alter the social relations themselves.

Fanon's *Black Skin, White Masks* (the original title of which was 'An Essay for the Disalienation of Blacks') is a detailed account of forms of alienation specific to the process of colonisation in the French Caribbean, in the lived experience of the black man. According to Fanon's research, black people tended to suffer from a sense of inferiority, having internalised their oppression and understood it as a personal failure. This inferiority complex made black people unable to properly relate to themselves, inevitably producing an alienation in the sense of a loss of selfhood, agency, and ability to act. We can understand this as a specific form of cognitive dissonance systemically propagated at the structural level.

In order to grasp this process, Fanon developed the concept of sociogeny, which extends Freud's use of the notions of ontogeny and phylogeny, concepts he took from biology. Ontogeny describes the development of an individual organism, while phylogeny refers to the evolutionary development of the species. Freud adapted the terms, using ontogeny to mean the development of the person from the perspective of what happens throughout their entire life, in relation to early childhood when the child was unconscious. On occasion he even tried to use this concept to trace the origin of the human race. On the other hand, he designates as phylogenesis the explanation for the development of the neuroses in general, across the generations of a family or even the life of the species. To these two concepts Fanon added that of sociogeny, to designate the development of a phenomenon that is socially constructed rather than ontologically given, immutable, or static, and in particular as a way to understand how certain assumptions become naturalised within the concept of race.

Since sociogeny works at the level of the social totality, it cannot be observed or its causal mechanism grasped from the perspective of the individual; it must be analysed at the social level. If alienation is produced by sociogeny, which in turn is a social process, then the cure cannot lie at the individual level, but calls for radical change. As Sylvia Wynter writes, following Fanon,

> [t]his situation calls for a prognosis different to that of psycho-analysis whose goal is to adjust the individual to society. Instead, since 'society', the social order, cannot, 'unlike biochemical processes, escape human influences', since it is the human itself that 'brings society into being' (the social order never preexists our collective behaviours and creative activities), the prognosis is one of overall social transformation. As such, the 'cure' is 'in

the hands of those who are willing to get rid of the worm-eaten roots of the structure'.[14]

Taking these arguments into account, it is important to adopt a 'sociodiagnostic' approach and to interrogate history in order to understand how certain forms of subjectivation reproduce violence, injustice, and forms of exploitation, which in turn contribute to the sociogeny of neuroses, complexes, mental states of noise, and catastrophic reactions.

CAGE AS A CAGE: THE IDEOLOGY OF THE ANECHOIC CHAMBER EXPERIENCE

How might this understanding of a specifically social form of dissonance be related back to noise in the sonic sense, and sound and performance practices in general?

Art and music have long been sites in which notions of autonomy and freedom are at stake and have been repeatedly critically questioned—indeed, it could be said that such questions continually return because the promises made by these practices are rarely fulfilled.

The instructional score *Social Dissonance* took as its starting point John Cage's *4'33"*, a piece designed to allow the context to come to the foreground. As is well known, *4'33"* demonstrated that any sound can be treated equally as music, and that in a social situation it is impossible to perceive silence.

14. S. Wynter, 'Towards the Sociogenic Principle: Fanon, the Puzzle of Conscious Experience of "Identity" and What It's Like to be "Black"', <https://studylib.net/doc/8810338/fanon--the-puzzle-of-conscious-experience--of>; published version in M. Durán-Cogan and A. Gómez-Moriana (eds.), *National Identity and Sociopolitical Change: Latin America Between Marginalization and Integration* (Minneapolis: University of Minnesota Press, 1999), 30–66; quoting F. Fanon, *Black Skin White Masks*, tr. C.L. Markmann (London: Pluto, 1986), 13.

However, in $4'33''$ the audience is supposed to hear the sounds in themselves for what they are, independent of their context and their meaning. Effectively, Cage was trying to generate an artificial white cube or black box: the context within which the material is presented is meant to be as neutral as possible, separated from everyday reality, allowing the audience to focus purely on the sonic material as an aesthetic experience. In $4'33''$, the listener is supposed to isolate the sounds and hear them as music, bringing listening into the foreground but leaving behind the cultural and social context in which that listening is being produced. In *Social Dissonance,* instead, the audience hear themselves and reflect upon their own conception and self-presentation: aesthetics is deliberately refused any autonomy from the social.

John Cage's experience of being in an anechoic chamber in 1951, as famously recounted in his own words, was a very strong influence on the creation of $4'33''$:

> It was after I got to Boston that I went into the anechoic chamber at Harvard University. Anybody who knows me knows this story. I am constantly telling it. Anyway, in that silent room, I heard two sounds, one high and one low. Afterward I asked the engineer in charge why, if the room was so silent, I had heard two sounds. He said, 'Describe them.' I did. He said, 'The high one was your nervous system in operation. The low one was your blood in circulation.'[15]

As Seth Kim-Cohen rightly points out, this moment marks 'the creation myth of [Cage's] aesthetics: an aesthetics summed up

15. J. Cage, 'John Cage's Lecture "Indeterminacy" 5'00'' to 6'00''', in H. Eimert and K. Stockhausen (eds.), *Die Reihe* 5 (1961), English edition, 115.

by his proclamation "let sounds be themselves"'.[16] This approach could be seen as comparable to a phenomenological *epoché* in the Husserlian sense: Cage 'brackets out' any extraneous meanings of the sounds by suspending judgement and blocking biases and assumptions. Yet he then performs his descriptions from a *first-person point of view* in order to explain a phenomenon in terms of its own inherent system of meaning—but without questioning how this first-person perspective is produced. This is crucial because it marks a special moment not only in the history of avant-garde music but also in how the artist conceives of themselves and the assumptions they make in doing so. As Douglas Kahn points out, in fact Cage was not only hearing these two sounds, but also a third 'quasi-sound' that was the realisation of hearing these two other sounds:

> [The anechoic chamber] absorbed sounds and isolated two of Cage's usually inaudible internal bodily sounds, but in the process there was a third internal sound isolated, the one saying, 'Hmmm, wonder what the low-pitched sound is? What's that high-pitched sound?' Such quasi-sounds were, of course, antithetical to Cagean listening by being in competition with sounds in themselves, yet here he was able to listen and at the same time allow discursiveness to intrude in the experience because such sounds would be absorbed by clinical and scientific discourse, if not by the materials of the chamber itself, which historically had been allowed to intrude on musical listening.[17]

16. S. Kim-Cohen, *In the Blink of an Ear: Toward a Non-Cochlear Sonic Art* (London: Bloomsbury, 2009), xvi.

17. D. Kahn, *Noise Water Meat: A History of Sound in the Arts* (Cambridge, MA and London: MIT Press), 190.

Here we have a moment of social dissonance that happens retroactively: John Cage produces a narrative about what he thinks is his individual experience by isolating these two sounds, but forgets or remains unaware of the process of conceptual mediation that occurred within this experience, and how this conceptual mediation is produced at the structural level in the sociogenic process of the reproduction of the self. This 'intrusion' or conceptual level of mediation, which I explore throughout the book, and which the *Social Dissonance* score welcomes and encourages, tends to undermine any claim to immediate contact with 'the sounds themselves'.

NOISE IN THE VALLEY AND BEYOND

If, as Cage said, there is no such a thing as silence, if there are always sounds, then we could also say that in our present society there is always already noise—the psychological noise that emerges from the social dissonance present in our own self-conception. Given how he passed over this noise in silence, it is not surprising that Cage's politics amounted to little more than a bland form of individualist anarchism. In his own words:

> Society, not being a process a king sets in motion, becomes an impersonal place understood and made useful so that no matter what each individual does his actions enliven the total picture. Anarchy in a place that works. Society's individualized.[18]

How exactly would this society be individualised? Through rights? Through an organic composition? Through mutual understanding? Many open questions.

18. J. Cage, *Anarchy: New York City–January 1988* (Middletown, CT: Wesleyan University Press, 1999), viii.

In *From Counterculture to Cyberculture*, Fred Turner tells the story of Stewart Brand, a photographer, writer, former army lieutenant, impresario, and consummate networker, who between 1968 and 1972 ran the influential *Whole Earth Catalog*, and in 1993 founded the now famous *Wired* magazine covering technology, economics, culture, and politics. Turner explains how Stewart Brand was influenced by Cage, his Zen philosophy, and the experimentations of Black Mountain College and the sixties New York art scene.[19] Subsequently, in the nineties, Brand became a key figure in the development of Silicon Valley, where, as Turner emphasises, practices that had seemed radical in the fifties and sixties turned out to be the seeds and sources of inspiration for the platform economy of today's capitalism.

Emerging from these same circles is a libertarian tendency that has shaped contemporary thought on the Right. For example the 2009 declaration of Peter Thiel, co-founder of PayPal, that 'I no longer believe that freedom and democracy are compatible' seems to have been a turning point for certain libertarians such as Curtis Yarvin and Nick Land, today associated with the ultra-right-wing and often racist neoreactionary movement (NRx). As Ana Teixeira Pinto points out,

> [t]he overlap between Landian theory and the Valley's political cal agenda is not coincidental. 'The Dark Enlightenment,' which the NRx takes as its foundational text, is basically Land infusing theoretical jargon into Yarvin/Moldbug's blog 'Unqualified Reservations'. Yarvin's Tlon (a corporate vehicle for Urbit, his open-source computing platform) is backed by PayPal founder and Trump advisor Peter Thiel, who is known for his antidemocratic

19. Thanks to José Luis Espejo for pointing out this relationship to me.

activism. Cyberlibertarian views and Land's brand of transhuman-ism are pervasive throughout the tech industry.[20]

25

INTRODUCTION

Once the crisis of 2008 had demonstrated just how weak democracy is before the ebb and flow of the global economy, the decade that followed saw an increasing number of young people turning away from liberal values and drifting toward radi-cally individualist tendencies advocating the survival of the fit-test. But liberalism has always had a dark side. None other than John Locke, the supposed father of liberalism, was also 'the last major philosopher to seek a justification for absolute and perpetual slavery',[21] part of a history which Domenico Losurdo exposes with extreme precision, showing for example how the USA, taken by many to be the liberal country per excellence, was not only founded on slavery, but had slave owners as its Founding Fathers.

The greatest fallacy of both liberalism and anarchism, though, concerns the primacy of the individual. What John Cage, anar-chism, Silicon Valley ideology, certain assumptions about free-dom in the free improvisation and noise scenes, reactionary movements, and far-right identity politics such as the alt-right have in common is their belief in a naturalised conception of the individual as proprietor of their experiences. Furthermore, they share the assumption that the unmediated core of this individual has the potential, from within the given situation, to express their freedom. These assumptions are made without taking into account either the determination of subjects at the

20. A.T. Pinto, 'Artwashing NRx and the Alt-Right', *Texte zur Kunst* 106 (June 2017).

21. D. Losurdo, *Liberalism: A Counter-History*, tr. G. Elliott (London: Verso, 2011), 3.

level of the social totality, or the fact that the notion of the individual is an abstraction arising from these forms of determination. Today's urgent political climate and the ideological shift toward the far right that followed the 2008 crisis mean that it is now crucial to disentangle these assumptions.

The specific moment outlined above—the primal scene for John Cage's belief in sounds in themselves—can be seen as an example of how the collapsing of self, individual, and subject promotes a type of thinking that leads the individual to claim such agency, fuelling the narrative of the autonomous and sovereign self. In the anechoic chamber experience ideology, emphasis is placed on individual experience without taking social determination into account. But thinking social dissonance implies breaking with the idea of listening itself as an ideological anechoic chamber, where listening is just an action that relates you to the sound, and where the sonic is emphasised at the expense of understanding the interrelation between whatever we claim to be music and the values which produce that claim (and here lies the interrelation between value in the cultural sense and value in the economic sense). Cage's understanding of letting 'sounds be themselves'[22] and his anarchist politics are entirely in accordance, in the sense that the former supposes that 'sounds in themselves' are perceived individually outside of the social continuum,[23] just as the latter—especially in the American anarchist tradition—emphasises individual agency.

In order to challenge this ideology, *Social Dissonance* seeks to shift the emphasis from the sonorous to the social, precisely because this division is fictitious in the sense that the perception

22. J. Cage, 'Experimental Music', in *Silence: Lectures and Writings* (Middletown, CT: Wesleyan University Press, 1973), 10

23. The relation between this type of thinking and the theories of Clement Greenberg is well explained in Kim-Cohen, *In the Blink of an Ear*, xvi.

of the sonorous is *already social*. The question, though, is what type of social relations are at play when we gather to perform and listen, and this is the question inhabited by those who interpret and participate in *Social Dissonance*.

I am quite aware that this exploration will inevitably be aestheticised; it is designed to incorporate an awareness of and a self-reflection on its own aestheticisation. Nonetheless, the emphasis here is not on aesthetic questions or a critique of aesthetics, but on how aesthetic recuperation is embedded within a broader ideology of capitalist relations.

ALIENATION AS AN ENABLING CONDITION

The first part of this book deals with the concept of alienation, here understood not as a condition to be escaped, but as a constitutive part of subjectivity. In Marx, the concept of alienation serves to problematise our assumptions as to what we believe ourselves to be, and how we relate to production. Certain interpretations of the term have been heavily criticised for presupposing that the human has some essential qualities from which it is alienated, and that there is an originary position that could be restored. The argument I will present here, reexamining Marx's use of alienation in light of Thomas Metzinger's demystification of selfhood and Ray Brassier's anti-essentialism, is that this is always a form of mystification.

I approach alienation as a concept that allows us to demystify the ways in which the self is produced through various forms of mediation: how individuals are embedded in abstract relations of production which in turn condition our doing and thinking, producing our agency at the social level ('Alienation from Above', Chapter 1); but also how the self as proprietor of its own experiences is a model that produces the illusion of agency at the personal level ('Alienation from Below', Chapter 2).

The *Social Dissonance* score tries to bring this doubly alien-ated condition into the foreground by exhibiting how the per-formance situation already resounds to the dissonances that such alienation induces. In this respect, the score may seem to belong to an established tradition. In aesthetics, the notions of alienation, estrangement, and defamiliarisation have long been used in modern art, theatre, literature, and cinema in order to render unfamiliar that which formerly seemed familiar, thereby encouraging us to question mechanisms of production that appear to be natural or neutral (we might think here of Viktor Shklovsky, Sergei Tretyakov, Bertolt Brecht, Jean-Luc Godard, Yvonne Rainer, Straub-Huillet, Arthur Jafa, and Gina Pane). These techniques have served to allow artists to challenge our habitual modes of perception, and in this sense, alienation in aesthetics has been an enabling condition for thought and practice. In noise and improvisation—the contexts in which I work—some of these techniques have been used in the past and have obtained powerful results. However, as advanced in Chapter 3, 'Externalising Alienation', my contention is that they have become conventionalised and emptied of their original critical purchase in so far as they continue to invoke the self as the decisive agent of freedom. I then seek to synthesise the theoretical resources gathered from the analysis of alienation in order to develop new techniques for a contemporary use of alienation in aesthetics, and more specifically in the practices of noise and improvisation.

This allows me to develop what I call *constituting praxis*, a praxis that tries to understand its conditions while generating its own rules and norms. The concept of freedom here is dif-ferent to that usually at work in improvisation: rather than a spontaneously available capacity to create ex nihilo, freedom is a cultural achievement that has to generate its own rules and

norms, as there is no freedom without norms. Nor is there any way to understand the human without any form of determination.

SOCIAL DISSONANCE AS A WAY TO DIG INTO REALITY

Following these theoretical discussions and a brief Conclusion, I present the *Social Dissonance* score itself, along with observations on how it has been interpreted and performed.

While dissonance has negative connotations, in avant-garde and noise practices dissonance has been taken as a positive, in the sense that it can allow us to think differently about music. Historically, the notions of dissonance and noise have been seen as challenging hierarchies in the understanding of sound. In dealing with social dissonance, we shift this challenge from the sonic to the social, and in doing so discover for ourselves that social dissonance is actually the realm that we have to deal with; it's the opaque map in which we find ourselves, the condition that we are in. Essentially, the score says: let's take what we have at hand and explore how we are determined. By playing with, amplifying, and addressing this dissonance in terms of social relations, we are simply dealing with reality.

In *Living in the End Times,* Slavoj Žižek addresses the foreground/background distinction in John Cage's *4'33"* and Erik Satie's *Musique D'ameublement*. According to Satie, music should be a part of the sound of the environment, whereas for Cage, the noises of the environment *are* the music. Žižek claims that Satie's *Musique D'ameublement* was in fact the opposite to Muzak,

> a music which subverts the gap separating the figure from the background. When one truly listens to Satie, one 'hears the background'. This is egalitarian communism in music: a music which

shifts the listener's attention from the great Theme to its inau-
dible background, in the same way that communist theory and
politics refocus our attention away from heroic individuals to the
immense work and suffering of the invisible ordinary people.[24]

In the interpretation of *Social Dissonance*, what we hear is the
impossibility of egalitarian society today, in a system that con-
stantly demands the production of heroic individuals who are
compelled to deal with increasingly competitive conditions.
It's not that the noises are the music or that social dissonance
simply 'becomes' music, but rather that our frustrations, our
social determination, and the possibility of collective agency
come to the foreground as 'quasi-sounds' that testify to the
'intrusion' of something more than 'the sounds themselves'.
Given the potential for all aspects of reality to become a part
of social dissonance, the negotiation between foreground and
background shifts constantly.

Social dissonance requires us to acknowledge that Cage's
ideological anechoic chamber does not exist—just as the neu-
trality of the white cube does not exist. You are already a part
of this reality, these dissonances are already running through
you. The question then becomes: What are you as subject—
if you are one—and how do you relate to others? The point
is not to generate an artificial reality in order to isolate your-
self—as if you already were a subject capable of exercising
the authority of taste (by having a specific knowledge, educa-
tion, or background),[25] but to generate a direct connection to

24. S. Žižek, *Living in the End Times* (London and New York: Verso, 2010), 381.

25. For a more extensive debate on the authority of taste see my conversa-
tion with Martina Raponi, 'The Authority of Taste: Mattin and Theses on Noise',
<http://www.digicult.it/news/authority-taste-mattin-theses-noise/>.

other aspects of reality, to investigate the intrinsic connections between economy, culture, and the way that you are produced as a subject (which is always an act of contestation). *Social Dissonance* is an attempt to address these issues at the same level, while keeping in mind that you will inevitably be producing sounds.

Shifting the emphasis from the sonic to the social does not mean that the sonic is neglected; rather, established aesthetic values are set aside in order to explore in a more direct way the function of the artist and musician and their practice in today's society, but also that of the audience, and how the relations between the two can be disturbed. Of course, I understand that at the same time we are engaging in a process of aestheticising aspects that might not yet have great aesthetic value (the sound of conversations, embarrassment, confusion, power relations, intense atmospheres, and so on) just as, when Cage presented *4′33″*, the audience were confronted with sounds which, at the time, were not perceived as music, but soon became the object of aesthetic appreciation. However, while Cage was interested in integrating these sounds into the canon of musicmaking, the *Social Dissonance* score sets out to constantly undermine and question its own aestheticisation, while understanding the roles we play within this aestheticisation process. One might think of this act through the metaphor of a hamster in a wheel going nowhere, with the performance of the score as a method for, at least, visualising this wheel: understanding how it functions, so as hopefully to dismantle it in the future. It is important to have a picture, an allegory, or a metaphor for what is going on, for such figurative models may allow us to understand what we are caught up in—and where we'd like to go.

Schoenberg exposed the conventions of tonal music, which opened up possibilities for a new understanding of musicmaking. Cage questioned the impossibility of silence for humans, making us aware that whatever sounds we perceive can be appreciated as music. In doing so, these artists exposed and altered the conventions of our understanding of music and what our perception of sound is. With *Social Dissonance*—if the score is successful—the conventions of how we understand *ourselves* are exposed. This might help us not only to reconsider the function of music in today's society, but to directly address how society itself could be changed.

1

ALIENATION FROM ABOVE: SPECTRAL OBJECTIVITY

Let us now look at the residue of the products of labour. There is nothing left of them in each case but the same phantom-like objectivity; they are merely congealed quantities of homogeneous human labour, i.e. of human labour-power expended without regard to the form of its expenditure. All these things now tell us is that human labour-power has been expended to produce them, human labour is accumulated in them. As crystals of this social substance, which is common to them all, they are values—commodity values.

Karl Marx[1]

What is this phantom-like or spectral objectivity (*Gespenstige Gegenständlichkeit*)[2] and how does it relate to our experience of selfhood? We produce commodities through our human labour-power and this labour is transmuted into 'crystals of social substance'. However, the process of becoming a commodity erases all subjective and social traces by making the commodity appear as an objective thing, a natural phenomenon; what we take to be a relation between things (i.e. commodities), is a relation between people (i.e. expended human labour-power),

1. K. Marx, *Capital: A Critique of Political Economy, Volume One*, tr. B. Fowkes (London: Penguin Books, 1990), 128.

2. *Gespenst* is also translated as 'spectre', 'spook', 'ghost', or 'spirit'. While the term 'spectre' was used for the translation of *Gespenst* in *The Communist Manifesto*, 'spook' was used in Max Stirner's *The Ego and Its Own* and in *The German Ideology*, for example when Marx criticised Stirner, as we will see later on. Here we find 'spectre' more appropriate than a translation that suggests phantomatic properties, because it emphasises its social character, even if spectrality also encompasses phantomaticity. Thanks to Ray Brassier for pointing out this differentiation and to Cecile Malaspina for directly addressing the relationship between the spectrality of commodity production and the phantomaticity of selfhood.

and what we take to be a relation between people is actually driven by commodities such as money which have become quasi-personified agents. This is what György Lukács, following Georg Simmel, called *reification* (*Verdinglichung*) and, as we shall see, it has effects not only on our perception of the world, but also on our self-conception. Capitalist mediations of the social and our engagement in value production have effects which we cannot fully understand through our personal experience, but which nonetheless condition the way in which we experience, and our understanding of our experiences and of ourselves as persons. This is precisely because spectral objectivity arises from the non-immediate and non-observable processes that constitute value production: even if 'not an atom of matter enters into the objectivity of commodities as values',[3] this value appears as if is a natural property. Here we have a critique of substance understood in the Aristotelian sense: the substance of value has no material basis in the physical world whatsoever, but it is impossible to decipher this on the basis of perception or experience.

Another of the effects of this process of naturalisation is to personify selfhood, i.e. to make us appear as natural individuals, and to clearly delineate what are supposed to be our own properties, generating ideological boundaries and a sense of property relations. It is here that the seeds of social dissonance are sown.

By tracing back the concept of alienation, which bears upon the subject/object relationship, we will be able to better identify where this spectral type of objectivity comes from, and how suprapersonal structures come to produce a corresponding

3. Marx, *Capital 1*, 138.

phantom subjectivity—that of a liberal subject that believes itself to be the owner of its experiences.

As Samo Tomšič argues, the notion of alienation is characteristic of the age of the modern subject:

> While economic liberalism can be counted among attempts to repress the link between alienation and production of subjectivity, modern philosophy was inaugurated by the encounter of alienation in the form of radical doubt. It was on the background of this encounter with a problematic, which remained unthought in premodernity, that philosophy could abolish the premodern theory of the subject, the metaphysical soul. The problem of alienation could thus be seen as the demarcation line between philosophical premodernity and modernity.[4]

The twentieth century produced many discussions of alienation and reification,[5] but the problem with many of these approaches is that they take as their starting point certain presuppositions concerning how the self relates to experience, and thus imagine the undoing of the mediated, reified, capitalist self as

4. Tomšič, *The Labour of Enjoyment*, 128.

5. According to Guy Debord, for instance, 'The alienation of the spectator to the profit of the contemplated object (which is the result of his own unconscious activity) is expressed in the following way: the more he contemplates the less he lives; the more he accepts recognizing himself in the dominant images of need, the less he understands his own existence and his own desires. The externality of the spectacle in relation to the active man appears in the fact that his own gestures are no longer his but those of another who represents them to him. This is why the spectator feels at home nowhere, because the spectacle is everywhere' (G. Debord, *The Society of the Spectacle* [1967], <https://www.marxists.org/reference/archive/debord/society.htm>, thesis 30). Note that Debord says *his own existence and his own desires*. This conception of ownership is what I will seek to question below, in particular using the work of Metzinger and Sellars.

a regaining of an originary metaphysical experience of freedom. This starting point is part of the problem of the political paralysis of the Left. In this and the subsequent chapter I argue that instead, alienation must be taken as an *enabling condition*: as a way to reveal the social dissonance between our image of ourselves (as free individuals endowed with rational agency) and our socio-physical determination or constitution by the capitalist totality, understood to include the value-relation and technological mediation, in interaction with the subpersonal mechanisms that are necessary for the production of selfhood.

THE MEMES OF STIRNER

> I can never take comfort in myself as long as I think that I have still to find my true self.
>
> Max Stirner[6]

The contradiction between the belief that an individual can achieve self-determination and the way in which modern structural realities simultaneously promote and negate this possibility has never been so thoroughly expressed as in the work of Max Stirner (1806–1856) and in Marx's critique of his thinking in *The German Ideology*. Stirner's thought represents a very specific moment in the history of different understandings of the notion of alienation.

Otherwise a rather obscure figure, Stirner's extreme individualism has recently become popular through memes in certain online communities and he is often admired in anarchist and libertarian circles for his uncompromising position in regard

6. M. Stirner, *The Ego and Its Own*, tr. S. Byington (Cambridge: Cambridge University Press, 1995), 283.

to the particularity and primacy of what he called *die Einzige* (often translated as 'the Ego' or 'the Unique').[7] In his defence of the 'ownness' (*Eigentum*) of the individual Ego against society, Stirner stood against any form of universalism because it would imply the ascendancy of an abstract concept over the uniqueness of the individual's properties. His concept of egoism militates against any form of morality that would deprive the Ego of autonomy: 'Like religion, morality demands that the individual sacrifice her autonomy to an alien end, that she give up her own will "for an alien one which is set up as rule and law"'.[8] Accordingly, Stirner developed a critique of liberalism, but also of communism (as proposed by Proudhon).[9] His main target, however, was Ludwig Feuerbach (1804–1872). In his attempt to finally be done with Christianity, Feuerbach had developed the concept of alienation to describe how man projected an idea outside of himself in order to find inner fulfilment. Religion was

7. See <https://www.reddit.com/r/fullegoism/>. Thanks to Timothy Treciokas, Andrei Chitu and Jacob Blumenfeld for an ongoing discussion on Stirner. For a collection of memes see for example <https://www.reddit.com/r/fullegoism/comments/bgkwh6/an_explanation_of_max_stirner_memes_for_the/>.

8. D. Leopold, Introduction to Stirner. *The Ego and Its Own*, xxiii, quoting Stirner, 75.

9. It is also to be noted that Stirner, a student of Hegel's, followed a dialectical approach in conjunction with a racial and racist conception of history. In his Introduction to the 1995 Cambridge University Press edition of *The Ego and Its Own*, David Leopold writes: 'Individual and historical development are the two primary forms of the Stirnerian dialectic, but in order to clarify its form he inserts "episodically" a racial (and racist) analogue of the historical account. Human history, in this new narrative, "whose shaping properly belongs altogether to the Caucasian race", is divided into three "Caucasian ages". The first, in which the Caucasian race works off its "innate Negroidity", is vaguely located as including the era of Egyptian and North African importance in general and the campaigns of Sesostris III in particular, but its importance is clearly symbolic' (xvii).

for Feuerbach an outward projection of humanity's essential nature as an emotional and sensuous being, an attempt to try and produce happiness through images:

> Every being experiences peace only in its own element, only in the conditions of its own nature. Thus, if man feels peace in God, he feels it only because in God he first attains his true nature, because here, for the first time, he is with himself, because everything in which he hitherto sought peace, and which he hitherto mistook for his nature, was alien to him.[10]

According to Stirner's critique, though, Feuerbach's humanist and anthropological concept of Man was still an abstraction with theological residues—what Stirner called a 'spook', sometimes also referred to as a 'fixed idea':

> The most oppressive spook is *man*. Think of the proverb, 'The road to ruin is paved with good intentions.' The intention to realize humanity altogether in oneself, to become altogether man, is of such ruinous kind; here belong the intentions to become good, noble, loving, and so forth.[11]

This attack on 'fixed ideas' also extended to communism: according to Stirner, since the abolition of property is nothing but the very 'essence of Christianity', communism can be regarded as the 'absolute religion'.[12] For our purposes though, what is interesting is the distinction Stirner makes, when discussing

10. L. Feuerbach, *The Essence of Christianity*, tr. G. Eliot (Walnut, CA: MSAC Philosophy Group, 2008), 12.

11. Stirner, *The Ego and Its Own*, 69.

12. Ibid., 279.

liberation from such 'spooks', between *revolution* and *insurrection*, and the correlation of this distinction to the relationship between the collective and the individual. Stirner understands revolution to be about overturning conditions, the status quo, the state, or society, in the hope of establishing a new arrangement. Revolution is therefore a collective political or social act. Insurrection, on the other hand, is a kind of self-liberation that involves the individual literally rising above all institutions and refusing fixed ideas. 'Insurrection', Stirner writes,

> leads us no longer to *let* ourselves be arranged, but to arrange ourselves, and sets no glittering hopes on 'institutions'. It is not a fight against the established, since, if it prospers, the established collapses of itself; it is only a working forth of me out of the established. If I leave the established, it is dead and passes into decay. Now, as my object is not the overthrow of an established order but my elevation above it, my purpose and deed are not a political or social but (as directed toward myself and my ownness alone) an *egoistic* purpose and deed.[13]

Let us note here that this overblown anarchism of Stirner's is reminiscent of certain approaches to the expression of freedom in improvisation touched upon in the Introduction above—in particular, the idea that one can express freedom and produce self-determination through sheer will. For Stirner, alienation is produced by the state because it strips you of this individual will: the state tells us that '[t]he true man is the nation, but the individual is always an egoist. Therefore strip off your individuality or isolation wherein dwells discord and egoistic inequality, and consecrate yourselves wholly to the true man—the

13. Ibid., 280.

nation or the state.'[14] In opposition to these commands of the state, Stirner recommended what he called 'self-discovery'. For Stirner there are two forms of self-discovery, one that occurs when the child discovers their own mind, their conscience, reason and their courage and shrewdness. But this, for Stirner, is still a lower ideal level of discovery. A second self-discovery occurs when the individual discovers their corporeal self and can develop personal and egoistic interests, taking *ownership* of the world: '"I alone am corporeal". And now I take the world as what it is to me, as mine, as my property [*Eigentum*]; I refer all to myself.'[15] Thus Stirner announces a crass form of materialism which Marx will heavily criticise.[16] Stirner was crucial in the development of Marx's thought, and in particular in his leaving behind the Feuerbachian concept of *Gattungswesen* (species-being) used in the Paris Manuscripts of 1844. As we shall see below, it was after Marx read Stirner that his concept of alienation changed, or at least developed dramatically, to the point where he even mocked himself for using the concepts of Man, essence, or species-being.[17]

EGOISM AS ALIENATION: MARX'S CRITIQUE

In *The German Ideology*, the work in which the concept of historical materialism first emerges, Marx spends a good many pages attacking Stirner. Many have dismissed this largest part of

14. Ibid., 90. It is perhaps unsurprising that Stirner had such problems with the state and its institutions, as his mother Sophia Elenora Reinlein suffered from mental health problems and was treated very poorly by the institutions of the time.

15. Ibid. 17.

16. Ibid., 307.

17. Marx, *Capital 1*, 128.

the book as an angry and ironic rant. However, in recent years it has been the focus of more involved discussion, from Jacques Derrida in his late and controversial book *Specters of Marx* to a recent text by the young Berlin-based philosopher Andrei Chitu which returns to Marx's critique of the lack of determination within Stirner's concept of freedom as self-liberation or self-discovery. As Chitu remarks, 'Stirner's notion of self-discovery [...] is not the result of a historical situation in which an individual finds herself. It is also not the result of any form of content that can be deemed external to the autonomous life of the mind.'[18] This lack of determination brings with it the question of historicity: Stirner's assumption that the ego can achieve autonomy and self-determination is inevitably naturalising and dehistoricising because it implies that the ego can free itself of the constraints of history:

> Thinking about oneself as an individual outside of dependency relations with the world and thinking about the world as given ready-made are thoughts that determine each other, as they share a common denial of historicity. Historicity does not only mean the possibility of changing the environment and the self but also implies the habitation of an already structured reality that is the result of previous activity.[19]

Marx's own critique of Stirner's concept of alienation in *The German Ideology* runs as follows: According to Stirner the non-ego is alien to the ego, and whatever is alien to the ego is an abstraction, a spook, something holy. And yet in the absence of

18.　A. Chitu, 'Stirner, Marx and the Unreal Totality', in Iles and Mattin (eds.), *Abolishing Capitalist Totality*.

19.　Ibid.

description of any specific aspects of the ego and its relation to the non-ego at a situated moment in time, Stirner's conception of the ego also falls into abstraction. As Marx writes, if, for Stirner, the non-ego is a spook,

> [t]he ego instead is supposed to be real. Thus [instead] of the task of describing [actual] individuals in their [actual] alienation and in the empirical relations of this alienation, [purely empirical] relations, [...] the setting forth is replaced by the [mere idea] of alienation, of [the alien], of the holy. [The] substitution of the category of alienation (this is again a determination of reflection which can be considered as antithesis, difference, non-identity, etc.) finds its final and highest expression in 'the alien' being transformed again into 'the holy', and alienation into the relation of the ego to anything whatever as the holy.[20]

Extending this critique, Marx then seeks to criticise morality and religion from a far more radical point of view than Stirner's, by revealing their ahistorical character:

> Morality, religion, metaphysics, and all the rest of ideology as well as the forms of consciousness corresponding to these, thus no longer retain the semblance of independence. They have no history, no development; but men, developing their material production and their material intercourse, alter, along with this their actual world, also their thinking and the products of their thinking. It is not consciousness that determines life, but life that determines consciousness.[21]

20. K. Marx and F. Engels, *The German Ideology* (New York: Prometheus, 1998), 298.

21. Ibid., 42.

Humans are the producers of their conceptions, but this production is mediated by the historical mode of production and the division of labour. Because of this, they can never be fully conscious of what they are doing because they can only retroactively and partially make sense of it—otherwise they would be able to have access to all of history at once, which is impossible.[22] Here Marx is of course approaching what would become his own mature concept of alienation. Aware that Stirner had warned against any form of fixed idea as a form of abstraction, though, Marx had to be extremely specific about the way alienation would function. Consciousness and ideology, he tells us, emerge from the 'historical life-process', a process which is not transparent to those living within it—or rather is transparent in the sense that it operates upon what appears but does not itself appear:

> If in all ideology men and their relations appear upside-down as in a camera obscura, this phenomenon arises just as much from their historical life-process as the inversion of objects on the retina does from their physical life-process.[23]

This is precisely why, in *The German Ideology*, alienation emerges at the material level within the division of labour:

> The social power, i.e., the multiplied productive force, which arises through the co-operation of different individuals as it is caused by the division of labour, appears to these individuals, since their co-operation is not voluntary but has come about naturally, not as their own united power, but as an alien [*fremd*] force existing

22. As discussed in Chitu, 'Stirner, Marx and the Unreal Totality'.

23. Marx and Engels, *The German Ideology*, 42.

outside them, of the origin and goal of which they are ignorant, which they thus are no longer able to control, which on the contrary passes through a peculiar series of phases and stages independent of the will and the action of man, nay even being the prime governor of these.[24]

Cooperatively produced social power is appropriated by an outside, 'alien' force which removes control from the producers themselves. In order to abolish this specific form of alienation arising from the division of labour—what Marx calls '[t]his "estrangement [*Entfremdung*]" (to use a term which will be comprehensible to the philosophers)'—a revolution at the universal level would be required.[25] Marx's universalist analysis here acts as an implicit critique of various forms of anarchist secessionist approaches, but also national liberation movements. While Stirner narrows his point of focus down to the insurrectionist individual, Marx takes an overview at the level of the social totality. Precisely because capitalism is an ever-expanding system generating forms of equivalence in the exchange abstraction, we cannot isolate a given moment or instance and believe that it can break out of this totality, as would be the case with Stirner's Ego. Without looking at the particular mode of production and how this mode itself is reproduced, without taking into account the historical determinations of a specific form of interaction, it is all too easy to fall into a mythologising position like Stirner, who, in striving to get rid of all spooks, ended up with the biggest one of all, the Ego, which, as we see under current conditions, can very well be totally overblown into forms of extreme individualism without posing

24. Ibid., 53–54.

25. Ibid., 54–57.

the slightest threat of insurrection. Indeed, the radical individualism promoted by Stirner is well suited to today's crumbling neoliberal conditions, and it is perhaps not surprising that he is sometimes mentioned within the far right, or that he influenced figures such as Julius Evola[26] and has been compared to Ayn Rand.[27] Hans G. Helms, a student of Adorno, went much further and claimed that Stirner was not only the ideological representative of the middle class, but was an important figure in the development of fascism, tracing his influence on Marinetti and possibly Hitler himself.[28] Marx's analysis thus reveals the individual's power of self-determination, celebrated by Stirner, to itself be an ideological construct beneath which there lies the current capitalist mode of production. Now, despite its apparent resilience, recent crises suggest that the contradictions of this specific form of production may not be able to hold for much longer, and that we may be at the end of the liberal epoch (although developments in China today show that an unfamiliar form of capitalism may be on the horizon). The increasing

26. For an account of the influence of Stirner throughout the history of the Right see A.R. Ross, 'EGOMANIA! A Response to My Critics on the Post-Left', <https://ecology.iww.org/texts/AlexanderReidRoss/Egomania>.

27. See D.S. D'Amato, *Egoism in Rand and Stirner*, <https://www.libertarianism.org/columns/egoism-rand-stirner>.

28. '[A]nalogous documents to Stirner from National Socialist literature [...] are widely dispersed, easily accessible and well enough known. There is difficulty in producing a catalog of parallel passages in the "Einzige" and in *Mein Kampf*. That does not mean that Hitler knew and got the full value out of the "Einzige", although [...] a Stirner-influence on Hitler mediated through Dietrich Eckart is at least not to be excluded. It does mean that Hitler articulated a specific middle-class ideology and that Stirner and national socialism are a variation of the same fascist ideology.' H.G. Helms, *Die Ideologie der anonymen Gesellschaft*, quoted in P.B. Dematteis, *Individuality and the Social Organism: The Controversy Between Max Stirner and Karl Marx* (New York: Revisionist Press, 1976).

strain placed on these contradictions is producing more 'mental noise', greater social dissonance, at the level of the individual called upon constantly to affirm and perform their freedom, to market their ego, and to 'improvise' their way through a highly economically determined situation. In order to deal with this mental noise, we need to understand where it comes from, and it will therefore be important to engage with the concept of alienation in its contemporary specificity. But in preparation for this, let us examine its history in a little more detail.

A BRIEF HISTORY OF ALIENATION: *ENTÄUSSERUNG* AND *ENTFREMDUNG*

The concept of alienation inevitably implies mediation and separation, and the origins of the term can be traced back to Martin Luther's translation of the Bible, or, to be more specific, the New Testament, where Paul uses the word *apellotriome-noi*, often translated as 'alienated', to refer the state of having fallen from grace, which produces a separation from God.[29] At another point, Paul refers to the moment of incarnation when God *ekenesen* (empties) himself in order to become a human. Luther translated *kenosen* as *Entäußerte* (which could also be translated as 'externalised'), and this in turn became the source of the Hegelian concept of *Entäußerung*, which relates to the externalisation and objectification of spirit.[30] Subsequently, in *The Essence of Christianity* Feuerbach used the term *Entfremdung*[31]

29. S. Skempton, *Alienation after Derrida* (London: Continuum, 2010), 22.

30. Ibid., 54.

31. As an example of how Feuerbach uses the verb *entfremden* (to alienate) in relation to religion, take the following: 'Warum *entfremdest* du also dem Menschen sein Bewußtsein und machst es zum Selbstbewußtsein eines von ihm unterschiednen Wesens, eines Objekts?' 'Why then dost thou *alienate* man's consciousness from him, and make it the self-consciousness of a being

(translated as 'alienated' or 'estranged'—the term then adopted by Marx) to criticise religion for projecting the characteristics of human nature into an imaginary non-human, divine being, thus separating humanity from itself.[32] In the previous century, from a secular point of view, Rousseau, understanding the term *aliéner* as meaning 'to give' or 'to sell',[33] had sought 'to demonstrate the inalienability of the right of freedom and of the sovereignty of the "general will" of the people': freedom cannot be bought or sold, it is essential to being human, and yet people give up their freedom—*alienating* their essential humanity—'in order to gain "civil liberty", a legally guaranteed freedom through property laws'.[34] Marx too would remark that, while the legal system was there to protect property, freedom was taken away from the worker through the wage relation. Andrew Chitty explains how, given the complexity of *Entäußerung* and *Entfremdung* in the German language and its history, by the time Marx was writing, various meanings had come to be interwoven in the concept translated by the English term 'alienation':

> *Entäusserung* [...] literally means 'externalisation'. [...] [I]n the everyday German of Marx's time [it] means 'relinquishing ownership of' [...] equivalent to the legal sense of the English word 'alienation' as when we speak of 'inalienable rights'. [...] To take just the example of Hegel, he uses the term to describe God's incarnation in Jesus. By contrast *Entfremdung* means in everyday German 'becoming (or being) cut off'. This is equivalent to the interpersonal sense

distinct from man, of that which is an object to Him?' (Feuerbach, *The Essence of Christianity*, 186).

32. Skempton, *Alienation after Derrida*, 36.

33. Ibid., 25.

34. Ibid.

of the English word 'alienation', as when we speak of someone being alienated from their friends or family.[35]

In his text 'Strange Sameness: Hegel, Marx and the Logic of Estrangement', Ray Brassier suggests using the term 'externalisation' for *Entäußerung* and 'estrangement' for *Entfremdung*, explaining that, for Hegel's Spirit, self-*externalisation* is constitutive of freedom, but when this freedom is subjected by a foreign power it becomes *estranged*.[36] This means that while all estrangement is externalisation, not every externalisation is an estrangement. Since for Marx's materialism, practice is a form of self-externalising, the termination of subjected or estranged externalisation is not the reinstatement of some form of interiority. De-estrangement or the end of estranged externalisation is another form of externalisation, not the end of externalisation itself. By looking at the difference between externalisation and estrangement, Brassier suggests, we can understand alienation as a dialectical process, rather than adopting an 'all-or-nothing' understanding of the concept.

MARX'S SHIFTING CONCEPTION OF ALIENATION

Marx himself altered his perspective on the notion of alienation throughout his life. In the Paris Manuscripts of 1844, he described alienation as the separation that occurs between man and his *Gattungswesen* (sometimes translated as 'species-being' or 'genus being'). This concept is influenced by Feuerbach, and

35. A. Chitty, 'Review of Sean Sayers, *Marx and Alienation: Essays on Hegelian Themes*', <https://marxandphilosophy.org.uk/reviews/7864_marx-and-alienation-review-by-andrew-chitty/>.

36. R. Brassier, 'Strange Sameness: Hegel, Marx and the Logic of Estrangement', *Angelaki* 24:1 (2019), 98–105.

in particular by his claim that '[t]he single man *in isolation* possesses in himself the *essence* of man neither as a *moral* nor as a *thinking* being. The *essence* of man is contained only in the community'.[37] It is the human possibility of generic consciousness that allows for abstraction and universals, which in turn can also allow for sociality.

According to the early Marx's conception of *Gattungswesen*, in opposition to animals, the human can make of its life an object which it can transform in and for the community. The essence of man, then, lies in the community, but under capitalism human sociality is mediated by capitalist categories such as wage labour, making it impossible to realise its *Gattungswesen*. Only in communism would the human be able to return to its *Gattungswesen*.[38] Later on, between 1845 and 1846, in his *Theses on Feuerbach* and in *The German Ideology*, Marx criticises his own use of the notion of *Gattungswesen* as an anthropological abstraction. Turning against Feuerbach, he

37. L. Feuerbach, *Principles of the Philosophy of the Future* [1843], tr. Z. Hanfi Marxists.org, <https://www.marxists.org/reference/archive/feuerbach/works/future/future2.htm>.

38. Here we have the famous quote from the Paris Manuscripts on Communism: '*Communism* as the *positive* transcendence of private property as *human self-estrangement*, and therefore as the real *appropriation* of the *human essence* by and for man; communism therefore as the complete return of man to himself as a social (i.e., human) being—a return accomplished consciously and embracing the entire wealth of previous development. This communism, as fully developed naturalism, equals humanism, and as fully developed humanism equals naturalism; it is the *genuine* resolution of the conflict between man and nature and between man and man—the true resolution of the strife between existence and essence, between objectification and self-confirmation, between freedom and necessity, between the individual and the species. Communism is the riddle of history solved, and it knows itself to be this solution.' K. Marx, *Economic and Philosophic Manuscripts of 1844* (Moscow: Progress Publishers, 1959), ed. A. Blunden for Marxist.org, (2000), <https://www.marxists.org/archive/marx/works/1844/manuscripts/comm.htm>.

refutes the notion of man as an abstract ahistorical concept—
a mere idea—and thereafter determines to conceive of man
as a historical human embedded in concrete conditions and
relations.[39] As Chris Arthur puts it,

> one cannot speak of 'Man' as such, except at a highly abstract
> level. History is made by particular kinds of men, with specific
> needs and problems, and specific conditions of life determining
> the possibility of a solution to those problems.[40]

Later still, in *Capital*, Marx says that alienation is concretely
defined in the capitalist mode of production as the division
between the products of labour—which are the objective con-
ditions of labour—and labour itself, subjective labour-power. For
Marx, this is the foundation of capitalism. But this is just the
starting point of a constant, ongoing process, a process founded
on the fundamental asymmetry between workers who lack the
means to convert their material energy into social wealth and a
production process that converts this potential material wealth
into the actuality of wealth: capital, i.e. the capitalist means of
valorisation.[41] Therefore the worker reproduces themselves as
a worker as well as reproducing the conditions that perpetuate
this relation between themselves and capital:

> Since, before he enters the process, his own labour has already
> been alienated [*entfremdet*] from him, appropriated by the capi-
> talist, and incorporated with capital, it now, in the course of the

39. This is well explained in I. Monal, 'Ser genérico, esencia genérica en el
joven Marx', <https://www.ifch.unicamp.br/criticamarxista/arquivos_bibliote-
ca/artigo97artigo4.pdf>.

40. C. Arthur, Introduction to Marx and Engels, *The German Ideology*, 21.

41. Marx, *Capital 1*, 716.

process, constantly objectifies itself so that it becomes a product alien to him [*fremder Produkt*]. Since the process of production is also the process of the consumption of labour-power by the capitalist, the worker's product is not only constantly converted into commodities, but also into capital, i.e. into value that sucks up the worker's value creating power, means of subsistence that actually purchase human beings, and means of production that employ the people who are doing the producing. Therefore the worker himself constantly produces objective wealth, in the form of capital, an alien power that dominates and exploit him; and the capitalist just as constantly produces labour-power, in the form of subjective source of wealth which is abstract, exist merely in the physical body of the worker, and is separated from its own means of objectification and realization; in short, the capitalist produces the worker as a wage-labourer. This incessant reproduction, this perpetuation of the worker, is the absolutely necessary condition for capitalist production.[42]

In this process, the worker is involved in two very distinct forms of consumption. In the first, which Marx calls productive consumption,[43] the worker consumes the means of production, but in doing so, makes products of a value higher than that which capital advances to them. This is followed by individual consumption,[44] where the worker uses the money paid to them to merely buy their means of subsistence. In productive consumption, the worker belongs to the capitalist and generates capital; in individual consumption, they just try to survive. Here we can see how labour in its alienated form as

42. Ibid.

43. Ibid., 423.

44. Ibid., 422.

labour-power enables the expansion of capital and the capitalist. In late Marx, then, the abstraction called 'man' is left behind in order to understand how labour-power is embedded concretely in the production process, which reproduces the conditions for the worker's perpetuation as a worker.

In the *Grundrisse*, Marx goes so far as to criticise the division between subjectivity and objectivity, questioning what it means to be an individual under the capitalist mode of production. For him, labour cannot produce its own objectivity: the worker's living labour is only an abstraction that cannot be concretised for and by them, because capital takes this capacity away from them. Labour is not an object but an activity that is the living source of value. Labour, Marx continues, 'is the *absolute poverty as object*, on one side, and is, on the other side, the *general possibility* of wealth as subject'.[45]

In Marx's words here we can already begin to see the crucial role played by alienation in the subject/object relation, and the way in which capitalism transforms this relation, making it far from straightforward to identify an individual autonomous subject.

AN ULTRA-LEFT DEBATE

As a way to frame a contemporary discussion on alienation, I would like to turn now to a debate over the term that took place in the 90s and early 2000s between the Brighton, UK-based magazine *Aufheben*, the Marseille ultra-left group Théorie Communiste, and the Marxist-Hegelian philosopher Chris Arthur.

Aufheben, who state that 'the market or law of value is not the essence of capital; its essence is rather the self-expansion of value: that is, of alienated labour',[46] see alienation as consisting

45. K. Marx, *Grundrisse: Foundations of the Critique of Political Economy (Rough Draft)*, tr. M. Nicolaus (London: Penguin, 1976), 296.

46. Aufheben, 'Communist Theory—Beyond the Ultra-Left', *Aufheben* 11

in the ontological inversion of subject and object that lies at the heart of the capitalist mode of production. This dynamic of inversion is said to unfold as a two-way process that happens when subjectivity as labour becomes a product of capitalist objectivity, in the same way that capitalist objectivity is a product of subjectivity.

In a 1999 text, Théorie Communiste (TC) responded to a series of articles published between 1993 and 1995 by Aufheben. One of the subjects of TC's critique was Aufheben's use of the term 'alienation', to which they preferred—following what can be seen as an Althusserian perspective—the term 'exploitation'.[47] TC (like Althusser) suspect the notion of alienation of containing some Hegelian idealist residues, in particular the presupposition that 'revolution is the return of the subject to herself'.[48] They criticise the notion of alienation in the early Marx, considering that it designates a loss of the essence of man as *Gattungswesen* (generic or species-being) and of the attributes of this species-being: universality, consciousness, freedom. For TC, this implies a notion of history that is problematic because of its speculative nature. Their claim is that history must be produced by social struggles, without prior speculation on the ideal categories of the subject.

(2003), <https://libcom.org/book/export/html/1736>.

47. Aufheben's text 'Decadence: The Theory of Decline or the Decline of Theory?', originally published in three parts (Part 1, *Aufheben* 2 [1993]; Part 2, *Aufheben* 3 [1994]; Part 3, *Aufheben* 4 [1995]), was translated into French in *Théorie Communiste* 15 (1999) accompanied by Théorie Communiste's response, 'A propos du texte "Sur la décadence" de "Aufheben"' (84–89), <https://libcom.org/files/TC15.pdf>. The response is translated as a part of Aufheben's account of the controversy, 'Communist Theory—Beyond the Ultra-Left', cited above.

48. Aufheben, 'Communist Theory—Beyond the Ultra-Left' (citing TC).

TC's charge is that Aufheben's use of alienation resorts to a procedural characterisation of revolution, in which the overcoming of alienation operates in teleological terms.[49] This proceduralism is criticised on the basis of its relation to political 'programmatism'—the institutional affirmation of class identity through the union and party and the application of this symbolic collectivity as a revolutionary programme, i.e., 'the collective-worker is *this* and wants *that*'.[50] TC argues that programmatism was a historical phase of working-class organising which today has no further relevance. They put forth two central theses in support of this claim: (1) The workers have lost their autonomy in the capital-labour relationship, i.e. they no longer have the capacity to impose their interest within the particular confines of the wage-relation as such; (2) Several failed revolutions (such

49. Ibid.

50. TC's basic definition of programmatism runs as follows: '[P]rogramme would entail what is commonly understood as "autonomous organisation". The proletariat can only be revolutionary by recognising itself as a class, and it recognises itself as such in every conflict and even more so in a context where its existence as a class is the situation that it has to confront in the reproduction of capital.' Théorie Communiste, 'Self-organisation is the first act of revolution it then becomes an obstacle which the revolution has to overcome', <https://libcom.org/library/self-organisation-is-the-first-act-of-the-revolution-it-then-becomes-an-obstacle-which-the-revolution-has-to-overcome>. 'At first the theoretical work of TC (in cooperation with the group who published *Négation*) consisted of elaborating the concept of programmatism. The crisis at the end of the '60s/beginning of the '70s was the first crisis of capital during the real subsumption of labour under capital. It marked the end of all the previous cycles which, since the beginning of the 19th Century, had for their immediate content and for their objective the increase in strength of the class within the capitalist mode of production and its affirmation as the class of productive work, through the taking of power and the putting in place of a period of transition. Practically and theoretically, programmatism designates the whole of that period of the class struggle of the proletariat.' Redtwister, 'Who Are We', <https://libcom.org/library/who-are-we>.

as social democracy, Stalinism, anarchism in Spain...) serve as examples of how capitalism reemerges if any trace is left of the capitalist mode of production and its categories (such as value, money, labour, the workers, or the state). Against programmatism, TC emphasise the importance of looking at the concrete settings and desires that inform social struggles and refraining from superimposing ideal trajectories on their ends (e.g. 'to what extent did this struggle overcome alienation?'). According to TC, social struggles, if they are to be effective and emancipatory, must generate their own ethical conceptions as necessities within the process of revolt—as opposed to invoking a preconceived 'we' along with all of the elevated concepts and programmes that go with it.[51] According to TC's critique, then, alienation is not a matter of recovering an essence that has been lost by the subject, and the overcoming of alienation cannot be the subject of any programme set in advance.

The other central problem with Aufheben's conception of alienation, according to TC, is its shortsightedness. It is limited in so far as it focuses solely on the problem of the objectification of labour in the commodity relation.[52] In this sense, TC insist on the importance of reading beyond Marx's chapter on commodity fetishism in order to actually grasp the real movements and barriers that capital poses as a totality. They prefer to use the concepts of exploitation and production, regarding 'alienation' as posing the danger of potential mystification.

In a reply to TC, the philosopher Chris Arthur supports Aufheben by claiming that there are two different kinds of alienation. One emerges from the social division of labour, and brings about the separation of the worker from the object produced.

51. Théorie Communiste, 'Self-organisation'.

52. Aufheben, 'Communist Theory—Beyond the Ultra-Left' (citing TC).

But this first form of alienation is succeeded by a second form of alienation, which occurs in exchange, the value-form, money and the capital relation. More precisely, according to Arthur, the first alienation is 'sublated but preserved as the alienated condition reproduced through the activity of second alienation'.[53] Arthur explains that Marx had not developed the necessary concepts to understand this second process of alienation early on when he wrote the 1844 Manuscripts: '[H]e could not explain then the true nature of the power of capital as a self-constituting power. He knew the capital relation reproduced alienation but he didn't yet understand how it did this'.[54] Arthur notes that effectively what TC does is to bring out the differences in emphasis in Marx's work between the 1844 Manuscripts (the alienation of man) and the missing sixth chapter of *Capital* (the process of the alienation of labour). In the mature Marx, it is the division of society and of labour that produces alienation. Alienation occurs in the production process between living and dead labour, not from the loss of an original essence or capacity of the human, part of its *Gattungswesen*. Nevertheless, TC continue to use the term 'alienation' in a generalised sense, acknowledging that there is a separation of individuals from one another and from the means of production. Indeed, for them, the revolution, as communisation, consists in the destruction of all those alienated social relations of production that constitute the separation of subjectivity and objectivity experienced in capitalism. Thus, revolution necessarily means destroying the material basis of the counter-revolution.[55]

53. C. Arthur, 'Notes on TC's First Letter', <https://libcom.org/library/on-theorie-communiste>.

54. Ibid.

55. A thesis further developed by Endnotes. See Endnotes Collective, 'Communisation and Value-Form Theory: introduction', <https://endnotes.org.uk/issues/2/en/endnotes-communisation-and-value-form-theory>.

TC place an emphasis on the totality of capitalism as opposed to taking the human as a starting point, a position which resonates with the German school of value theory critique in which 'Marx's theory of value is understood not as a theory about the distribution of social wealth, but rather a theory of the constitution of the social totality under the conditions of capitalist commodity production'.[56] This inevitably leads to a rejection of the possibility of an emancipation in stages where the worker gradually attains access to the means of production. Instead, TC demand a focus on the totality of capitalism, shifting the emphasis from the question of 'distribution to an overcoming of the form of labour, of wealth and the mode of production itself'.[57]

As we can see from this debate, the question of the contemporary use of the term 'alienation' has serious repercussions for political strategies and even economic analyses. If one puts the emphasis on the subjective side, one might easily fall into a romantic model of the subject understood in a substantial sense. On the other hand, in placing the emphasis on capitalist structures, one might negate subjective agency by yielding to overblown or incorrect totalisations.

In what follows I suggest an understanding of alienation that is based neither on some return to a whole subject, nor on a progression to another, prefigured state. Instead, I call for a reconsideration of the term, taking into account TC's criticisms, but also acknowledging what Arthur refers to as the second form of alienation. The aim, then, is to construct a theory of alienation which takes into consideration the value-form and

56. M. Heinrich, 'Invaders from Marx: On the Uses of Marxian Theory, and the Difficulties of a Contemporary Reading', *Left Curve* 31 (2007), <http://www.oekonomiekritik.de/205Invaders.htm>.

57. Endnotes, 'Communisation and Value-Form Theory'.

fetishism, but understands value as an ongoing social process, in which the subject/object inversion happens continuously through the exchange relation, as will be explained below.

Acknowledging our alienated condition is a prerequisite for engaging in a process of *demystification*: we need to know how we are constituted by capitalist relations of production in order to begin to reveal its mechanisms. Any real process of demystification would require the destruction of the value-form, but it is necessary to explore in greater detail the mechanisms of mystification in the processes of alienation as it is structured through the contradictions in the labour relation; the study of such processes can help us to explore emancipatory practices of social mediation (alienation) as opposed to calling for the romantic-idealist return of the true subject.

MYSTIFICATION, FETISHISM, ALIENATION

In the early seventies, Jacques Camatte, a central figure for TC's thinking, addressed the relationship between alienation and mystification with reference to the later writings of Marx. For Camatte, mystification is 'linked with alienation in its most acute form: reification, which springs from the autonomization of exchange-value. The exposition of mystification therefore supposes that of the other two.'[58] In volume three of *Capital*, Marx explains how mystification occludes the way in which labour becomes surplus value, and then profit. He takes this to be a further continuation of the inversion of subject and object that occurs in the production process itself. The more capitalism develops, the more it generates new processes of circulation

58. J. Camatte, *Capital and Community: The Results of the Immediate Process of Production and the Economic Work of* Marx (1988), <https://www.marxists.org/archive/camatte/capcom/ch05.htm>.

which demand different divisions and separations, thus loosening the connection between labour and value: 'the threads of the inner connection get more and more lost, the relations of production becoming independent of one another and the components of value ossifying into independent forms.'[59] This loosening of the inner connections makes it difficult to identify more complex forms of alienation. For Marx, all the secrets of the social production process are developed and contained in what he calls the trinity formula:

 (1) capital — profit (profit of enterprise plus interest),
 (2) land — ground-rent,
 (3) labour — wages.[60]

In order to explain how labour becomes 'crystals of this social substance'[61] called value, we need to identify where these processes emerge from.

> Capital-profit (or better still capital-interest), land-ground-rent, labour-wages, this economic trinity as the connection between the components of value and wealth in general and its sources, completes the mystification of the capitalist mode of production, the reification of social relations, and the immediate coalescence of the material relations of production with their historical and social specificity: the bewitched, distorted and upside-down world

59. K. Marx, *Capital. A Critique of Political Economy, Volume. 3*, tr. D. Fernbach (London: Penguin Classics, 1991), 967.

60. Ibid., Part VII, chapter 48, 'The Trinity Formula', 953–70.

61. Marx, *Capital 1*, 128.

haunted by Monsieur le Capital and Madame la Terre, who are at the same time social characters and mere things.[62]

Here we have the second form of alienation, where it 'is not only workers' products which are transformed into independent powers, the products as masters and buyers of their producers', but where now the social forces of labour, the socialised form of labour and this form's future 'confront [workers] as properties of their product'.[63]

It is in this trinity that we encounter the most developed form of mystification. Here Marx describes a world in which commodities (especially money) appear to be the subjects that generate social processes, and people become things through labour and exchange. The social is converted into things, and things become personified. In the course of this process, fetishism attaches itself to the products of labour, 'so soon as they are produced as commodities'— a process 'which is therefore inseparable from the production of commodities'.[64] From this perspective, fetishism permeates the whole of society, becoming an 'objective form of thought that structures the perception of all members of society'.[65] We can see then how Marx can go on to extend Feuerbach's critique of religion into a critique of this fetishistic 'religion of everyday life'.[66]

62. Marx, *Capital 3*, 968–69.

63. Ibid., 953–54.

64. Marx, *Capital 1*, 165.

65. M. Heinrich, *An Introduction to the Three Volumes of Karl Marx's Capital* (New York: Monthly Review Press, 2012), 185.

66. Marx, *Capital 3*, 969.

It is necessary here to understand what fetishism meant at the time Marx was writing. The Freudian notion of fetishism—with its sexual connotations—had of course not yet been developed, and the understanding of fetishism current at the time came from the moment colonisers arrived in West Africa and encountered black magic practices such as Juju, involving the projection of magical powers onto objects made out of wood, leather, etc. and their use in rituals. The colonisers, in return, justified colonisation through the application of humanist Enlightenment philosophy (secular rationality) onto what they perceived as primitive societies.[67] According to Marx, then, the power attributed to money and commodities operates in a similar fashion. But how does such fetishism come about? As Michael Heinrich explains: 'the labour that produces value cannot be directly observed because it is abstract labour'.[68] Yet value is a purely social entity emerging from abstract labour: a social construction which is definitely not natural. The appearance of this social abstraction is, however, built upon definite material relations. In other words, it is a real social process and not merely an illusory fantasy. It is at this point that we confront the contradictory tendency of capitalism: while humans are dependent upon each other and remain so under capitalism, they no longer directly interact with each other; their interactions are mediated by things. This mediation occurs through commodities, exchanged for money, which become the most

67. This point is made by Michael Heinrich in his talk 'Value, Fetishism and Impersonal Domination', <https://www.youtube.com/watch?v=TsblBQ0Jkql>. For a critical account of the fetish from a decolonial perspective, see Paul B. Preciado's presentation 'The Parliament of Bodies: Communism will be the Collective Management of Alienation', <https://www.documenta14.de/en/calendar/24799/communism-will-be-the-collective-management-of-alienation>.

68. Heinrich, An Introduction, 185.

important things in bourgeois society.[69] Abstract labour can only be measured as money, but in order to understand how money operates as a measure, you need to understand how capitalism works *in its totality*. Abstract labour is a substance of value. But it is not a substance in the sense of its having a substantial or solid character or quality. Substance instead functions here as a common attribute in the exchange process and this is the basis of Marx's criticism of Aristotle's notion of substance. It is a relational substance whose appearance is manifested in the value-form. The value of a commodity can only be expressed by another commodity (money). Value needs money, and this is where Marx distinguishes his value theory from Ricardo's. Value, labour, and money are completely interdependent; this is what is called the monetary theory of value. We cannot destroy one sphere without destroying the other.

On this basis, we can begin to observe the opacity of the relationship between labour and value. For the bourgeois, the value of labour appears totally natural. But as we have seen, value consists in an extremely complex process consisting in social mediations which cannot be identified at first sight. They require comprehensive and detailed analysis in order to render them intelligible. In the end, the intelligibility of such complex processes depends upon our ability to trace the functions of value in relation to the totality of capitalist production.

Universal alienation is the basis of the capitalist mode of production as, caught up in the constant processes of exchange, we experientially lose track of the complex mediations that are at work in the formation of what then appears as a 'given' reality— a sophisticated mystification. Aufheben's claim that alienation

69. This is further explained in Heinrich's 'Value, Fetishism and Impersonal Domination'.

is the essence of capital resonates with Marx's understanding of universal alienation, when he talks about the alienation of different kinds of labour:

> Commodities are the direct products of isolated independent individual kinds of labour, and through their alienation [*Entäußerung*] in the course of individual exchange they must prove that they are general social labour, in other words, on the basis of commodity production, labour becomes social labour only as a result of the universal alienation [*Entäußerung*] of individual kinds of labour.[70]

Camatte understood this, and even anticipated the further abstractions of financial capitalism:

> If capital originally appeared on the surface of circulation as a fetishism of capital, as a value-creating value, so it now appears again in the form of interest-bearing capital, as in its most estranged and characteristic form.[71]

The consequences of the exponential autonomisation of capital under financial capitalism unfold into ever more complicated forms of mystification:

> The fetish character of capital and the representation of this capital fetish are now complete. In M–M' we have the aconceptual [*begriffslose*] form of capital, the reversal and the reification of the relations of production, in its highest power; the interest-bearing

70. K. Marx, *A Contribution to the Critique of Political Economy* (1859), *Marx and Engels Collected Works* (London: Lawrence and Wishart, 50 vols., 1975–2004), vol. 29, 1–22 (emphasis mine).

71. Camatte, *Capital and Community*.

form, the simple form of capital, in which it is taken as logically anterior to its own reproduction process; the ability of money or a commodity to valorize its own value independent of reproduction—the capital mystification in the most flagrant form.[72]

Alienation, then, is not just about the way in which labour is taken away, abstracted, from a self, but how this is a process that takes place at many different stages of capitalist development. Nevertheless, in capitalism, selves are regarded as sovereign subjects, as recognised in the freedom and rights of the individual—even if, as Marx explains, for the worker this freedom merely means the ability to sell her labour and to be free from accessing the means of production. In a continually amplified process of individualisation, increasingly the only freedom offered is the freedom of consumption.

Focus on the individual, therefore, prevents us from seeing the totality in which we are immersed. This does not mean that we should not question how the individual is produced, but that we need to look simultaneously at how alienation occurs within the totality of capitalism *and* at how we conceive of the individual within that process.[73] We can only understand the complex process that gives rise to fetishism by tracing our way through the whole social totality; but this is not possible in experience—if we rely on experience alone, we inevitably end up falling prey to mystification.

72. Marx, *Capital 3*, quoted in Camatte, *Capital and Community*.

73. G. Lukács, *History and Class Consciousness* (London: Merlin Press, 1971), 91.

IMPROVISATION VS CONTEMPLATION

We saw above how the late Marx turns from the abstraction called 'man' to the social totality of the production process which reproduces the conditions for the worker's perpetuation as a worker. But what are the social consequences of this process for the worker?

In his 1923 essay *Reification and the Consciousness of the Proletariat*, György Lukács describes how the personality of the worker is no longer connected to the type of bonding between individuals that existed when production was still organic. Therefore, the worker's 'personality can do no more than look on helplessly while its own existence is reduced to an isolated particle and fed into an alien system [...] mediated by the abstract laws of the mechanisms which imprisons them'.[74] For Lukács, the worker's consciousness is shaped by the commodity-structure, which permeates and fragments it, leaving it in a state where it is capable only of passive 'contemplation', because of the reificatory qualities of commodity fetishism. Very early on in the text he explains reification as follows:

> The essence of commodity-structure has often been pointed out. Its basis is that a relation between people takes on the character of a thing and thus acquires a 'phantom objectivity', an autonomy that seems so strictly rational and all-embracing as to conceal every trace of its fundamental nature: the relation between people [] As labour is progressively rationalised and mechanised his lack of will is reinforced by the way in which his activity becomes more and more *contemplative*.[75]

74. Ibid.

75. Ibid., 83, 89.

Guy Debord took Lukács's theory as a starting point in developing his 1967 *The Society of the Spectacle*, which describes how this 'contemplative' stance penetrates the worker's leisure time and subjectivity, producing a totalitarian dictatorship of fragments.[76] Debord insists that since this is the case, the only way to oppose capitalism is to take it on in its totality: 'The only possible basis for understanding this world is to oppose it; and such opposition will be neither genuine nor realistic unless it contests the totality.'[77] The Situationists' early work suggested that the fusion of theory and practice, in the form of the construction of situations, would overcome the division between art and life and strive toward this form of totality described above. In an early text by Debord from 1957, written when he was only twenty-five, he explains how the construction of situations would be able to counter the contemplative character of life in capitalism:

> The construction of situations begins beyond the ruins of the modern spectacle. It is easy to see how much the very principle of the spectacle—nonintervention—is linked to the alienation of the old world. Conversely, the most pertinent revolutionary experiments in culture have sought to break the spectator's psychological identification with the hero so as to draw them into activity by provoking their capacities to revolutionize their own lives. The situation is thus designed to be lived by its constructors. The role played by a passive or merely bit-part playing 'public' must constantly diminish, while that played by those who cannot be called actors, but rather, in a new sense of the term, 'livers',

76. As described in A. Jappe, *Guy Debord* (Berkeley, CA: University of California Press, 1993), 25.

77. Quoted in ibid., 21–22.

must steadily increase. We have to multiply poetic subjects and objects—which are now unfortunately so rare that the slightest ones take on an exaggerated emotional importance—and we have to organize games for these poetic subjects to play with these poetic objects. This is our entire program, which is essentially transitory. Our situations will be ephemeral, without a future. Passageways. Our only concern is real life; we care nothing about the permanence of art or of anything else. Eternity is the grossest idea a person can conceive of in connection with his acts.[78]

As discussed in the Introduction above, I myself come from the context of free improvisation in experimental music, which shares a great deal of common ground with Debord's construction of situations as described above: a fetishisation of experience, of the present and the ephemeral; appeals to subjective agency which entail the ability to spontaneously come up with a disruption through unexpected gestures; and the belief that 'doing something' is already a kind of exit from the zone of complacency, from the spectator's 'contemplative' condition.

The problem for these practices is that capitalism has changed. To a great extent it has absorbed the antagonism of the situation through an ever-expanding variety of participatory outlets, in particular those of social media. The notion of the construction of situations and some of the foundations of the ideology of free improvisation have not only been co-opted by capitalist fragmentary consciousness, but now seem to be a result of this ongoing fragmentation, a type of fragmentation that embraces experience and tends to rebel against conceptual

78. G. Debord, 'Report on the Construction of Situations and on the International Situationist Tendencies Conditions of Organization and Action' (1957), <http://www.cddc.vt.edu/sionline/si/report.html>.

mediation as a form of authority. While some might think that these practices overcome alienation, and even potentially capitalist totality, by promoting immediacy and means-without-ends praxis, I argue that it is precisely through an understanding of the forms of mediation that we can start to understand how we are objectified in capitalism.

REAL SUBSUMPTION, FORMS OF MEDIATION, AND PROBLEMATIC TOTALISATIONS

In 'Results of the Immediate Process of Production', the so-called unpublished sixth chapter of volume one of *Capital* from the summer of 1864, Marx describes how the social relations of production enter the labour process itself, in doing so making a distinction between formal and real subsumption.[79] Formal subsumption is when capital appropriates already existing modes of production such as agriculture. In contrast, in real subsumption the whole mode of production is conceived through the logic of the extraction of value. The concept of real subsumption has often been used to described the way capitalism has been able to colonise many if not all aspects of life. It is at the heart of an ongoing debate which has numerous repercussions for the way in which we approach political agency.[80] However, many of the arguments around real subsumption tend to generate problematic forms of totalisation such as those proposed by Jacques Camatte and Toni Negri.[81]

79. Marx, *Capital 1*, 412.

80. For a thorough discussion and critiques of the different forms of totalisation, see Iles and Mattin (eds.), *Abolishing Capitalist Totality.*

81. See J. Camatte, *The Wandering of Humanity*, <https://www.marxists.org/archive/camatte/wanhum/index.htm>, and A. Negri, *Marx Beyond Marx: Lessons on the Grundrisse*, tr. H. Cleaver, M. Ryan, and M. Viano (South Hadley, MA: Bergin and Garvey, 1984).

The concept of real subsumption lies at the intersection between a logical and an historical understanding of capitalism. Often historical understandings of real subsumption tend to think of capital teleologically, yielding forms of periodisation based on the progressive integration of the proletariat into the capitalist mode of production, where their capacity for antagonism is radically reduced. In the present context, the question of real subsumption is useful because it problematises what we mean by capitalist totality, and what our relationship to this totality is. In subsumption, the labour process not only becomes part of the valorisation process, but is also transformed through form-determination. Form-determination in the Marxist materialist sense relates to the way that social individuals are transformed in relation to their environment, but in the process forms of abstraction are generated that appear to be alien powers.[82]

Under such conditions, situationist-style experiential participation through engagement with 'ephemeral situations' and 'real life' is simply not enough to overcome the passive, contemplative condition. Such experience, however spontaneous it may feel, is already embedded in mediations at different levels:

1. By being engaged in the exchange abstractions (commodity form, exchange relation) of capitalist relations.

2. At the neurobiological level, where neuroprocesses produce a 'phenomenal representation in which an individual information processing system generates a reality-model', a model of yourself.[83]

82. See A. Saenz De Sicilia 'History, System and Subsumption', in Iles and Mattin (eds.), *Abolishing Capitalist Totality*.

83. As discussed in the following chapter.

3. Through the conceptual mediation of language, which in turn is developed through sociality.

In short, it is not only objects that are fetishised and appear in a form of 'spectral objectivity', but experience itself. To fetishise experience is to assume the presence of a layer of absolute immediacy, and to envision the undoing of reification in order to return to this unmediated layer of experience. And this is an illusion that is vulnerable to the same critiques Marx directed at Stirner, because capitalist mediation is as constitutive of experience and the self as it is constitutive of the commodity.

Our experience is already conceptually mediated, but at present we are not in control of how concepts mediate our experience. Now, the problem cannot be mediations as such— otherwise there would be no hope at all—but the capitalist colonisation of these mediations. Fortunately, we do have the cognitive capacity to understand these mediations and to act upon them. When we actively conceptualise our experience, we involve ourselves in a fight for a new form-of-mediation.

ESTRANGEMENT 2.0

Social dissonance is the result of an ongoing social fragmentation produced by the reifing qualities of capitalist relations, identity being a crucial part of this process. On the one hand we have the expansion of different types of identities seeking to assert themselves, while on the other hand these identities often neglect the need to think, at the level of the totality, the mediations that constitute them. The fragmentation continues today, to the point of even giving agency to objects through

theories that challenge the nature/culture division.[84] Brassier
expresses it well:

> [T]he logic of liberalism culminates with the ontological ratification
> of capitalism's personification of things and reification of people
> in the formal equivalence of human and non-human. Its ideologi-
> cal corollary is an 'ethics of affirmation' that not only masks but
> consolidates capital's sub-division of class into the ramifying
> fractures of race, gender, ethnicity, culture, etc.[85]

These are the products of a perverse democratisation fermented
under capitalist relations: the double freedom of capitalism
(i.e. the ability to sell your labour-power and the freedom from
access to the means of production) expands to the point where
freedom means constructing your own situation (in regard to
a specific type of belonging or belief) and where objects are
endowed with human attributes. This type of thought enjoys full
institutional approval, as long as you don't take into account the
structural and economic conditions that generate and perpetu-
ate this 'freedom' which, in turn, fuels the expansion of capital.

Freedom is often connected to democracy, but this asso-
ciation has been radically challenged by recent events (Greece,
Spain, Brexit, the FARC vote in Colombia, Trump…). The prob-
lem with democracy is precisely that it collapses the difference
between individual and subject, and in doing so can give the

84. Here we might think of Graham Harman's development of 'Object Ori-
ented Ontology', which is perfect for the art market; a market which has ap-
preciated its expansion in the post-recession era.

85. R. Brassier, 'The Human: From Subversion to Compulsion', text delivered
as part of a seminar at *Foreign Objekt* on 6 November, 2020, <https://www.
foreignobjekt.com/post/ray-brassier-posthuman-pragmatism-selecting-pow-
er-the-human-from-subversion-to-compulsion>.

appearance of sovereignty to the individual even as this sovereignty is increasingly undermined.

Representative democracy in liberal states often neglects the class division that is the kernel of capitalism. Amadeo Bordiga, like Stirner another recent meme star of the internet, albeit a communist one, brings out the theoretical inconsistencies of the capitalist system which professes to reconcile political equality with class divisions and material inequality:

> Political freedom and equality, which, according to the theory of liberalism, are expressed in the right to vote, have no meaning except on a basis that excludes inequality of fundamental economic conditions.[86]

Furthermore, Bordiga shows how a religious and idealist ideology lurks behind democracy and the liberal state, which suggests that one could be—like a divine creator—a single source of power, autonomous and capable of direct one's will and future, without taking into account the contingencies of physical and social factors. For Bordiga this religious and idealist conception differs from democratic liberalism or libertarian individualism in appearance only:

> The soul as a spark from the supreme Being, the subjective sovereignty of each elector, or the unlimited autonomy of the citizen of a society without laws—these are so many sophisms which, in the eyes of the Marxist critique, are tainted with the same infantile

86. A. Bordiga, 'The Democratic Principle', *Rassegena Communista*, February 1922, <https://www.marxists.org/archive/bordiga/works/1922/democratic-principle.htm>.

The understanding of the specificity of the mediations currently in force is a complex affair in an age when, for example, the practice of 'expressing yourself' on social media generates the affect of self-expression while simultaneously promoting fragmentation, by 'suggesting' your interactions according to your taste and personality so as to reinforce an idea of yourself. This is a very different mode of alienation to the one where the worker alienates themselves in making objects that are of no use to them, leaving them in a 'contemplative' state.

Aufheben critique both Lukács and Debord for focusing too much on the subjective effects of capitalism, and neglecting any analysis on economics, class struggle, and commodity production. However, it might be said that today subjectivity is a crucial site of struggle: for the self in the social media era is now an integral part of commodity production. We therefore need an account of alienation which can be an enabling condition for understanding the different forms of mediation in which we are embedded. This conception of alienation would not presuppose the possibility of a whole subject, or even the possibility of overcoming alienation. It would take alienation to be a constitutive part of what we are.

One might say—following the criticisms made by Marx in *The German Ideology*—that this would be an ahistorical understanding of alienation. However, today's society calls for a radical reconsideration of what the self, the individual, and the subject are, and in order to do this we need to understand the subject/object split in order to gain a vantage point from which

87. Ibid.

to overcome capital's colonisation of consciousness. Since this cannot be done only in consciousness but must also be carried out in practice, I suggest that it may be achieved through what I call *externalising alienation*: a practical engagement in the subject/object split that proceeds through the exploration of social dissonance.

As Wilfrid Sellars suggests, the sapience/sentience distinction hinges on the sapient being able not just to perceive something, but to perceive something *as* something, i.e. through conceptual mediation.[88] If selfhood is a form of reification, then further mediation of this sort—further alienation—is necessary in order to gain sufficient awareness to perceive the self *as* commodified and to understand how this commodification occurs. This understanding of alienation—non-essential and non-teleological—doesn't need to presuppose full agency and the already-available possibility of expressing freedom, as was the case with the Situationists' construction of situations, or in the context of free improvisation. Instead it assumes alienation as a negative condition which can be taken as a *starting point* in order to develop the necessary reflexive distance to perceive our selves *as* something. This reflexivity is perhaps not yet agency, but it would allow us gradually to develop a conceptual grasp of the different levels of mediation in which we are embedded.

One might criticise this approach for a drift toward the theoretical, and for therefore falling into the theory/praxis divide. In response I would return to Hegel's dictum that 'there is nothing, nothing in heaven, or in nature or in mind or anywhere else which does not equally contain both immediacy and

88. While this might seem close to the discussion on *Gattungswesen*, here I will be proposing a specific historical understanding of this notion via the work of Sellars.

mediation, so that these two determinations reveal themselves to be unseparated and inseparable and the opposition between them to be a nullity'.[89] If consciousness is determined by the abstraction of capitalist relations, then there is a concrete level at which these abstractions are manifested in ourselves, namely the reified notion of the liberal individual, which historically has masqueraded as part of a universal subjectivity. In the name of an abstraction at the concrete material level, extreme exploitation has been produced. This brings us to the difficult question of the relationship between the ideal and the material.

HUMANISM AND ANTIHUMANISM

The dilemma of idealism and materialism is of course one of the most complex issues in philosophy, and lies at the core of the question of humanism, which is often attacked for harbouring residual forms of idealism. Anticipating the debate between Aufheben, TC, and Chris Arthur, the notions of alienation and subjecthood were disputed between humanist and antihumanist schools of Marxism in the late twentieth century. Here the debate had to do with the perspective from which we can describe the effects of capitalism in regard to consciousness and structure, and the question of the nature and even the existence of the subject.

György Lukács, a Marxist who defended humanism, attempted to show the ways in which bourgeois consciousness resembles the commodity-form, split between use-value and exchange-value, producing a distorted subject-object relationship and, in doing so, naturalising and reifying social processes. For example, he shows how the bourgeois relate to machines

89. G.W.F. Hegel, *Science of Logic*, tr. A.V. Miller (Atlantic Highlands, NJ: Humanities Press, 1969), 68 [§92].

as individual objects separated from the whole set of relations of production, so that for them it is impossible to understand the complex issue of the mediation of the class relation which lies at the heart of alienation. In an illuminating passage, Lukács quotes Marx and Engels's 1845 *The Holy Family*:

> The property-owning class and the class of the proletariat represent the same human self-alienation. But the former feels at home in this self-alienation and feels itself confirmed by it; it recognises alienation as its own instrument and in it possesses the semblance of a human existence. The latter feels itself destroyed by this alienation and sees in it its own impotence and the reality of an inhuman existence.[90]

While alienation is the necessary instrument the ruling class must wield in order to exploit, it is the proletariat that suffers the consequences and has to deal with its negative consequences. But the realisation that one is unfree is a precondition for freedom. Criticising the inability of bourgeois society to understand is own origins, Lukács quotes Hegel on the issue of mediation:

> [T]he mediating factor would have to be something in which both sides were one, in which consciousness would discern each aspect in the next, its purpose and activity in its fate, its fate its purpose and activity, *its own essence in this necessity*.[91]

Lukács goes on to explain that it is impossible for the bourgeois to understand the concept of revolution, because for them it would spell a catastrophe altering the natural order.

90. Lukács, *History and Class Consciousness*.
91. Ibid.

The production of value in capitalist society reifies conscious-ness by generating eternal laws of nature out of social historical relations, making it impossible for bourgeois consciousness to conceive of any change or radical form of transformation.[92] But whereas bourgeois thought is based upon contemplation, Lukács argues that the proletariat can become self-conscious by realis-ing itself as the subject-object of history through a revolution .

In opposition to this, the antihumanist Marxist Louis Althusser rejected the notion of alienation as ethical and therefore theo-logical. Althusser's criticism of humanism was a part of heated debates that took place with the PCF (French Communist Party) in the sixties. He viewed humanism as a pseudo-Hegelo-Feurba-chian tendency in the Stalinist current which promoted a notion of the human that, for him, was entirely ideological, to the point that one could state that 'every humanist is a liberal'.[93] Echoing to a certain extent Stirner's critique of Feuerbach, Althusser confirms that Feuerbach's notion of human essence is consti-tuted by an abstraction.[94] For Althusser there can be no prior idea of the human, and in fact, there is no subject of history:

> History is a process without a Subject or a Goal where the given
> circumstances in which 'men' act as subjects under the determina-
> tion of social *relations* are the product of class struggles. History
> therefore does not have a Subject, in the philosophical sense of
> the term, but a *motor*: that very class struggle.[95]

92. Ibid.

93. L. Althusser, *The Humanist Controversy and Other Writings (1966–1977)* (London and New York: Verso, 2003) 223.

94. Ibid. 236

95. L. Althusser, 'Lenin and Philosophy', in *Lenin and Philosophy and Other Essays*, tr. B. Brewster (New York: Monthly Review Press, 2001), 99.

Hence Althusser claims that the Marxist 'science of history' must take as its starting point the mode of production, infrastructure (productive forces and relations of production), superstructure (juridico-political and ideological), social class, class struggle and so forth. These should replace what he considers humanist and ideological formulations such as man, alienation, disalienation, emancipation, reappropriation of species-being, 'the whole man', and so on.[96] As part of his critique of humanism, Althusser would go further in his criticisms of existentialism and phenomenology: 'Existentialist-phenomenological subjectivism' is simply the 'spiritual complement' of bourgeois 'neo-positivism'.[97] Following Lacan's mirror stage, he claimed that we are already subjects ready to be interpellated by ideology, but while Lacan made a distinction between ego and subject, Althusser collapses them together.[98] For Lacan the subject is split; it is an impossible response to the other that remains as a question because it can never be properly expressed in language. The subject can never fulfil its own representation and can never be whole. Instead, criticising contemporary existential philosophy for presupposing the self-sufficiency of consciousness, Lacan defines the ego as a function of the imaginary which produces the illusion of autonomy of the subject. For Althusser, the subject assumes this function as part of the interpellation process because, for him, individuals are 'always-already' subjects of ideology. According to Althusser, then, as individuals we merely respond to the subjective forms that are imposed upon us as concrete

96. Ibid. 186

97. Althusser, 'Lenin and Philosophy', 17; cf. 202n2

98. A. Callari and D. F. Ruccio, *Postmodern Materialism and the Future of Marxist Theory* (Hanover, NH and London: Wesleyan University Press, 1996), 79.

individuals in order to reproduce the existing relations of production and reproduction.

While Lukács's findings are fundamental to understanding our current condition, his concept of reification is liable to fall into generating a false totalisation that attributes so much power to capital that without a conscious revolutionary proletariat we cannot do anything about it. This implies a messianic approach to history that even Lukács himself would criticise later on his 1967 preface to the new edition of *History and Class Consciousness*, where he admits that his 'account of the contradictions of capitalism as well as of the revolutionisation of the proletariat is unintentionally coloured by an overriding subjectivism [...] As a result the conception of revolutionary praxis in this book takes on extravagant overtones that are more in keeping with the current messianic utopianism of the Communist left than with authentic Marxist doctrine.'[99]

On the other hand, although Althusser is right to say that we must place the emphasis on practice rather than consciousness, and dismantle the notions of man and the human along with other forms of totality as abstract conceptualisations such as society, by rejecting the dialectical nature of alienation and saying that there is no subject of history, he himself produces a totalisation. Althusser's rejection of alienation and reification in favour of exploitation and more structural and economic forms of determination impede us from understanding the relationship between alienation from above and alienation from below. The debate between humanism and antihumanism has to do with whether to emphasise the subjective or the structural economic forms of determination at the level of totality. But in the present day, these are intertwined in so far as the hegemonic ideological

99. Lukács, *History and Class Consciousness*.

force is the neoliberal mantra that all subjects must enter into constant competition with one another. While real subsumption might not be total, it is true that through social media, the pharmaceutical industry, and other technological advancements, economic determinations are rapidly and increasingly being integrated into the production of subjectivity. Therefore, to make any separation between what is economic and what is subjective is more complicated than ever. This is not to offer another totalising perspective on the power of capital, but to indicate the challenges that we have ahead when we try to determine the relationship between the production of subjectivity and economics. As we have seen in this chapter, there is a tension between what we define as the totalising capacities of capital and the level of agency possible in these conditions. Contrary to Althusser's claims, alienation is not related to an essence of the human or a return to some sort of wholeness. For us it simply means that there is neither god nor harmony, and therefore different forms of alienation and noise are here to stay. The question is, how do we deal with them?

POSTHUMANISM AND NEORATIONALISM

Let's now look at how the relationship between the ideal and the material and the role of dialectics and alienation has been dealt with in some more recent work. As we have seen, the concept of alienation emerges out of a long philosophical and political debate regarding the constitution of the subject. Late modernity has seen a plethora of criticisms of the notion of the subject, and a questioning of certain problematic assumptions of humanism.

Recently these discussions have broadened with the appearance of concepts such as posthumanism and transhumanism. Here I would like to briefly discuss two perspectives

that attempt to think beyond the human as we understand it today. Where Rosi Braidotti tries to relinquish alienation and its dialectical and negative connotations, Reza Negarestani attempts to think alienation through the potential of artificial general intelligence (AGI).

A strong proponent of posthumanism, Braidotti, in her book *The Posthuman*, traces the history of its various currents, explaining the development of her own position as follows:

> My anti-humanism leads me to object to the unitary subject of Humanism, including its socialist variables, and to replace it with a more complex and relational subject framed by embodiment, sexuality, affectivity, empathy and desire as core qualities. Equally central to this approach is the insight I learned from Foucault on power as both a restrictive (*potestas*) and productive (*potentia*) force.[100]

In opposition to Althusser's antihumanism, here we don't have a structural analysis of capital and forms of exploitation but a discussion of force. Here as elsewhere in poststructuralist thinking, especially that of Foucault, the class relation disappears and is replaced by the elusive concept of power or force, with its suggestions of Nietzschean vitalism. In another passage Braidotti develops her concept of the subject further, describing it as a process of autopoiesis or self-styling, having to constantly negotiate with dominant forms and values as part of a process-oriented political ontology, in what she calls a post-secular turn:

> The double challenge of linking political subjectivity to religious agency and of disengaging both from oppositional consciousness

100. R. Braidotti, *The Posthuman* (Cambridge: Polity Press, 2013), 35.

and from critique defined as negativity is one of the main issues raised by the posthumanist condition.[101]

Braidotti then seeks to recuperate the notion of the subject, taking into consideration the developments of technology and science and the death of Wo/Man (of gender as we know it).[102] The following gives some indication of how she makes a case for this:

> In my view, a focus on subjectivity is necessary because this notion enables us to string together issues that are currently scattered across a number of domains. For instance, issues such as norms and values, forms of community bonding and social belonging as well as questions of political governance both assume and require a notion of the subject. Critical posthuman thought wants to re-assemble a discursive community out of the different, fragmented contemporary strands of posthumanism.[103]

Rather than a stable category of selfhood, she proposes a nomadic subject governed by an ethics of becoming:

> A posthuman ethics for a non-unitary subject proposes an enlarged sense of inter-connection between self and others, including the

101. Ibid., 35.

102. Ibid. 37. She further develops this in terms of 'the decline of some of the fundamental premises of the Enlightenment, namely the progress of mankind through a self-regulatory and teleological ordained use of reason and of secular scientific rationality allegedly aimed at the perfectibility of "Man". The posthumanist perspective rests on the assumption of the historical decline of Humanism but goes further in exploring alternatives, without sinking into the rhetoric of the crisis of Man. It works instead towards elaborating alternative ways of conceptualizing the human subject.'

103. Ibid., 35.

non-human or 'earth' others, by removing the obstacle of self-centred individualism.[104]

In the case of Braidotti's posthumanism, alienation and negativity play no role whatsoever in the development of the subject. What we have is pure affirmation. But what does affirmation mean in capitalism if not the affirmation of capital? Braidotti seeks to go beyond self-centred individualism, but in order to do so she is willing to concede political subjectivity to spiritual agency. To view the forms of differentiation that we have today in a positive light is to affirm the forms of determination generated through a capitalist mode of production whose negative consequences we are powerless to negate. In order to deal with social dissonance, we need to engage with its negative consequences and their origins. Otherwise we negate any possibility of forming a broader and fuller picture of our reality, a necessary requirment in order to change it. Braidotti's vital materialism emphasises affects, desire, and their autonomy, and according to her relational and processual understanding of the subject, it can generate the conditions of its own expression as if we were on a neutral *tabula rasa*. For a writer so intent on embracing the affirmative, the way Braidotti describes the ultimate oportunity for the destitution of selfhood seems very bleak to me: 'Impersonal death is the ultimate destitution of selfhood into embodied and embedded relations, that is to say, into radical immanence.'[105] Rather than a philosophical solution, I must say that this is a clear example of the desperation

104. Ibid., 49.

105. R. Braidotti 'Conclusion: The Residual Spirituality in Critical Theory: A Case for Affirmative Postsecular Politics' in R. Braidotti et al (eds.), *Transformations of Religion and the Public Sphere: Postsecular Publics* (Basingstoke: Palgrave, 2014), 267.

of our times as well as an example of our current philosophical and political weakness.

Nevertheless, the concepts of alienation and negativity are not enough to understand our relationship within the capitalist mode of production either. Reason alone would not allow us to overcome the way that we are determined by capitalist relations. Reza Negarestani's recent work offers another fierce critique of self-centred individualism from an almost opposite perspective to that of Braidotti. In *Intelligence and Spirit,* Negarestani claims that what is at the core of the human is its capacity for self-transformation. For him, the mistake of posthumanism is to think that one can know what the posthuman might be. According to Negarestani, although the human cannot survive, the only option we have is to learn and explore what might come after it. Drawing on multiple sources including pragmatism, computational science, recent developments in mathematics and, more importantly, German Idealism, Negarestani claims that Artificial General Intelligence (AGI) offers the possibility of achieving the radical transformation of the human, a possibility that can be conceptually grasped by understanding intelligence as Geist. In his case, a Hegelian notion of alienation lies at the core of the argument. Speaking of intelligence as a regulative and necessary form whose experiences have not yet been fully suspended in self-experience, Negarestani writes:

> It is the logical excess of the Transcendental that crafts intelligence, initiates and regulates the mind's strivings for new unities, and sets the mind into a permanent state of alienation where 'the Spirit is at home'. And it is the same excess that retroactively reveals to thought reality in its radical otherness.[106]

106. R. Negarestani, *Intelligence and Spirit* (Falmouth and New York: Urbanomic/Sequence Press, 2018), 22.

But if we assume, as Negarestani seems to, that it is *the mind* that is responsible for initiating and for persevering in the 'labour of the inhuman', the process of alienation through forms of externalisation, by initiating the artefactualising of the world and of itself, then we miss some of the most important lessons that we learnt from Marx. Alienation as a process of externalisation is instead produced by our practical activities as part of our reproduction. Mind is determined by this process, but is not fully able to comprehend it.

Even if Braidotti and Negarestani critique what we might understand as the liberal selfhood, they continue to fall prey to some of the premises of liberal ideology. Braidotti assumes an ethical potential activated between actors purely by their accepting each others' differences, when we might well ask how these differences are produced if not through a process of reification. On the other hand, Negarestani presupposes that agents are already able to engage in the social 'game of giving and asking for reasons' that is fundamental for his concept of rationality, that they have these capacities ready to exercise, to function properly, without any need to investigate the external limitations placed upon reason at the present moment. In other words, what Braidotti and Negarestani have in common is that they accept the possibility of agency (rational or ethical) in the current conditions without giving an account of the ways in which this agency is currently determined.

In conditions of extreme asociality, to talk about the possibility of either ethics or rational agency (even in spite of Negarestani's insistence on socialising rational agency) is to neglect the social dissonance that exists at the present moment, and this inevitably leads them to believe in 'spooks' of potentiality by endowing subjects yet to come with overblown capacities. Our aim here is more humble: to deal with and to *play* (in the

sense of a musical instrument) the different forms of alienation to which we are subject, as a way to understand practically the ways in which we are determined.

RATIONALISTS BEWARE: REAL ABSTRACTION MINDSCREW

If the dialectical process does not occur in the mind, but in our social reproduction and in the relationship that we have to nature, none of which is immediately available to the mind, then here the concept of *real abstraction* can help us to clarify the mind's inability to access the social processes that capitalism involves us in. For the real of 'real abstraction' has to do precisely with a process which is social but is not easily traceable or accessible to our understanding.

The double character of the commodity (use value and value), as part of the exchange relation, generates forms of fetishism. Out of this fetishism we generate ahistorical categories that negate or occlude the social processes involved in their making, but this does not mean that fetishism is a distortion that takes place in our mind:

> The dual character of the commodity is not the result of an intellectual abstraction but the articulation of a material, yet non-empirical reality of redoubling abstractions. Therefore, commodity fetishism is not an illusion of the subject of cognition but the result of the split nature of objective reality itself—it belongs to what Sohn-Rethel called 'socially necessary forms of cognition.'[107]

107. S. Khatib, '"Sensuous Supra-Sensuous": The Aesthetics of Real Abstraction' in S. Gandesha and J.F. Hartle (eds.), *Aesthetic Marx* (London: Bloomsbury Academic, 2017). 56.

The possibility of cognitive abstraction arises and flourishes within our relationship with commodity production, but our abilities to conceive and understand real abstraction are simultaneously limited by the effects of this commodity split, because it produces an spectral form of objectivity: in the context of commodity production, objective reality already implies the split. Alfred Sohn-Rethel therefore explains real abstraction as inherrently 'non-empirical':

> [T]he real abstraction of exchange has as its distinguishing mark the total exclusion of empirical content. Its abstractness is non-empirical. Thus, if it or any of its elements are correctly identified, this results in the formation of concepts as non-empirical as the exchange abstraction itself. And being non-empirical, they bear no trace of the locality, the date or any other circumstances of their origin. They stand outside the realm of sense-perception without, however, forfeiting their own prime claim to reality. But this reality is that of being as a whole, not that of any specific object.[108]

The non-empirical character of real abstraction produces a spectral objectivity, an objectivity that feels so natural, robust, and stable that it impedes us from understanding its mechanisms. Our cognitive categories and assumptions are mired in this spectrality, which therefore troubles easy categorisations between idealism and materialism. Without taking into account the complexity involved in the processes of real abstraction, mind is subject to a form of blindness.

In other words, objectivity is necessary in order to make intelligible claims, but claims to objectivity and intelligibility as

108. A. Sohn-Rethel, *Intellectual and Manual Labour: A Critique of Epistemology* (London: Macmillan, 1978), 67.

if they were given are problematic under the circumstances of real abstraction. Even the most dynamic and dialectical schema fails if it is ahistorical and unsituated. Negarestani's idealism therefore has some serious blinkers on if it takes the negativity of reason to be sufficient as the engine of freedom:

> Self-relation is the formal condition of intelligence. But only when it is steeped in the negativity of reason does it become an engine of freedom, for which intelligence cannot exist without the intelligible, and the intelligible cannot be conceived without intelligence.[109]

While recognition of alienation is a precondition for freedom, freedom cannot be guaranteed by rational means, any more than through vitalist affirmation. Negarestani takes as a starting point Hegel's *Geist* or Spirit, where the I/we relationship exists in self-consciousness as part of absolute Spirit which can transform reality. But reality tells us otherwise: it tells us that I/we are bound to property relations constantly mediated by the exchange abstraction, material relations which condition our consciousness (again, '[c]onsciousness [*das Bewusstsein*] can never be anything else than conscious being [*das bewusste Sein*], and the being of men is their actual life-process').[110]

As a way to understand the relationship between the ideal and the material, Brassier uses Marx's distinction between concrete-in-act and concrete-in-thought. There is a concrete material activity that is not available to self-consciousness— what Brassier calls 'concrete-in-act' or 'concrete-in-reality':

109. Negarestani, *Intelligence and Spirit*, 31.

110. Marx and Engels, *The German Ideology*, 42.

> What is concrete-in-reality is a practical act whose nature does
> not reveal itself either to those executing it or to the theoretical
> consciousness that takes the consciousness of practitioners as
> its starting point.[111]

Concrete-in-act or concrete-in-reality, then, designates the totality of impersonal social practices that have not been socially validated or ratified at the level of consciousness or experience. 'Concrete-in-thought' designates those abstractions in consciousness that emerge from our concrete social activity, such as the individual, property, productivity, population, and the market. These emerge from many determinations, but in thought they appear already as a result, making it impossible for us to trace them back to their origins in what is really concrete and the way in which they arise from the social totality. But this does not mean that we cannot grasp them at all. Brassier explains Marx's critical method in two steps: first, we take these abstract notions represented as concrete-in-thought and decomposed them into their simplest and most elementary abstractions. Secondly, we recombine them, generating a determinate abstraction as concrete-in-thought. By doing this it is possible to trace their components rather than take them as natural results: this method yields 'the totality of determinations as concrete-in-thought. What is *represented* as concrete-in-reality is an indeterminate whole. What is *reproduced* as concrete-in-thought is a determinate totality.[112] Brassier claims that the movement from abstract representation to concrete

111. R. Brassier, 'Concrete-in-Thought, Concrete-in-Act: Marx, Materialism and the Exchange Abstraction', *Crisis and Critique* 5:1 (2018), <https://crisis-critique.org/2018h/brassier-v1.pdf>.

112. Ibid., 119

reproduction is logical and not material, and because of this warns that 'it is necessary to distinguish ideal movement from the real act of production'.[113]

The relationship between thought and practice is not metaphysical even though the actuality of practice is that which validates thought: 'While thought can adequately represent the structure of practice, there is no similarity or resemblance between the structure of thought (what is concrete-in-thought) and that of practice (concrete-in-reality).'[114] For Brassier, the distinction between 'living' (objectivating) and 'dead' (objectified) labour has to do with the formal contrast that occurs when unconscious unvalidated practices become consciously and socially validated activity. This process is necessarily dissociative in so far as it is a process of alienation that consists in severing its concrete social practical origins by becoming value. By doing this it fetishises social relations via reification: the relations between producers become relations between products.

ACCELERATION AND ALIENATION

In Marxist theory, alienation is most often viewed in a strictly negative light, as something produced by capitalist relations. Recently however there has emerged a theoretical camp that embraces alienation as a positive condition (Nick Srnicek and Alex Williams's *Manifesto for an Accelerationist Politics*, the *Xenofeminist Manifesto* by Laboria Cuboniks, and the work of Bassam El Baroni and Armen Avanessian). Here alienation is considered as a malleable vector for the development of new forms of subjectivity made possible through the rational

113. Ibid.

114. Ibid., 121.

application of recent technological innovations. Inevitably, these innovations do indeed disrupt how we understand ourselves—but the question is, in what direction? Laboria Cuboniks's *Xenofeminist Manifesto* provides an interesting definition of these positive accounts of the politics of alienation:

> XF seizes alienation as an impetus to generate new worlds. We are all alienated—but have we ever been otherwise? It is through, and not despite, our alienated condition that we can free ourselves from the muck of immediacy. Freedom is not a given—and it's certainly not given by anything 'natural'. The construction of freedom involves not less but more alienation; alienation is the labour of freedom's construction. Nothing should be accepted as fixed, permanent, or 'given'—neither material conditions nor social forms.[115]

Here we have what could broadly be described as the left-accelerationist standpoint, which holds that advanced capitalist hardware, i.e. logistics, computing, machinery, etc, has made communism an immanent possibility. The problem is therefore solely a matter of the replacing of capitalist software (i.e. the ways in which we interact with technology) with communist software. Hence we find an embrace of the historically specific manifestations of capitalist alienation, in 'the insistence that the only radical political response to capitalism is [...] to accelerate

115. Laboria Cuboniks, 'Xenofeminism: A Politics for Alienation', <http://www.laboriacubonlks.net/>. While I agree with some of their arguments, here Laboria Cuboniks ahistoricise and ontologise the notion of alienation, therefore they essentialise that which they are criticising for essentialism, without explaining exactly how alienation emerges and how it is produced especially when they claim: 'We are all alienated—but have we ever been otherwise?'

its uprooting, alienating, decoding, abstractive tendencies'.[116] But this accelerationist approach to alienation does not seem to take into account discussions on real subsumption and the ways in which our consciousness itself becomes commodified, nor how reification works. Such optimistic accounts of the immanent potential for 'fully automated luxury communism'[117] are closely related to the historical imaginary of the workers' movement, most clearly expressed in the reformist visions of the German Social Democratic Party under Eduard Bernstein. Presaging contemporary accelerationism, Bernstein believed that the growth of productive forces, to be realised through advances in automation, would lead to the organic transition to communism, i.e. the post-work and post-scarcity world of freely associating producers.[118]

On the ultra-left, on the other hand, there is an acute aware-ness of the integration of the proletariat within the process of real subsumption, making it impossible for them to make demands and to have a programme. Take for example TC's critique of programmatism (as discussed above):

> Generally speaking, programmatism may be defined as a theory
> and practice of class struggle in which the proletariat finds, in its

116. R. Mackay and A. Avanessian (eds.), Introduction to *#Accelerate: The Accelerationist Reader* (Falmouth and Berlin: Urbanomic/Merve, 2014), 4, cited in S. O'Sullivan, 'The Missing Subject of Accelerationism', <http://www. metamute.org/editorial/articles/missing-subject-accelerationism#_edn1>.

117. B. Merchant, 'Fully Automated Luxury Communism', *The Guardian*, 18 March 2015, <https://www.theguardian.com/sustainable-business/2015/mar/18/fully-automated-luxury-communism-robots-employment>.

118. See Endnotes Collective, 'A History of Separation: The Rise and Fall of the Workers' Movement, 1883–1982', *Endnotes 4: Unity In Separation* (2015), <https://libcom.org/files/Endnotes%204.pdf>, 70–85.

drive toward liberation, the fundamental elements of a future social organisation which become a programme to be realised. [...] However, since programmatism is intrinsically linked to the period of formal subsumption of labour under capital, during the first phase of real subsumption, which began in the 1920s, It 'decomposed' into the specific form of a workers' identity.[119]

While accelerationists leave behind the romantic version of the possibility of an unalienated life, they presuppose a form of agency highly reliant on uncritical imaginings of human-technological innovations under capitalism. They even rely on certain conceptions of sociality compatible with liberal individualism. For example, Alex Williams and Nick Srnicek—authors of the 'Manifesto for an Accelerationist Politics' and more recently *Reinventing the Future*—in their appeal for universal basic income among other reforms, assume a bland form of programmatism (i.e. a non-revolutionary theory of emancipation) that closely resembles existing sociodemocratic solutions.[120] Apart from uncritically retaining agency for the individual, these tendencies seem to ignore the historical contradictions of social democracy and the role played by social democratic parties in repressing revolutionary movements. The essential problem in their analysis appears in their total misconception of value. They only address the problem of the distribution of money—as though value was like a glass of water that could be simply distributed more equally—while overlooking the valorisation

119. Théorie Communiste, 'Real Subsumption and the Contradiction between the Proletariat and Capital', in Iles and Mattin (eds.), *Abolishing Capitalist Totality*.

120. However, in a recent talk on platforms, Srnicek was not quite so positive about Universal Basic Income in the near future. See <https://www.youtube.com/watch?v=YxT59mXDLDI>.

process: the value-form can continue to expand even if an equivalent of labour to time is accomplished. The reifying qualities of value generate both the spectral objectivity and phantom subjectivity that limits the potential for a different and properly egalitarian society. Without abolishing the value form it would be impossible to generate the basis for true equality.

On the one hand, then, we have on the ultra-left a compelling critique of the historical problems and limitations of the capacity of the proletariat to act. On the other hand, with left accelerationism we have an acute awareness of mediation, but a failure to understand how our current sense of agency is mediated by real abstraction and the exchange relation. The ultra-left, however, have not been able to deal with the notion of mediation, in the sense that they totalise capitalist relations without looking at the specific forms of capitalist determination in order to identify how these work and underwrite capitalist totality, leaving us with no option but a leap of faith and an expectant waiting for 'immediate communizing measures' which at the present moment can only be an abstraction; while the left accelerationists have not been able to deal with the historical moment of capitalism within the process of real subsumption, and continue to offer us forms of pragmatism which assume a degree of agency that is highly questionable under today's conditions—especially if they still retain their liberal character.

DEAD LABOUR AND LIVING NOISE

What accelerationism and recent discussions on posthumanism, transhumanism, accelerationism, and Negarestani's idealism have in common is that they obviate the crucial distinction between *dead* and *living* labour, which is decisive in any discussion regarding technology. Living labour is the only source

capable of producing surplus value; it is what Marx also called variable capital. It is labour-power before its objectification:

> It is the natural property of living labour, to transmit old value, whilst it creates new. Hence, with the increase in efficacy, extent and value of its means of production, consequently with the accumulation that accompanies the development of its productive power, labour keeps up and eternises an always increasing capital value in a form ever new.[121]

Living labour is variable capital because it can produce more value than it needs for its own reproduction. Dead labour, on the other hand, is already-objectified living labour which cannot therefore generate further value:

> Capital is dead labour, that, vampire-like, only lives by sucking living labour, and lives the more, the more labour it sucks. The time during which the labourer works, is the time during which the capitalist consumes the labour-power he has purchased of him.[122]

Although this may change in the future, as yet technology is not able to reproduce itself without assistance, and therefore it cannot produce surplus value. And, even thought it may not seem like it, we humans still have the potential to stop being just living labour waiting to die and become dead labour. While capitalism still needs us for its own reproduction, in order for capitalism to continue, some elements of our concrete-in-act activity must in principle lie outside of the valorisation process. Therefore we can say that real subsumption is not total, that it

121. Marx, *Capital 1*, 425.

122. Ibid., 163.

has not fully integrated everything—to think otherwise would be to ontologise capital. The question is how it determines consciousness and what room to manoeuvre we have. There is a potential here which is not the potential to become value like living labour, but instead something that remains beyond the reach of the valorisation process, a *living noise* which, in opposition to labour-power, is not yet objectified. We cannot define this living noise as labour because it is what is not yet subsumed. This however does not mean that our comprehension of it is not tainted by the processes of reification discussed above. This is why it might be best described as a form of noise, understanding that is full of distortions, an as-yet unconscious and unvalidated form of dissonance that we do not have the cognitive abilities to deal with. If the complete totalisation of the process of real subsumption is not possible, as we have argued, then this means that there are forms of activity that are outside of the valorisation process, even if we cannot grasp them yet. *Living noise* is not yet valorised because once it enters a system or is objectified by capitalism, it ceases to be noise:

> [It is] noise when it is interfering with a system, but as soon as it is integrated by the system as a stabilising element it becomes problematic to use the concept of noise, precisely because it is no longer perturbing the system.[123]

We should distinguish this living noise from the symptomatic mental state of noise that is an accelerated form of social dissonance. Living noise is the negative or residual potential of living labour, where psychological pathologies meet the harsh

123. M.Prado Casanova, 'Noise and Synthetic Biology: How to Deal With Stochasticity?', *Nanoethics* 14: (2020), 113–22: 120.

material reality of contemporary society *before* being diagnosed, personified, and pathologised. What I propose here is to *socialise* our social dissonance, the micro-mental state of noise that lurks below the threshold of pathology, the suggestion being that this might help us in the long run to better understand living noise, a more general form of noise, within practices that are yet not socially validated or valorised by capitalism. Living noise therefore stands as a critique of the totalising perspective of real subsumption, the argument that capitalism has already commodified everything.

This does not however automatically supply us with the grounds to lay claim to being wholly 'rational'. In *Intelligence and Spirit*, Negarestani also critiques this totalising perspective.[124] He argues that we cannot think that every activity or characteristic of an individual or a person is subsumed, shaped, or assimilated by the system to which it contributes or of which it is a part:

> Particular individuals, or collections of them—classes—are actively included in the capitalist system not in virtue of their living in it or being a part of it, but by virtue of whatever they may do that—in one way or another—counts as conforming to or being involved with capitalism's mode of production. An individual adheres to capitalism if what they do fits the pattern of capitalism's mode of production. In this sense, not every activity or characteristic of an individual or a person is subsumed, shaped by the system to which it contributes or of which it is a part.[125]

Negarestani here points out a common conflation between (1) capitalism as the totality of ways of producing, and (2)

124. Negarestani, *Intelligence and Spirit*, 37.

125. Ibid., 16.

society as what we perceive to be the totality of social rela-
tions. To flatten the distinction between these two, according
to Negarestani, is to 'risk mistaking functions or activities for
things, links between the distinct levels of individuals' activities
and capitalism's mode of production for metaphysical relations
between things'.[126] Furthermore, collapsing this distinction can
only yield an impoverished binary choice:

> [C]apitalism will be judged as a matter of all or nothing: either we
> should by any means possible contribute to it since there is no
> alternative, or we should seek its total collapse and with it the
> collapse of all social relations since such relations in their entirety
> are—supposedly—assimilated by it.[127]

Negarestani also warns us against making another equivoca-
tion between (1) socially instantiated functions of the mind and
(2) social practices in general, claiming that, if social practices
are misshapen by a system of social relations, reshaped and
distorted by capitalism,

> then powers of reason and judgement, or the structuring functions
> of the mind, are also tainted by this all-encompassing distortion
> or corruption. But such a thesis is based on flattening the dis-
> tinctions between social linguistic practices and social practices
> in general, act and object, form and content.[128]

Here we might object that the space of reasons and the socially
instantiated functions of the mind are indeed embedded within

126. Ibid.

127. Ibid., 17.

128. Ibid.

social relations (or social practices in general, as Negarestani calls them), but that social relations are not transparent from within the space of reasons. The problem emerges however if we don't take into account the class relation that determines this social relationship. This is not to say that reason is just ideology, but that the Kantian conception of rationality as intersubjectivity falls prey to ideology if the dialectic of mutual recognition fails to take the class relation into account. Here once again we can see where social dissonance emerges, as a dissonance between self and subject: we think that mutual recognition is possible and transparent enough for us to trust the potential of reason, but we negate the layer of determination of the class relation. While the class relation conditions our consciousness and cognition, it cannot fully determine it because this would imply the objectification of all living labour, which would mean labour was not be able to create value. The normative realm of self-consciousness is influenced by categories such as commodity, class, property, labour, state and the law. One cannot claim freedom or autonomy without taking into account how we are conditioned by these categories. In order to truly achieve autonomy and freedom, a social revolution would be necessary. We need to change material conditions in order to reach the potential for rationality. And while we need to recognise that there is no alternative within capitalist totality, there is an outside to the valorisation process which is noisy, unconscious, and socially unvalidated. Reason can barely reach it but not properly articulate it, because our engagement in this totality constantly distorts our conceptual tools. This means that we cannot simply trust in the power of reason—we need to constantly interrogate it in relation to capitalist totality. Nevertheless, we can claim that *living noise subsists*.

Living noise is not yet socially validated i.e. commodified. It lies at the intersection between our activities and our unconscious. We might not have cognitive access to it, but understanding that it is there, as a kind of fault line that impedes rationality from being fully functional, can help us to better grasp how we are conditioned, and the limitations of our present means. Living noise is precisely that which cannot be objectified in the labour process, because it is residual and remains below the threshold of measurement.

DEATH OF THE UNALIENATED SUBJECT

The concept of alienation allows us to understand the complex forms of mediation and determination involved in capitalist relations, and to see how social dissonance emerges out of a specific historical moment and mode of production. Stirner's notion of alienation based on the empirical individual was exposed by Marx as an indeterminate abstraction; instead, Marx developed a concept of alienation which takes into consideration the social totality on the widest scale. Althusser helped us to understand how ideologically we are made to conflate the individual with the subject because we are interpellated as such by capitalist institutions, when the notion of the individual is actually an abstraction arising from social practices in which labour is subsumed by value.

At the level of practice, we engage in relations whose abstract character is not accessible to us, and simultaneously we reify our self-conception by describing our subjective agency phenomenologically. By doing this we generate an illusion of agency and freedom anchored in selfhood. The bridge between our self-conception and our self-model involves many intricate subpersonal mechanisms and ideological connotations, as explored further in the next chapter. For the time being, what

we can say is that, at the level of the concrete-in-act or con-crete-in-reality, we engage in social relations in ways that we remain unconscious of. One of the reasons social dissonance emerges is that we are unified at the level of exchange through engaging in real abstractions, but we remain dissociated at the level of consciousness, making it difficult to understand how social relations function at the level of the totality. This is what I call *dissociative unity*,[129] and we could say that it is the pre-condition for the emergence of social dissonance.

What we are and what we think we are, are not the same thing, meaning that we don't have direct access through ration-ality to full self-understanding. In other words, the concepts of autonomy, freedom, and subjectivity that we have are limited and distorted in specific ways. But these concepts are the ideo-logical engine of the capitalist mode of production. The under-standing of the subject as an empirical and phenomenological individual thus obviates and obscures the structural conditions that have produced it.

If we understand 'subject' to mean an active agent gen-erating its own self-determination and in doing so transform-ing reality, we could say that the real subject today is capital, which objectifies our living labour through a set of impersonal practices irreducible to interpersonal relations. But at present this can still only be achieved if we feel that we have a sense of agency in the process.

If in the present chapter we have explored how alienation works at the broadest scale, at the level of social totality where *spectral objectivity* gives rise to a reified idea of the individual as having subjective agency. In the next chapter we will look

129. See my text 'Dissociative Unity', in Mattin and Iles (eds.), *Abolishing Capi-talist Totality*.

at another form of alienation that exists on the most intimate scale—a *phantom subjectivity*—in the process leaving behind any possibility of an unalienated subject.

Examining alienation from above exposes some of the mediations involved in real abstraction, but we need to complement this with the scientific knowledge available to us in order to understand the forms of mediation in operation at the neurocomputational level.

2

ALIENATION FROM BELOW: PHANTOM SUBJECTIVITY

Metzinger characterises the self as a neuro-computationally generated illusion—that is, he pronounces the scientific image of unobservable neuro-computational processes to be the true image and considers the manifest image of the person and its phenomenological experience as a *phantasm*.

Inigo Wilkins[1]

It is the invariance of bodily self-awareness, of agency, and autobiographical memory which constitutes the conscious experience of an enduring self. The conceptual reification of what actually is a very unstable and episodic process is then reiterated by the phenomenological fallacy pervading almost all folk-psychological and a large portion of philosophical discourse on self-consciousness. But it is even phenomenologically false: we are not things, but processes.

Thomas Metzinger[2]

We must learn to dissociate subjectivity from selfhood and realize that it, as Sellars put it, inferring is an act—the distillation of the subjectivity of reason—then reason itself enjoins the destitution of selfhood.

Ray Brassier[3]

In the previous chapter I explored how individual experience is always mediated by social relations, and suggested that therefore our consciousness must find the resources to challenge

1. I. Wilkins, *Irreversible Noise* (Falmouth: Urbanomic, forthcoming 2022).

2. T. Metzinger, *Being No One: The Self-Model Theory of Subjectivity* (Cambridge, MA: MIT Press, 2004), 325.

3. R. Brassier, 'The View from Nowhere', *Identities: Journal for Politics, Gender and Culture* 8:2 (2011), 7–23.

the commodification of individual experience in practice by understanding its involvement at the level of the totality.

But our experience is also determined by subpersonal mechanisms that we are only just beginning to grasp. What has historically been understood as the 'individual' is being radically questioned from many angles today, including neuroscience, virtual realities of various kinds, and, most importantly, technosocial interconnections such as consumer algorithms from the likes of Google and Facebook which shape our tastes and behaviours.[4] Although in light of these changes there is no way to go back to previous conceptions of the individual, we still need to account for the processes which, under contemporary conditions, continue to produce faith in the self. Social dissonance, after all, is driven partly by the conflict between these 'dividualising' trends and the continuing naturalisation of personal experience understood as the proprietary right of individuals. In trying to grasp the mediations that underpin such processes of naturalisation, we face a different type of mystification to that covered in the previous chapter, one that this time has to do with the slippage from self to individual. As we shall see, attempts to give a rational account of the subject (Wilfrid Sellars) and recent philosophical accounts of neuroscience (Thomas Metzinger) move to dispel this mystification. This may demonstrate to us that reason and science have something to say to the revolutionary subject, even if they remain embedded in the mystified topsy-turvy world described by Marx—indeed, it is precisely this tension that I am interested in addressing.

4. See e.g. T. Striphas, 'Algorithmic Culture: A Conversation with Ted Striphas', <https://medium.com/futurists-views/algorithmic-culture-culture-now-has-two-audiences-people-and-machines-2bdaa404f643>.

> You live your life feeling as though every waking moment is spent walking around in a bubble. You feel completely detached from everything and everyone around you. You hear your voice when you talk but struggle to connect it as your own. You see your reflection in the mirror, it is familiar but it does not feel truly yours. Everything around you appears unreal and somewhat distorted. You feel a passenger to someone else's life story, watching it play out through someone else's eyes.
>
> LBLimboland13, 'Living with DPDR'

Taken from a pseudonymous post on an internet forum, these are the words of somebody suffering from chronic Depersonalization/Derealisation Disorder (DPDR), which is the third most prevalent psychological disorder today—current estimates suggest that up to 74% of the population have an encounter with it at some point in their life.[5] DPDR is a serious and debilitating condition: one sufferer says that '[i]t's as if you have no self, no ego, no remnant of that inner strength which quietly and automatically enabled you to deal with the world around you, and the world inside you.'[6] Yet this disorder is barely understood and vastly overlooked.[7] When I asked the psychologist Rodrigo Oraa about the origins of this pathology, he attributed it to competition and precarity in contemporary

5. E.C.M. Hunter, M. Sierra, and A.S. David, 'The Epidemiology of Depersonalisation and Derealisation. A Systematic Review', *Soc. Psychiatry Psychiatr. Epidemiol.* 39:1 (January 2004): 9–18, <https://pubmed.ncbi.nlm.nih.gov/15022041>.

6. Ibid.

7. Ibid.

life and the influence of the various virtual realities in which we spend our time. But even though it may be an effect of the conditions of everyday life today, it is not surprising that it is still perceived as a pathology, because in order to function in society one must maintain and project a clear and stable idea of selfhood that does feel 'truly yours'. The same conditions that reinforce selfhood, then, also generate the stresses and pressures that produce such pathologies.

Here I would like to consider DPDR as a specific case of a type of alienation—I will call it *alienation from below*—which has rarely been discussed within Marxism, a discourse that is generally more concerned with the ways in which sociopolitical and historical conditions produce what I have called *alienation from above*. These two forms of alienation are inevitably connected, but their interconnection is complex.

Alienation from below has to do with the way in which biological systems produce self-models in order to cope with the exorbitant costs of processing information in their environment. As described by neurophilosopher Thomas Metzinger in his major work *Being No One*, the self-model is a kind of navigational instrument generated by subpersonal processes, a 'user interface' generated by our brains. Because we don't have access to the mechanisms that produce this illusion, we cannot help but experience the self-model as a foundational reality—unless, that is, we reach a pathological stage where that self-model breaks down.

What is the relation of such breakdowns to the regime of capitalism? Capitalism needs stable selves in order to sell commodities back to its labourers on the market, but at the same time this stable sense of self is increasingly undermined by the technological saturation of the social. On the one hand technologies reinforce the user's notion of selfhood—they solicit

personal details, and encourage the projection of an image of the self—but on the other, they operate on the basis of sub-personal reflexes, and feed the user socially-generated input and information calculated to shape the way they think without appealing to rational thought or conscious agency.

This tension is very much alive in politics. For some, 2016, with Brexit and the Trump election, saw a triumph of democracy, while for others it was about the radical manipulation of the many by the few through fake news and electoral sabotage. These are conditions of social dissonance, under which the narrative of the self continues to be prevalent, while our actions are in fact increasingly determined technologically by economic interests. In this respect, once again, the gap between how we under-stand our selves and how those selves are socially constructed and modified widens to the point of threatening social and personal disintegration.

In light of this, it is not surprising that people in vastly dif-ferent parts of the world share the common desire to hold on to values associated with roots and identity. The more spectral objectivity reifies selfhood, the more difficult it becomes to dis-entangle neurobiological mechanisms from phenomenological experience. This is in part because the hegemonic ideology makes the possibility of conceiving subjectivity in other radical ways practically unthinkable. In a society where everything is based on ownership, one takes the most immediate sense of property (i.e. selfhood) as natural and given. In this chapter we will seek to problematise and deconstruct this naturalisation.

Spectral objectivity is based upon our social interaction under the regime of commodity production. As a corollary it produces a phantom subjectivity, but in order to generate the first-person perspective, this phantom subjectivity also requires mechanisms that are neurobiological rather than social.

The model of selfhood gives us a phantom sense of subjective agency that comes from a reification of first-person experience which in turn renders opaque the possibility of understanding the complex mechanisms that produce this reification.

How does phenomenal experience relate to the sense of ownership of selfhood? How does the first-person perspective emerge? Phenomenal experience is based on an activation of consciousness that triggers the processes for the generation of the illusion or phantomaticity of selfhood. Phantomacity here means that it is not substantial, but counterfactual, a kind of projection simulating a sense of nowness and ownership. According to Metzinger, access to the mechanisms that produce this projection is blocked off so as to optimise the deployment of neurocomputational resources.

In order to have a cognitive first-person perspective we need to have the phenomenal first-person perspective which allow us cognitive self reference, the possibility of conceiving oneself as oneself.[8] But the phenomenal first-person perspective impedes us from having an objective view of the process, allowing us only a subjective perspective based on the phenomenology of 'being someone'. So what happens when the sense of ownership and individual agency provided by this mechanism breaks down, when one loses this first-person perspective? Such alienation from below is described by Metzinger when he turns to the neurophenomenology of schizophrenia:

> Schizophrenics experiencing thought insertion and introspective alienation may present us with a more specific case. Phenomenologically, they experience cognitive agency: specific, conscious thoughts are being selected and forced into their own minds, into

8. Metzinger, *Being No One*, 405.

what I have termed the opaque partition of their PSM [...]. Phe-
nomenologically, there is a cognitive agent—someone else who
is thinking or sending these thoughts. That is, the causal history
of these states is phenomenally modeled as having an external
origin. They are caused by an agent.[9]

This is an extreme case of mental noise or social dissonance,
where the agent is not identical to the subject of experience
and the illusion of ownership of self collapses catastrophically.
Metzinger describes many more pathologies in which the sense
of ownership of selfhood becomes distorted: first and foremost
Cotard's Syndrome, in which the patient thinks that they do
not exist, or even that they are rotting; often patients cannot
recognise themselves in the mirror, and may deny the external
world. (The term initially used in 1880 by the neurologist Jules
Cotard was '*delire de négation*', and he described it as a form
of nihilist delusion; Metzinger calls this 'existence denial'.)[10]
But also *reverse intermetamorphosis* (the belief that there
has been a physical and psychological transfer of oneself into
another person), *reduplicative paramnesia* (the belief that a
place or location has been duplicated, existing in two or more
places simultaneously, or that it has been 'relocated' to another
site), *intermetamorphosis* (the belief that the patient can see
others change into someone else in both external appearance
and internal personality), *Capgras syndrome* (also known as
'imposter syndrome' or 'Capgras delusion'; an irrational belief that
someone the patient knows or recognises has been replaced by
an imposter), *Fregoli delusion* (the belief that different people
are in fact a single person who changes appearance or is in

9. Ibid., 608–9.

10. Ibid., 454.

disguise). There are also different forms of *agnosia* (inability to process sensory information, to recognise and identify objects or persons) such as *usamusia* (selective inability to recognise and consciously experience tones and melodies; disturbances concerning rhythm and tempo), *sound agnosia* (inability to recognise and consciously experience the meaning of non-verbal sounds), *asterognosia* (inability to consciously recognise objects by touching them), *autotopagnosia* (inability to identify and name body parts), *anosodiaphoria* (inability to emotionally react to an existing disease or deficit), and *prosopagnosia* (inability to grasp the identity of persons, in some cases one's own identity).

It is precisely by analysing phenomena where the sense of self breaks down, such as the pathologies enumerated above, out-of-body experiences (OBE), and experiments such as the Phantom Limb experiment, that Metzinger develops a theory of how self-consciousness emerges by way of what he defines as a 'phenomenal self-model' (PSM). He is then able to propose a comprehensive positive account of how selfhood and the first-person perspective emerge out of subpersonal representational mechanisms:

> Once consciousness is minimally defined as the activation of an integrated world-model within a window of presence, then self-consciousness can be defined as the activation of a phenomenal self-model (PSM) nested within this world-model: A self-model is a model of the very representational system that is currently activating itself within itself.[11]

According to Metzinger, phenomenal transparency—the sense that we are experiencing something directly and without

11. Ibid., 302.

mediation—is an artifice that economises on neurocomputational expenditure by filtering data into vectors or patterns of sense-making. The drawback is that phenomenal transparency must necessarily obscure the mechanisms of its production. The apparently immediate surface phenomena, the polished representational result, hides its own inorganic means. The economy and the evolutionary advantage here lies in *not* having to manifest to consciousness in its entirety the process of producing a world-model, but only the model itself—which *appears* as just a transparent and immediate representation of how things are.

This transparency mechanism, which produces a represented content, e.g. the illusion of the individual as purposeful car driver, is a dynamic process which has three different states: internal representations (unconscious—sensing and adjustment to small changes on the road), mental representations (sometimes conscious—a car that has just pulled out in front of me and I need to slow down) and phenomenal representations (representations experienced transparently as the presence of something real and existing). When the transparent self-model is activated, it hides the representing mechanisms because otherwise it would develop a debilitating regress of recursive self-modelling—the inclusion of everything in the representing process. This hiding generates what Metzinger considers the phenomenological fallacy: the apparently clear and immediate access to phenomena, according to him, is in fact 'a special form of darkness'.[12]

In Plato's allegory of the cave, the mind of the human is portrayed as a prisoner held in a cave with their head placed

12. R. Brassier and T. Metzinger, 'A Special Form of Darkness', <https://iokolice.wordpress.com/2014/12/03/a-special-form-of-darkness/>.

in a fixed position. The only thing they have ever seen are shadows on the wall which are formed by a fire burning from behind them. For Metzinger's Self-Model Theory of subjectivity (SMT), the neurophenomenal cave 'is simply the physical organism as a whole, including, in particular, its brain'.[13] The shadows on the wall are phenomenal mental models for the SMT, 'low dimensional projections of internal or external objects in the conscious-state space in the biological organism'.[14] The fire is the neural dynamic information processing shaped by its sensory and cognitive input.[15] For Metzinger, however, there is no one there in the cave who could go out, see true reality, and then return, as in Socrates's parable.[16]

Reviewing all of these pathologies with Metzinger, a crucial question emerges: Is it possible for us to rationally take up the third-person perspective implied in such disorders, to inhabit this other alienated standpoint on ourselves, to get beyond the 'special form of darkness' and objectify ourselves in thought? In the conditions of spectral objectivity outlined in the previous chapter, can we really gain this third-person perspective in order to explore how phantom subjectivity is produced? But before we try to answer this question, we first need to distinguish between 'experienced properties' (phenomenological) and 'properties of experience' (neurocomputational).

13. Metzinger, *Being No One*, 548.

14. Ibid.

15. Ibid.

16. Ibid., 549.

THE EXPERIENCELESS SUBJECT VS. SUBJECTLESS EXPERIENCE

> The social constitution of the human mind which unfolds within interpersonal relationships can be made accessible only from the perspective of participants and cannot be captured from the perspective of an observer who objectivates everything into an event in the world.
>
> Jürgen Habermas[17]

In his 2011 text 'The View from Nowhere', Ray Brassier addresses the humanism of Jürgen Habermas. According to Brassier, Habermas disregards the fact that the interpersonal space described in the above quote is shaped by supra-personal and sub-personal mechanisms that cannot be grasped from within it.[18] Habermas thus assumes that cognition is strictly separated from its object, that human rationality must precede its object because this object is only made accessible, in comprehensible form, through the intersubjective community that objectifies it. Objectification, in other words, may only be conceived through the partiality of the experiencing individual who belongs to an intersubjective linguistic community. In this sense Habermas may be seen as presenting an ontology of the human as *a subject of experience that cannot be objectified*. As Brassier puts it:

> Habermas pre-emptively disqualifies by conceptual fiat every sci-
> entific attempt to describe and explain the transition from prelin-
> guistic to linguistic consciousness, from the sub-personal to the

17. J. Habermas. 'The Language Game of Responsible Agency and the Problem of Free Will: How Can Epistemic Dualism be Reconciled with Ontological Monism?', *Philosophical Explorations* 10.l (2008), 13–50.

18. Brassier, 'The View from Nowhere'.

personal, and from neurobiology to culture. For Habermas, the explanatory resources required in order to provide such an account threaten to cost too much: they would incur a self-objectification which would irrevocably estrange us from ourselves.[19]

Brassier compares and contrasts Habermas's view with those of Metzinger and Wilfrid Sellars, both of whom propose that the human subject be understood as a certain knot of physio-neurological determinations that precede and mediate conscious volitional experience and conception. Both Sellars and Metzinger, in different ways, attack the absolutising of individual experience as ownership. Their arguments rest upon the idea that, contra Habermas, there is no essential conflict between objectification and knowledge of the self, since the 'self' must necessarily have passed through processes of objectification—through conceptual mediation—in order to be presented as an element of experience from the outset. In this sense, the best way to know ourselves—along with interrogating the suprapersonal social forms that shape individual experience, as we did in the previous chapter—would be to understand the non-experiential processes and subpersonal mechanisms that determine our perception of our own individuality and ownership of experience.

Brassier goes on to suggest that the work of Metzinger and Sellars can help us realise the possibility of a rational account of a subject that is neither carried out from the point of view of a self-proprietor of experience, nor describes the subject in those terms. This is what would be a 'nemocentric subject', as Brassier explains in an interview:

19. Ibid., 20.

Some recent philosophers have evinced an interest in subject-less experiences; I am rather more interested in experience-less subjects. Another name for this would be 'nemocentrism' (a term coined by neurophilosopher Thomas Metzinger): the objectification of experience would generate self-less subjects that understand themselves to be no-one and no-where. This casts an interesting new light on the possibility of a 'communist' subjectivity.[20]

NEMOCENTRIC REVOLUTION

As outlined in the Introduction, the score *Social Dissonance* proposes a positive practice of dealing with the different forms of alienation and its consequences through an externalising use of alienation, so as to explore the possibilities and limitations of processes of objectification in current conditions. As an artist, to me this line of investigation appears crucial because: (a) self-less subjects would radically challenge notions of authorship, (b) audience-performer relationships disintegrate if there is no proprietor of experience, and (c) such practices would call for a radical reconsideration of aesthetic experience in regard to sensibility and rationality. In light of the nemocentric subject, art's function in society would have to be a different one, one in which it would no longer function unproblematically as a lubricant between democracy and capitalism by claiming a certain agency, or even freedom, through the expression of the self.

At the 2017 *Transmediale* in Berlin there was a great deal of talk about alienation and alien machines with agency. One exhibition entitled *Alien Matter* consisted of works that challenged the dualism of the man-made and the machine-made,

20. R. Brassier and B. Ieven, 'Against an Aesthetics of Noise', <http://www.ny-web.be/transitzone/against-aesthetics-noise.html>.

reflecting on 'the potential intelligibility of matter'.[21] All of these processes raise radical questions: What is consciousness? What is experience? And what is the self? In light of these discussions, I turned to a slightly different question: What is it that we are supposed to be alienated *from*? From a nemocentric point of view, there can be no return to an authentic self, and, as suggested by Metzinger's analyses of dissociative 'pathologies', it may even be the most apparently estranged states of mind that offer the most faithful description of ourselves. Here the problematic of alienation takes a turn toward the question of an affirmative destitution of the self: an understanding of ourselves as 'no-one and no-where'. Conceiving the self as a construction might enable us to acknowledge that there is no originary immediacy we are separated from. And yet under today's conditions, we all know what property means and how strongly our sense of self is tied up with it. Property rights operate as pervading conceptual norms, and we find ourselves constantly interpellated by these sense-making structures. Survival itself is at stake here: failing to assume the mediation of property as one's own can mean literally facing the threat of the suspension of your life chances.

But if the self is a construction, then who owns experience? One must be a self in order to be the proprietor of something. It is precisely this standpoint that makes it possible to distinguish between *selfhood* as a supposedly transcendental form and *subjectivity* as a form that is culturally and socially produced. Expanding upon this dissociation between subject and self, Brassier writes: '[I]f the subject is not a self, then the subject who knows herself to be selfless is neither the proprietor of this

21. See the introduction to the exhibition 'Alien Matter', <https://www. hkw.de/en/programm/projekte/2017/transmediale2017/transmediale_2017_ ausstellung/2017_transmediale_ausstellung.php>.

knowledge (since it is not hers) nor its object (since there is no-one to know)'.[22] This enables Brassier to claim that, if there is to be a revolutionary subject, 'neither the phenomenal self nor the ideological subject is the source of revolutionary agency: this subject is neither self nor individual'.[23] The revolution will be nemocentric. According to the nemocentric point of view, if subjective rational agency is possible, then this agency will neither postulate its grounding on an irrationality whose interests lie in self-expansion (as in capitalism), nor on a romantic version of an enlightened individual. This other subjective rational agency without selfhood would be a communist form where the I/we intersects in the most just and rational manner, one that has understood and taken into consideration the importance of both the social and the neurobiological in our constitution, and has the ability to account for how they operate.

THE FETISH OF EXPERIENCE
AND THE MYTH OF INTERIORITY

As discussed above, the narrative of the self is often promoted in artistic situations through notions of authorship or embodiment, which generally assume the idea of the self as proprietor of its own experiences, therefore emphasising a notion of natural experience which takes for granted the forms of selfhood that Metzinger's research undermines. In a certain sense the model of *self-possession* is what is taken for granted here as the ultimate ground of freedom, with the artist as a particularly exalted example.

Here it is worth mentioning the distinction made by Marx regarding the difference between 'having' and 'owning', where

22. Brassier, 'The View from Nowhere', 20.

23. Ray Brassier, private communication, 16 December 2019.

owning involves sensory capacities while having involves prop-
erty, instituted through specific social relations and intensified
in capitalism:

> In the place of all physical and mental senses there has therefore
> come the sheer estrangement of all these senses, the sense of
> having. The human being had to be reduced to this absolute
> poverty in order that he might yield his inner wealth to the outer
> world. The abolition [*Aufhebung*] of private property is therefore
> the complete *emancipation* of all human senses and qualities,
> but it is this emancipation precisely because these senses and
> attributes have become, subjectively and objectively, *human*.[24]

The term used by Marx is '*einfache Entfremdung*', an alienation
of the senses. While for Marx 'owning' in this sense has an
inclusive meaning, 'having' and private property instead alien-
ate the relationship with other senses. By constantly making
an *object* out of a *property*, having cancels out the possibility
of a much broader sense of perception in which the subject
and object relationship interpenetrate one another.

By emphasising a subjective sense of appropriation, having
disallows the possibility of a greater integration between the
subjective and the objective. Dan Zahavi's phenomenological
critique of Metzinger demonstrates what is at stake here in
terms of property and the spontaneity implied by the first-
person perspective. Zahavi insists that 'at its most primitive,
self-consciousness is simply a question of having first-person
access to one's own consciousness; it is a question of the
first-personal givenness or manifestation of experiential life'.[25]

24. Marx, *Economic and Philosophic Manuscripts of 1844*.

25. D. Zahavi, 'Being Someone', *Psyche* 11 (2005), 7.

For Zahavi, such 'primitive' experience of 'givenness' must be taken as a starting point and, since experience gives us this sense of mineness, it cannot be questioned outside the perspective of mineness. Phenomenology, in this sense, presupposes a first-person perspective as constitutive of the very possibility of subjectivity. But as we begin to see that this first-person perspective is determined by subpersonal mechanisms, as demonstrated and theorised by Metzinger, and as overtly instrumentalised by technologically-enabled capitalist socio-economic relations, our trust in its self-evidence is rightly eroded. The danger is that the supposed transparency of the phenomenological perspective becomes like wearing cognitive blinkers. It threatens to perpetuate the mystification of the self by denying any possibility of investigating from an impersonal perspective how the self-model and the sense of ownership over experience might be *produced*. By the same token, it makes it impossible to give any convincing account of those pathological states where the self-model breaks down. A phenomenology that takes for granted the self understood as an agent, doer and recipient— as the owner of experience—will find it difficult to grasp the reality of Cotard's Syndrome, where a subject experiences itself as not even being alive, and experiences its own image as not being 'truly its own'. Inversely, by basing his research on these pathological instances of non-ownership, Metzinger opens up the possibility of a third-person perspective on selfhood.

Edmund Husserl's original conception of phenomenology was far more sophisticated than the position described above, and did not necessarily presuppose a self or individual as owner of experience.[26] Nevertheless his theory does rely on

26. 'It should be stressed that the return to "experience in person" proclaimed by phenomenology does not involve an affirmation of inwardness as such, or a retreat into the private domain of an "inner personality". On the contrary,

the notion of 'primal impressions' which are not conceptually mediated[27] and are considered as the absolute beginnings of conscious experience. This proposition entails the claim that consciousness is continuously produced through spontaneous subconscious and 'alien' impressions:

> [I]t is what is primarily produced—the 'new', that which has come into being alien to consciousness, that which has been received, as what has been produced through consciousness' own spontaneity. The peculiarity of this spontaneity of consciousness, however, is that it creates nothing new, but only brings what has been primally generated to growth, to development.[28]

Here we find what might be called a phenomenological theory of alienation, a theory that differs a great deal from Habermas's Kantian reduction of sociality to intersubjectivity, an intersubjectivity which, as we have seen, for Marx, is not really possible in this straightforward form, since our own social reproduction under capitalism acts 'behind our back', distorting our own self-conception and our relation to others.

Husserl understood phenomenology as a "description of consciousness purified of personal ownership, "no one's thought"." Centre for Research in Modern European Philosophy (Kingston University), 'Phenomenology', in *Concept and Form*, <http://cahiers.kingston.ac.uk/concepts/phenomenology.html>.

27. In *Ideas 1* Husserl describes how the primal impression does not pass through any form of mediation: 'The primal impression is the absolute beginning of this production, the primal source, that from which everything else is continuously produced. But itself is not produced; it does not arise as something produced but through *genesis spontanea*; it is primal generation. It is primal generation. It does not spring from anything (it has no seed); it is primal creation.' E. Husserl, *Ideas 1* [1913] (Indianapolis: Hackett, 2014), 'Appendix I: Primal Impression and its Continuum of Modifications'.

28. Ibid.

However, this Husserlian alienation retains the problems of the presupposition of primary reception as un-objectifiable. Primal impressions are constitutive of the stream of consciousness, but nonetheless remain unthinkable—and hence unchangeable—as a mediation.

In improvisation and noise, a caricatural version of the concept of spontaneous primary impressions is often fetishised—as if 'raw' experiences were able to deliver something far richer than what our capacity for conceptualisation gives us. This fetish of spontaneity helps reinforce both what Wilfrid Sellars will call the 'myth of the given'—the view that knowledge of what we perceive can be independent of the conceptual processes which result in perception—and what Jacques Bouveresse called the 'myth of interiority'[29]—the Cartesian implication that there is something intrinsic in 'mineness', that there is something about the self, the first-person perspective, that must be maintained at all costs, a supposition which inevitably perpetuates the fiction of the sovereign subject. Both of these myths are ritualistically affirmed and nourished by performances that prioritise 'raw immediacy' over a conceptual grasp of what is happening, and who—or what—it is happening to. We already have very good reasons to reject such claims to immediacy. We have seen how our experience is mediated through two forms of alienation: the capitalist commodification of experience and consciousness, which produces value out of this ongoing expansion of the narrative of the self, and the alienation exposed by Metzinger's account of the self-model. Let us now turn to a third, our ability to conceptualise. It is this third and last form of alienation that can help us understand

29. J. Bouveresse, *Le Mythe de l'intériorité: expérience, signification et langage privé chez Wittgenstein* (Paris: Minuit, 1976).

the two others and the interrelation between them, and it is here that the work of Wilfrid Sellars comes in.

GIVENNESS, CONCEPT, AND LANGUAGE: THE AGENT AFTER SELLARS

> At the heart of the framework of givenness is the assumption, common to empiricism and rationalism, that mental states are self-intimating. Rejecting the framework of givenness, Sellars refuses the assumption that the mental is self-intimating. This means minds do not necessarily know themselves. There is a fundamental difference between thinking and knowing what is thought. By the same token, there is a fundamental difference between sensing and knowing what is sensed. The awareness of something is not the awareness of something as something. This difference—between thinking and thought, or sensing and sensed—follows from the rejection of givenness.
>
> Ray Brassier[30]

The demand for rationality and the rejection of the 'given' articulated by Wilfrid Sellars gives us some extra tools to meet Marx's demand for thinking in relation to a totality.

If, as Marx shows, one cannot understand value without taking into account the totality of social relations involved in capitalist production and reproduction, Sellars points out how the knowledge we gain from experiences is limited and often distorted, and claims that we need the knowledge yielded by

30. R. Brassier, 'The Metaphysics of Sensation: Psychological Nominalism and the Reality of Consciousness', in *Wilfrid Sellars, Idealism, and Realism* (London: Bloomsbury Academic, 2017), 59–82: 60.

scientific research in order to get attain a broader or 'stereo-scopic' vision of reality. In general terms, Sellars's position calls for

> [t]he conceptual integration of the subjective and the objective, reasons and causes, in the obligation to attain a maximally integrated understanding of the world and our position within it as creatures who are at once conceptually motivated and cause-governed.[31]

Sellars was writing during a time of momentous scientific discoveries, many of which seemed to tell against the intuitive understanding of the human subject. Sellars's overall project was to find a way to integrate this inherited intuitive picture—what he called the 'manifest image' of the human—with the emerging scientific image, in order to achieve a 'stereoscopic' fusion of the two.[32] For him, the manifest image has to do with our common sense, our ability to rationalise and produce a model of the world from what is perceptually available to us. The manifest image is favoured in particular in phenomenological accounts, which attempt to describe its structure in detail. However, given its programmatic refusal to apply 'external' conceptual frameworks, phenomenology cannot get beyond it to grasp the sub- and suprapersonal strata between which this image is sandwiched. The scientific image, in contrast, is oriented toward a knowledge of imperceptible entities—such as particles and their sub-atomic constituents—that are describable from a third-person perspective. As John McDowell explains, Sellars's notion of the 'myth of the given' is a critique of the idea that there is '[a] given in experience independently

31. Brassier, 'The View from Nowhere', 19.
32. Ibid., 18.

of acquired conceptual capacity [that] could stand in a justificatory relation to beliefs or a worldview'.[33] In Sellars's own words: 'To reject the Myth of the Given is to reject the idea that the categorial structure of the world—if it has categorial structure—imposes itself on the mind as a seal on melted wax'.[34] The myth of the given consists in believing that reality has a propositional form. There are two variants of the myth of the given: the epistemic variant, which confuses thinking with sensing, and the categorial variant, which confuses *sensing* with *sensing as*.[35] Sensory awareness is not awareness *as*. But like Metzinger's self-model, this critique is effectively also an attack on the 'myth of interiority'. Here I would like to pursue Sellars's criticism of the 'myth of the given' as a means to counter the narrative of the self as proprietor of experiences. Whereas phenomenology, as understood by Zahavi, presupposes that phenomena can only be experienced according to the form of the self—providing one with the sense of 'mineness', and thus leaving no room for the conceptual, social, and historical mediations that constitute such a sense of 'mineness'—Sellars recognises the self, as part of the manifest image, as a conceptual mediation that has been being socially constituted through the functional rules of meaning.

A key point to appreciate here is that, for Sellars, the manifest image is therefore already conceptual—that is, its model of the world necessarily invokes quasi-theoretical assumptions, albeit implicitly and unreflectively. For Sellars, then, the self and

33. J. McDowell, 'Conceptual Capacities in Perception', <http://citeseerx.ist. psu.edu/viewdoc/download?doi=10.1.1.472.5133&rep=rep1&type=pdf>.

34. W. Sellars, 'The Lever of Archimedes', *The Monist* 64 (January 1981), 4.

35. R. Brassier, 'Nominalism, Naturalism, and Materialism: Sellars's Critical Ontology', in B. Bashour and H.D. Muller (eds.), *Contemporary Philosophical Naturalism and Its Implications* (New York: Routledge, 2013), 101–14: 110.

its 'mineness' are not the inevitable form of all consciousness

but a socio-historical product, albeit a deep-rooted one that
operates through the mediation of language and concepts. In
order for a person to be a member of the linguistic community,
they need to understand the rules of the language game. Fur-
thermore, in order for that person to be an agent, they need to
have a grasp of certain concepts that allow them to play the
game of agency effectively:

> One isn't a full-fledged member of the linguistic community until
> one not only conforms to linguistic ought-to-be's (and may-be's)
> by exhibiting the required uniformities, but grasps these ought-
> to-be's and may-be's themselves (i.e., knows the rules of the
> language.) One must, therefore, have the concept of oneself as
> an agent, as not only the subject-matter subject of ought-to-be's
> but the agent-subject of ought-to-do's.[36]

In Sellars's account, then, rationality is developed through a
conceptual normativity that is socially instantiated by historically
mediated linguistic practices, and our self-model is a particular
feature that derives from this conceptual mediation:

> Self-knowledge certainly comprises a dimension of non-inferential
> immediacy that endows us with a privileged epistemic access to
> our own internal states, but only within certain limits, since the
> immediacy of self-knowledge is itself the result of conceptual
> mediation and cannot be invoked to ratify the appeal to an alleg-
> edly intuitive, pre-conceptual self-acquaintance.[37]

36. W. Sellars, 'Language as Thought and as Communication', in K. Scharp
and R.B. Brandom (eds.), *In the Space of Reasons* (Cambridge, MA and
London: Harvard University Press, 2007), 64.

37. Brassier, 'The View from Nowhere', 32.

Sellars's theory of cognition hence suggests a rational *understanding* of the agent-self as opposed to its *manifestation* as a pre-individuated entity. To attain this understanding, the agent must distinguish sensory consciousness from thinking. Sensory consciousness is a function of the organism, while thinking is a social capacity because it is rule-governed, and Sellars warns of the dangers of conflating the two. Perception already implies conception and conception, in turn, is embedded in collective social practices. In 'Meaning as Functional Classification', Sellars develops a theory of thinking based on the idea that uttered thoughts are formed through relations between conceptual functions. He understands thinking-out-loud 'as if it was like placing a pawn on a chessboard in the game and realises the function of a pawn that is related to other chess pieces'.[38] A child learns by making noises and slowly begins to understand how their utterances intervene on this gameboard, that is, how they function (or do not) in language (relations between conceptual functions). To say what a person means, then, is to give a functional classification of their utterance. This way of thinking about language avoids any form of foundationalism (i.e. any theory of knowledge that rests ultimately on a certain foundation involving no inferential knowledge), and is able to incorporate new empirical data without having to sacrifice certain existing commitments, precisely because there is no foundation to protect. It therefore takes into account the possibility of any subsequent radical advances in the scientific image. Compare this model with theories of performativity (such as Austin's) where certain special speech acts have the ability to perform a function (e.g., 'I promise you'

38. W. Sellars, 'Meaning as Functional Classification (A Perspective on the Relation of Syntax to Semantics)', *Synthese* 27 (August 1974), 417–37.

or saying 'I do' at a wedding):[39] In Sellars's account *all* expressions have a performative function (although not all the same one), because their currency emerges from the effects that they have in everyday life. At first the trainee (i.e. the child learning a language by copying what others say) learns to conform to the rules without fully understanding them. But eventually the trainee becomes a co-trainer who knows the rules that govern the correct functioning of the language.[40] For Sellars, then, thinking about something is a mode of speaking (and hence is always both social and conceptual), and it is through speaking that we become aware that we are thinking about something. He therefore effectively rejects both the Cartesian distinction between subjective interiority and objective exteriority, and the phenomenological distinction between immediate phenomena and conceptually-mediated contents of thought.

Taking thinking-out-loud as our model for mental acts, which would therefore consist of the linguistic activities of persons, enables us to question the primacy of experience, because we are using as our primary model linguistic objects which are the direct by-products of thinking-in-writing, i.e. inscriptions.[41] Sellars hence suggests that self-knowledge cannot be a matter of

39. See, J. Austin, *How to Do Things with Words* [1962] (Oxford: Oxford University Press, 1976).

40. As Sellars states, 'Only subsequently does the language learner become a full-fledged member of the linguistic community, who thinks thoughts (theoretical and practical) not only about non-linguistic items, but also about linguistic items, i.e., from the point of view of Verbal Behaviorism, about first level thoughts. He has then developed from being the object of training and criticism by others to the stage which he can train and criticize other language users and even himself. Indeed he has now reached the level at which he can formulate new and sophisticated standards in terms of which to reshape his language and develop new modes of thought.' Sellars, 'Meaning as Functional Classification'.

41. Ibid.

simple wordless introspection, but must be advanced through objectifying knowledge, and that this is a conceptual practice that is socially developed through language and inference.

With Sellars we have an account of meaning, consciousness, and experience in which none of these things are absolutised, as they can be in phenomenology. We also have a description of the I/We relationship that in principle is free of sociological and neurological reductionism. For Sellars as for Metzinger, the sense of 'mineness' is not a given, because experiences are not cognitively self-authenticating, just as phenomenal transparency is not epistemic transparency. Both are rather forms of epistemic blindness which produce 'the prejudice that immediacy is not the result of a mediating self-relation', but which can perhaps be collectively overcome.[42]

AWARENESS AND MEDIATION

As we have explored above, traditional Marxist understandings of alienation often seem to place their faith in the possibility of an unalienated condition. And many contemporary understandings of alienation similarly think of communism as its overcoming:

> The concept of alienation encompasses, without dissolving, the concept of economic exploitation, as well as biographical fragmentation, social reification, political subjection, and ideological illusion. While the concept of exploitation enables us to conceive of socialism; alienation constitutes the category par excellence of communism, for which it even supplies a basic definition: communism is both the process and result of supersession of all the

In doing so, these accounts presuppose the possibility of understanding the different mediations in which we are involved, and this inevitably implies having a certain more or less stable conception of the subject, which is after all the thing that needs to be liberated. But the problem is that of how to gain traction upon how conceptual self-consciousness is formed by unconscious social practices. This still requires us to grasp these unconscious practices through conceptual self-consciousness, so how do we get out of this loop of presupposing our own ability to grasp our alienation?

For Sellars, words depict reality because of the matter-of-factual connections that exist between the semantic regularities that speakers obey and the physical patterns of which those semantic regularities are a part.[44] The intentionality of thought is social and therefore derives from the intentionality of public discourse, which means that thought is not the origin of intentionality. Public candid speech is embedded in a community of speakers that have acquired metalinguistic resources through which they are able to talk about talk, thereby generating self-consciousness in regard to the normative rules for the thinking process. This process is linked to what Sellars calls *awareness as*.[45]

43. L. Sève, *To Begin With the Ends*, tr. C. Shames, <https://www.marxists. org/archive/seve/lucien_seve.htm>, 'Introduction: The Trap of the Term "Communism"'.

44. Brassier, 'Nominalism, Naturalism, and Materialism', 114.

45. W. Sellars, 'A Note on Awareness As', Wilfrid S. Sellars Papers, University of Pittsburgh, Box 35, Folder 4, <https://digital.library.pitt.edu/islandora/ object/pitt%3A31735062220151/viewer>.

According to Sellars, in order for a response to some stimulus to be an 'awareness', it 'must be a manifestation of a system of dispositions and propensities by virtue of which the subject constructs maps of itself' and its environment.[46] However, crucially for Sellars, as Brassier writes, '[t]he awareness of something is not the awareness of something *as* something'.[47] Awareness of something *as* a certain type of thing or as having a certain property is conceptual, and therefore requires language. This is not to say that a perceiver cannot be aware (sensory awareness) of red without having language at its disposal, but that a perceiver cannot be aware of it *as* red (cognitive awareness) unless it has at its disposal the *concept* of red, and by implication the collectively-established set of rules of language in which this concept is caught up.

Thus, whereas 'the cartesian is tempted to think that an awareness of a mental state is a direct grasp of its character *as* the specific kind of mental state it is',[48]—what Brassier calls the 'self-intimating' nature of mental states[49]—Sellars points out that we can well be aware of inner phenomena which belong to a certain category, without being aware of them *as* belonging to that category.[50]

A special case of this would be the assumption of phenomenological transparency: that 'the "directness" of an awareness, its *confrontation* with that of which it is the awareness, guarantees [that] [...] the awareness is an awareness of the

46. Ibid., 2.
47. Brassier, 'The Metaphysics of Sensation', 60.
48. Sellars, 'A Note on Awareness As', 13.
49. Brassier, 'The Metaphysics of Sensation', 60.
50. Sellars, 'A Note on Awareness As', 14.

item *as*' the type of item that it is[51]—precisely Zahavi's position as described above. On the contrary, Sellars insists, you can have awarenesses of inner representational states which are not awarenesses of those states *as* representational states (and here we find something similar to Metzinger's 'darkness'). Such an erroneous assumption reiterates the myth of the given because it suggests that concepts are just directly read off awareness-items on a one-to-one basis, without the involvement of any inferential relationships—i.e. without involvement in the complex web of language and its collectively-established rules.[52] The point is that awareness of our mental states *as* something objectively describable can help us to gain traction on the commodification of our own consciousness so that, instead of being able to talk about talk, we would be able to talk about our concrete alienated condition in precise terms. What I propose here is to extend the historically specific understanding of alienation in Marx (as different forms of mediation emerge such as divisions of labour, exchange, wages, and so on) by looking specifically at how we are embedded within these forms of mediation. But in opposition to the claim that we could somehow live an unalienated life, as if there were any possibility of subjectivity without mediation, I propose that, in order to undo the capitalist forms of self-commodification, the subject would need to be produced without any prefigured idea of the self.

However, we have to take into account that the subject is not pure self-consciousness, meaning that the subject cannot be constructed only through conceptual means. Instead of having an ahistorical understanding of alienation, it is necessary to investigate the precise points of *mediation* that are pertinent

51. Ibid., 14–15.

52. Ibid., 16.

for overcoming capitalist determinations. The subject beyond the self would be one which assumes its objectification for its own purposes, rather than for those of capital. It would take hold of the process of alienation, being aware of it *as* alienation, gain agency through it, and by doing so understand how it is specifically determined at each given point; thereby acting upon these points in order to produce its self-determination.

Many Marxist theories of alienation lack a clear concept of subjectivity—or retain traditional concepts of subjectivity that are problematic in light of Metzinger's and Sellars's challenges to the intuitive image of selfhood. On the other hand, pro-alienation theorists neglect the historical specificity of the marxist account of alienation, and put forward a somewhat naive account of technological alienation as positive—simply as a prosthetic vector of agency.

Sellars's approach to the question of agency is particularly helpful for us in providing reasonable (and sobering) expectations for human freedom, while offering a theory that insists upon the malleable potential of the subject. As creatures of concepts, we articulate ourselves through the game of giving and asking for reasons, an attribute that opens up the possibility of our becoming aware of our selves *as*, discerning the different forms of alienation in which we are involved and their interconnection (from the subsumption of our social relations, to the generation of self-models, to the level of sociality achieved through language). This provides us with the pivotal capacity to expose and manipulate the mystificatory self-models in which we are embedded through rational description and inference. Indeed, it is only by rational means that we can understand the extent to which our experience of ourselves is itself undergoing commodification—as we have seen, reliance on primal, given, or supposedly immediate experience may only serve to distort

our own perception of ourselves, or to reinforce the illusory transparency of the self. This awareness of our inner states *as* conditioned and determined, in turn, can only be achieved by opening up our representations of them to the collective scrutiny of concept and language.

ALIENATION AS

Alienation from for the Marxist means a separation from something that capitalism has taken from us, implying that we have a capacity that is being withheld from us. For the accelerationist tendency, meanwhile *alienation from* is understood as an alienation from our previous understandings of ourselves.

Instead, in exploring social dissonance, I want to consider *alienation as* a way to investigate the precise discrepancy between our conception of ourselves and the way in which this conception is produced. *Alienation as* would be an enabling condition for thought and action, because it explores the level of agency that we have, and sets out to gauge the precise room for manoeuvre available to us, something that other understandings of alienation seem to fall short of.

In order to carry out this interrogation we need a powerful integration of theory and practice, and precisely because Sellars's theory is based upon the rules generated through our social interactions, it already contains a critique of individual selfhood within a fusion of theory and practice. However, this needs to be complemented by exploring how these rules are nested within compulsive practices shaped by social forms. According to Sellars, you can question all the beliefs you want, but not all beliefs at once, because then you would not have the tools to question.[53] As in Otto Neurath's image, when you

53. W. Sellars, *Empiricism and the Philosophy of Mind* (Cambridge, MA: Harvard University Press, 1997), 79.

are in a boat, you can replace elements of the boat, but you cannot replace the whole boat at once.

PHANTOM SUBJECTIVITY AS A PART OF NECESSARY FALSE CONSCIOUSNESS

Ultimately, neither Sellars's nor Metzinger's theory takes into account how real abstraction—as the social actuality of abstraction through the subsumption of labour under value—produces abstractions in thought such as the individual, selfhood, the state, and so on. Therefore they cannot provide the full resources for understanding revolutionary subjectivation. Under current conditions our capacity for thinking is embedded within the valorisation process of capital. Here we must therefore turn back to Marx, and in particular to his discussion of the notion of the general intellect, where general social knowledge embodied in fixed capital becomes crucial for production through technology, and shaping social organisation.

What responses, then, can we give to the totalising and reifying powers of capital? Let us consider the most negative perspective on this question. Nobody has gone further than Alfred Sohn-Rethel in describing the way real abstraction in capitalism produces in us what he calls 'necessary false consciousness'.[54] In *Intellectual and Manual Labour: A Critique of*

54. Necessary false consciousness, then, is not faulty consciousness. It is, on the contrary, logically correct, inherently incorrigible consciousness. It is called false, not against its own standards of truth, but as against social existence. Roughly, the Marxist approach to historical reality can be understood as answering the question: what must the existential reality of society be like to necessitate such and such a form of consciousness? Consciousness fit to serve as the theme of enquire of this kind must be socially valid, free from accidental flaws and personal bias. Necessary false consciousness, then, is (1) necessary in the sense of faultless systematic stringency. Necessary false consciousness is (2) necessarily determined genetically. It is necessary by historical causation. This is a truth of existence, not imminently inferable from

Epistemology, Sohn-Rethel takes as a starting point Marx's materialist conception of history from the preface of 1859: 'It is not the consciousness of men that determine their being but, on the contrary, their social being that determines their consciousness'. But Sohn-Rethel takes this thesis a step further, extending the critique of ideology beyond the realms of legal, political, religious, aesthetic, and philosophical thinking to encompass the entire conceptual foundations of our cognitive faculty. For Sohn-Rethel the crucial form of alienation comes from the division of labour that separates head from hand:

> Clearly the division between the labour of head and hand stretches in one form or another throughout the whole history of class society and economic exploitation. It is one of the phenomena of alienation on which exploitation feeds.[55]

The division between intellectual and manual labour, for Sohn-Rethel, emerges with metallurgy, when individual labour became more productive than the communal economy and thus produced a surplus. We then have the emergence of coinage and, according to Sohn-Rethel, when coins are used in the market, the use-value of the coin as metal is estranged and instead 'serv[es] as the generally recognised equivalent of all other commodities and in its value represent[s] quantitative parcels of social labour in the abstract.'[56] This produces a non-empirical

the consciousness concerned. It is the truth specific of materialism. Necessary false consciousness is (3) necessarily false consciousness determined genetically so as to be false by necessity. Its falseness cannot be straightened out by means of logic and conceptual adjustments.' Sohn-Rethel, *Intellectual and Manual Labour*, 197.

55. Ibid., 6.

56. Ibid., 64.

form of abstraction which leads to the formation of non-empirical concepts of pure thought resembling the abstract materiality of money in thought, but without taking into account its social origins. Sohn-Rethel argues that Parmenides's equation of Being with 'the One; that which is' represents a prime example of this. Being, as understood by Parmenides,

> is unchanging through time, fills all space, lacks all properties of sense-perception, is strictly homogeneous and uniform, indivisible, incapable of becoming or of perishing and is for ever at rest (i.e., conforms to the static inertia common to thinking throughout classical antiquity).[57]

This is what has been called the 'Greek miracle',

> the beginning of the conceptual mode of thinking which is ours to this day and which carries the division of intellectual from manual labour that permeates all class societies based upon commodity production.[58]

This type of reasoning generates timeless truths, which are always certain and external to contextual and historical specificities and in doing it so it resembles the resembling the abstract material of money.

In opposition to this, historical materialism generates time-bound truths: 'For Marx, form is time-bound. It originates, dies and changes within time.'[59] Sohn-Rethel thinks nonetheless that these types of Parmenidean ideal truths are a 'necessary

57. Ibid., 67.

58. Ibid.

59. Ibid., 17.

false consciousness' which helped to perpetuate the division of intellectual from manual labour in all class societies. These social abstractions of consciousness are necessary in the sense that they are the glue that holds society together as a social form. Subsequently, as 'social forms develop and change so also does the synthesis which holds together the multiplicity of links operating men according to the division of labour.' This coherent framework is what Sohn-Rethel calls social synthesis.[60]

Parmenides's concept of the One would could be seen as an ultimate form of reification—or 'identity thinking', as Adorno would have it—it makes thinking and the thought that 'it is' one and the same, meaning that Parmenides is a precursor to Hegel's conceptual ontologism.

Sohn-Rethel's main argument is that there is an ultimate identity between the formal elements of the social synthesis and the formal constituents of cognition. He argues that what Kant called the transcendental unity of self-consciousness is an intellectual reflection of the exchangeability of commodities which underlies the unity of money and of the social synthesis:

> I define the Kantian 'transcendental subject' as a fetish concept
> of the capital function of money. As it assumes representation
> as the *ego cogito* of Descartes or of the 'subject of cognition'
> of philosophical epistemology, the false consciousness of intel-
> lectual labour reaches its culmination; the formation of thinking
> which in every respects merits the term 'social' presents itself
> as the diametrical opposite to society, the EGO of which there
> cannot be another.[61]

60. Ibid., 5.
61. Ibid., 77.

If we take seriously this proposition of Sohn-Rethel's, then it is difficult to find the conceptual tools that could aid us in investigating the interrelation between alienation from below and alienation from above, for conceptualisation itself is already tainted by the value-form.

Adorno would no doubt have criticised Sohn-Rethel's stark opposition between the concrete and use value on the one side and abstraction on the other side as a form of mythologising. For Adorno this is not a proper way of understanding the relationship between first Nature (concrete and use value) and second nature (abstraction). Instead, Adorno claims that nature and society are interpenetrated by the reality of the exchange abstraction, which is neither objective nor subjective. Just as Sellars argues that we cannot perceive without conceptualisation, Adorno argues that we cannot access first nature (for example, use value) from within the second nature capitalism has installed in us. Our access in present conditions is always tainted by the exchange abstraction.

Exchange abstractions mediate the interrelation between society and nature, but at the same time the exchange relation is mediated by the class relation. The class relation is integral to capitalist reproduction, placing the capitalist and the labourers in confrontation, yet it also reminds us of the violence of original accumulation. Brassier points out how this is the key to the difference between Sohn-Rethel and Adorno:

> The dialectic of identity and non-identity is rooted in this non-equivalence both within exchange as such and between the logic of exchange and the reality of the class relation. The first points to the non-equivalence of concrete and abstract labour time as source of surplus value; the second to the class antagonism upon which the logic of exchange depends. But, unlike his friend

Alfred Sohn-Rethel, Adorno does not oppose the concretion of use to the abstraction of exchange as first to second nature.[62]

To believe that we can access first nature, the concrete, or use value, from our second-nature perspective without taking into account the mediation of the exchange relation is to dehistoricise, to naturalise the latter.[63] We can see in what Adorno calls 'identity thinking' a form of reification that occurs in relation to the subject that thinks itself capable of securing its own autonomy by severing itself from the object, without taking into account the interpenetration mentioned above:

> What Adorno calls 'identity thinking' is the thinking that tries to secure its own autonomy by subjectifying the object and objectifying the subject. In so doing, it subjects itself to a mythified unity, thereby prolonging nature's fatal spell.[64]

If our self-understanding is conceptually mediated, meaning that (as we saw with Sellars) it is also socially mediated, then we have here another, deeper form of mediation at the level of our self-reproduction, a mediation that affects and distorts our relationship to nature and society.

Sellars here provides us with some of the resources we need to get traction on consciousness: because the functional classification of meaning is embedded in social practices, it counters the division of head and hand that Sohn-Rethel claims is presupposed by all thought and signification. Moreover, Sellars

62. R. Brassier, 'Adorno: The Affinity of Fatality and Freedom', lecture presented at the workshop 'Critical Theory and Psychoanalysis', American University in Cairo, 13–14 September 2019.

63. Ibid.

64. Ibid.

provides us with the conceptual resources we need to incorporate and work through the transformation in self-understanding precipitated by contemporary neuroscience, which offers us the possibility to counter some of the assumptions about how we can conceive of ourselves, and in doing so offers a potential critique of Sohn-Rethel's fatalism. The adaptability of Sellars's methodological materialism can allow for both: it helps us to understand how we are constituted by the value-form, but also holds open the possibility that we may have the resources to do something about it, even if this means engaging in generating a new understanding of subjectivity.

THERE IS NO FREEDOM
IN A NORMATIVE VACUUM

We are now in a better position to understand how social dissonance requires two levels of opaqueness or darkness: one that occurs in social reproduction, where it mediates our relation to nature to each other and our cognitive ability by producing what appear to be natural and transhistorical concepts such as the individual, labour, freedom, and society. And then an inner form of darkness in regard to the transparency of the self-model, where 'the representational character of the contents of self-consciousness is not accessible to subjective experience'.[65] The self becomes a distorted mirror image of the commodity in so far as it becomes quantifiable, with an appearance of autonomy. Social dissonance can be seen as the result of this intersection between suprapersonal mechanisms (ideology) and subpersonal mechanisms (neurobiology).

Phantom subjectivity presupposes that there is something inherent to the experience of selfhood that cannot be objectified.

65. Metzinger, *Being No One*, 330.

In doing so, it can easily fall into the myth of the given by not taking into account how this experience is inevitably embedded in social and conceptual mediation. But if experience is mediated by conceptual mediation, conceptual mediation is itself mediated by the exchange relation. Metzinger and Sellars together allow us to undermine the foundational belief that there is something unobjectifiable in selfhood, something private which provides a sense of ownership in regard to experience.

Phantom subjectivity, a form of fetishism and mystification, is not just a misrecognition attributable to our consciousness, it is an objective reality in so far as it emerges, like commodity production, from the social actuality of abstraction (through the subsumption of labour-power under capital, real abstraction is produced when concrete particular qualities of a given activity become abstract labour exchangeable and quantifiable in relation to the social totality). Even if some of the pathologies mentioned above emerge from dysfunctions of the brain, the way in which we understand them and their pathological character in relation to normative behaviour is socially determined. If the problem is to gain traction upon how conceptual self-consciousness is formed by unconscious social practices, this still requires us to grasp these unconscious practices through conceptual self-consciousness. There is no freedom in a normative vacuum, since freedom is a cultural achievement. Therefore we need to understand how the normative realm is produced, but also how the game of giving and asking for reasons is itself shaped by levels of unfreedom that are not apparent to us.

*

The relationship between alienation from above and alienation from below is extremely complex, and tackling it requires a broad level of analysis in regard to class, economics, and the social, philosophical, and neurocomputational domains. But my specific claim here is that it also requires practical and externalising engagement with these two forms of alienation through what we call *externalising alienation* (the subject of the next chapter). In order to understand the interconnections between these two forms of alienation we need not only conceptual means, which are themselves subject to reifying processes which in turn are implicated within the class relation, but also practical means.

As opposed to those theorisations of alienation that promise, sooner or later, to lead us directly to freedom, the modest claim here is that the resources brought together in this chapter, along with those discussed in Chapter 1, as limited as they may be, give us the means to grapple with our alienation—or rather, to *play* it, to at least hit it, allow it to resonate, and discover the effects its noise has upon us. By exploring alienation from above and below in this externalising way, by performing social dissonance, we can better understand our unfreedom.

3

EXTERNALISING
ALIENATION

> The purpose of art is to impart the sensation of things as they
> are perceived and not as they are known. The technique of art is
> to make objects 'unfamiliar', to make forms difficult, to increase
> the difficulty and length of perception because the process of
> perception is an aesthetic end in itself and must be prolonged.
> Art is a way of experiencing the artfulness of an object; the
> object is not important.
>
> Viktor Shklovsky[1]

The traditional role of alienation in aesthetics has been to chal-
lenge preconceptions. Directly connected to the avant-garde
and to modernism, it has been employed to disrupt assumptions
in regard to form, autonomy and the subject of reception. My
claim here is that a reconsidered use of alienation in aesthetics
can serve to expose certain problematics in which our senses
and our self-conceptions are articulated with the structural
determinations produced by capitalist relations. In doing so,
will allow us to investigate the complex relationship between
spectral objectivity and phantom subjectivity. The previous
chapter introduced 'externalising alienation' as a term for this
exploration into the ways in which alienation from above and
alienation from below relate to each other. 'Externalising' here
means confronting social dissonance, i.e. the consequences
of previous forms of alienation, with the understanding that
their effects are part of a historical process, and that enter-
ing into social dissonance is an irreversible process because it
involves leaving behind established conceptions of internality
and selfhood.

1. V. Shklovsky, 'Art as Technique' [1916], in L.T. Lemon and M.J. Reis (eds.),
Russian Formalist Criticism: Four Essays (Lincoln, NE: University of Nebraska
Press, 1965), 12.

This chapter revisits two of the most powerful uses of alienation in aesthetics, Viktor Shklovsky's *Ostranenie* and Bertolt Brecht's *Verfremdungseffekt*, in order to learn from them and try to update them taking into account the findings from the previous chapters. As we shall see, these inherited concepts and practices of noise and improvisation can help a great deal in developing a practice of externalising alienation.

Applying the techniques of *Ostranenie* and *Verfremdungseffekt* directly to ourselves as constructed subjects can help us to better understand the complex relationship between alienation from above and alienation from below. By confronting alienation in an externalising way, we are dealing inevitably with some of the foundations that produce social dissonance. In doing so, we are questioning the individual as subject. As there is no proper way back to a stable liberal concept of the subject, this externalisation takes an active role in exploring the limitations of what a subject could be under current conditions.

NOISE AS DEVICE

The history of noise has seen riots, scandals, misunderstandings, excitement, and misconceptions. If noise still has some potential today, then where does it lie? 'Noise' is a very diffuse term, but also names a sonic practice with a particular history, situated within a specific tradition.

What first attracted me to noise was the possibility of pushing the limits of what was acceptable—sonically, culturally, conceptually, and socially. But noise is not always disruptive. In order to be disruptive, it needs to enter into a negative encounter with a set of expectations—and once the tropes of noise have been understood and absorbed, its critical negative effect quickly dwindles. In order to identify what potential noise—as musical practice—may still hold for producing alienation and

estrangement, I will first address it through Russian Formalist Viktor Shklovsky's concept of *Ostranenie* ('making strange', estrangement, or defamiliarisation), in so doing arguing that noise needs to be understood both historically and contextually.

A Roughening of the Surface

The Russian Formalists, a group which, along with Viktor Shklovsky (1893–1984) also included Boris Eichenbaum, Roman Jakobson, and Yuri Tynianov, were interested in breaking artworks down into tropes, mechanisms, or devices (*priem*). Rather than adopting a metaphysical or traditional psychological or cultural-historical approach, they sought to analyse the functional role of literary devices in order to study 'literariness' or 'artfulness' in a quasi-scientific way. Since, for Shklovsky, '[t]he artwork is the sum of its techniques', for him the structural dance of literary devices is just as arbitrary and impersonal as the moves of chess pieces.[2] Shklovsky identified the literary device he called *Ostranenie*—meaning both a displacement or pushing-aside and a making-strange—as having the potential to 'roughen the surface' of reality so as to defamiliarise automated perception through decontextualisation and defamiliarisation. In his 1916 essay 'Art as Device' (sometimes translated as 'Art as Technique'), he takes an example of *Ostranenie* from a moment in Tolstoy's *Kholstomer*, where the narrator is a horse puzzled by the belief of humans in the system of property, and the lack of coherence between what they say and their actual deeds. The passage is worth quoting at length (as Shklovsky does):

> But even then I simply could not see what it meant when they called me 'man's property.' The words 'my horse' referred to me, a living horse, and seemed as strange to me as the words 'my

2. Ibid.

land,' 'my air,' 'my water.' But the words made a strong impression on me. I thought about them constantly, and only after the most diverse experiences with people did I understand, finally, what they meant. They meant this: In life people are guided by words, not by deeds. It's not so much they love the possibility of doing or not doing something as it is the possibility of speaking with words, agreed on among themselves, about various topics. Such are the words 'my' and 'mine', which they apply to different things, creatures, objects, and even to land, people and horses. They agree that only one may say 'mine' about this, that or the other thing. And the other who says 'mine' about the greatest number of things is, according to the game which they've agreed to among themselves, the one they consider the most happy. I don't know the point of all this, but it's true. For a long time I tried to explain it to myself in terms of some kind of real gain, but I had to reject that explanation because it was wrong. Many of those, for instance, who called me their own never rode on me— although others did. And so with those who fed me. Then again, the coachman, the veterinarians, and the outsiders in general treated me kindly, yet those who called me their own did not. In due time, having widened the scope of my observations, I satisfied myself that the notions 'my,' not only in relation to us horses, has no other basis than a narrow human instinct which is called a sense of or right to private property. A man says 'this house is mine' and never lives in it; he only worries about its construction and upkeep. A merchant says 'my shop,' 'my dry goods shop,' for instance, and does not even wear clothes made from the better cloth he keeps in his own shop. There are people who call a tract of land their own, but they never set eyes on it and never take a stroll on it. There are people who call others their own, yet never see them. And the whole relationship between them is that these

so-called 'owners' treat the others unjustly [...] And people strive
not for the good in life, but for goods they can call their own.[3]

The displacement of the narrative voice into the perspective of
the horse makes us see reality differently, in a way that breaks
the smoothness of the appearance of reality and reveals the
cruel reality of those who cannot express themselves.

Can noise also produce this 'roughening of the surface'?
Historically, this is indeed what noise has done: disturbing the
order of things, making us aware that those things that we
took as stable, those things that we took for granted, contain
elements which, in fact, we cannot decipher. In a similar way to
Shklovsky's *Ostranenie,* noise forces perception not because
it 'incorporates the sensation of things as they are perceived',[4]
but because we don't have the proper capacity to deal with it:
it produces a mismatch between cognition and sensation. We
sense something that we cannot yet process. This is a ques-
tion not only of sensibility, but of a deficit of conceptual cat-
egories with which to handle the experience. Noise can help
us to understand there is something deficient, or admit the
inadequacy of our tools to deal with reality. In this regard noise
can bring us, or our senses, closer to reality and to the impos-
sibility of ascribing meaning to reality. But this should not lead
us to fetishise indeterminacy, something that often happens
in contemporary art, free improvisation, and the noise scene.[5]
For the arrival of the appropriate categories is only a matter of
time. This is why noise, in some regards, is the most abstract
yet the most concrete of cultural expressions. On the one hand

3. Ibid., 15.

4. Ibid., 13.

5. On this point see Wilkins, *Irreversible Noise.*

it is abstract because, in the attempt to resolve it, it constantly forces material and cognitive complexity to reach another level which has not yet been explored. Yet it is concrete because its specificity has to do with the unacknowledged residue, in terms of information and complexity, that surfaces in a given send-receiver situation.

Furthermore, in this sense noise does not only pose problems for sound practices, or in the artistic field. It is an unavoidable problem for cognition in general:

> [The] correlation between noise and cognition, between noise as distortion of information and noise as a factor of the distortion of cognition, emerges as an important aspect of the conceptualization of noise. Any philosophical enquiry into rationality, human agency and collective self-determination must therefore arrive at an understanding also of the state of indecision and confusion associated with noise—a state to which information and knowledge are temporary and always fragile solutions. Any epistemological enquiry into the nature of knowledge, finally, must contend with the role of noise as lived ambiguity, indecision and error.[6]

With this in mind, what would it mean to claim the possibility of using noise as a device? It would mean incorporating and appropriating the very deciphering of noise into this device—it would mean accepting that noise never remains noise for long. While Shklovsky sought to prolong the 'artfulness' of the object as much as possible and, in doing so, to expand the frontiers of aesthetic experience, I propose that highlighting the process of the deciphering of noise could be a way to socialise its estrangement effect. Inevitably, this would mean the disappearance of

6. Malaspina, *An Epistemology of Noise*, 168.

the immediate experience of estrangement for the time being, but it would also allow us to explore how our social, cognitive, and sensory capacities work at resolving such experience. We could then apply the conceptual problems posed by noise to social relations as a way to develop further techniques or devices.

Why not simply follow Shklovsky in trying to expand aesthetic experience through the 'roughening' effects of noise? Because both 'aesthetic' and 'experience' are problematic terms that should not be taken for granted, especially from the point of view of a historical understanding of subjectivity (and its strong correlation with the notion of the individual). Brassier makes an excellent point regarding the refusal to subordinate the potential of noise to 'aesthetics':

> I am very wary of 'aesthetics': the term is contaminated by notions of 'experience' that I find deeply problematic. I have no philosophy of art worth speaking of. This is not to dismiss art's relevance for philosophy—far from it—but merely to express reservations about the kind of philosophical aestheticism which seems to want to hold up 'aesthetic experience' as a new sort of cognitive paradigm wherein the Modern (post-Cartesian) 'rift' between knowing and feeling would be overcome. In this regard, I would say that there can be no 'aesthetics of noise', because noise as I understand it would be the destitution of the aesthetic, specifically in its post-Kantian, transcendental register. Noise exacerbates the rift between knowing and feeling by splitting experience, forcing conception against sensation. [...] [In] 'nemo-centrism' [...] the objectification of experience would generate self-less subjects that understand themselves to be no-one and

nowhere. This casts an interesting new light on the possibility of a 'communist' subjectivity.[7]

In a recent conversation Brassier clarified that the rift between knowing and feeling cannot be regarded as eternal, but is revealing in so far as it is socially symptomatic—not of our estrangement from some originary integration of knowing and feeling, but of a social contradiction whose overcoming is indissociable from a revolutionary transformation that would re-articulate them.[8] Below I will argue that noise, in practice, can often produce this rift, and that in doing so it comes close to Shklovsky's insight when he claimed: 'I am studying the unfreedom of the writer'.[9] From our perspective, the best thing that noise can do is to question the constraints of what we consider to be freedom, and how it relates to what we understand as the production of subjectivity. To roughen the surface means to scratch beneath the surface of phantom subjectivity, in so far as it involves driving perception to deal with the limits of our cognitive capacity and, in doing so, reveals the fragility of that subjectivity.

Criticisms of Shklovsky: Noise as a Corrective

In *The Prison-House of Language*, Fredric Jameson criticises Shklovsky's notion of *Ostranenie* on three connected grounds: (1) Shklovsky's notion of *Ostranenie* is ahistorical; (2) For Shklovsky's theory to makes sense he needs to isolate the material that he is working with, thus allowing us not to see it as a text (in the Barthesian sense) i.e. not being able to take the context

7. Brassier and Ieven, 'Against an Aesthetics of Noise'.

8. Ray Brassier, private communication, 13 February 2020.

9. Shklovsky, 'Art as Technique', 8–9.

into account; (3) One is unsure whether *Ostranenie* resides in the form, the content, or the perceiver.[10]

As a corrective to these shortcomings in Shklovsky's position, Jameson finds in Brecht an updated historical understanding and use of the estrangement effect:

> The effect of habituation is to make us believe in eternity of the present, to strengthen us in the feeling that the things and events among which we live are somehow 'natural,' which is to say permanent. The purpose of the Brechtian estrangement-effect is therefore a political one in the most thoroughgoing sense of the word; it is as Brecht insisted over and over, to make you aware that the objects and institutions you thought to be natural were only historical: the result of change, they themselves henceforth in their turn became changeable. (The spirit of Marx, the influence of the *Theses on Feuerbach*, is clear.)[11]

Noise can contribute to the overcoming of these critiques of *Ostranenie*, because of the complexity and specificity of noise addressed above: noise cuts at the joint between indecipherability and cognition, and this site-specificity means that the question 'What is noise?' can only be answered historically and contextually, and our answer will always fall short because we will never be able to completely decipher certain aspects of noise. Having said that, noise's perturbation effect is specific in relation to a system, and as soon as it stops perturbing the system, it ceases to be noise.[12] Perturbing the system in this

10. F. Jameson, *The Prison-House of Language* (Princeton, NJ: Princeton University Press, 1972), 47.

11. Ibid., 58.

12. M. Prado Casanova, 'Noise and Morphogenesis: Uncertainty, Randomness and Control', PhD thesis, University of the West of England, 2021, 175.

case means disrupting what we take to be, our self-conception and exposing—in however small a way—the complexity of the reality that we are part of. Similarly, noise exposes and calls into question processes of individuation because it is simultaneously outside and inside the frame of the individual, pushing its margins back and forth. In fact noise constantly undermines its own framing, as Prado describes: 'What noise interferes in is the assumption of closed autonomy or independence within a system.'[13] Examples of 'noise' can never be encompassed as individual experiences, since noise undermines the autonomy of our individual understanding and experience of a situation. So long as the estrangement effect is still taking place, so long as there is still some noise, this means that our conceptual understanding is not fully able to grasp what it is being asked to process, meaning that it is difficult to individuate something precisely. As Malaspina writes,

> [n]oise, beyond the reference to unwanted sound, thus reveals itself to be conceptually polymorphous because it has never been about types, classes or measures of phenomena that qualify noise as a particular type of disturbance, but about the relation between contingency and control. Contingency and control, especially loss of control, means that in various domains of theoretical investigation and practical application, very different types of phenomena are at stake.[14]

Historically in the West, noise has often been set aside, but in various ways it actually subsists within Western music, even

13. M. Prado, 'Schelling's Positive Account of Noise: On the Problem of Entropy, Negentropy and Anti-entropy', unpublished paper, 2015.

14. Malaspina, *An Epistemology of Noise*, 222.

in its most fundamental element, the tone: Ulrich Krieger explains how 'the tones that we actually hear contain some noise because a mathematically perfect tone would actually sound strange to our ears'.[15] Finally, on the issue of whether, in the case of noise, estrangement takes place in the form, content, or perceiver, for Miguel Prado noise is both subjective and objective: subjective because it is constructive of perception and objective because nature produces intrinsic and irreducible forms of chance in any process. According to Prado, 'noise is posited as an intractable active ontological randomness that limits the scope of determinism and that goes beyond unpredictability in any epistemological sense due to the insuperability of the situation in which epistemology finds itself following the critique of the given.'[16]

Tension Without Release

Within the context that I deal with in *Social Dissonance*, this allows me to focus not necessarily on sound but on the general sense of a 'material' that perturbs how we understand ourselves in a concert. In this sense, noise could include non-phenomenal elements such as the expectations and projections of those involved and the general atmosphere that may be produced.

How do we know when noise is producing the estrangement effect? In concert situations we can perceive the estrangement effect when there is some tension in the atmosphere. This tension is produced because there is a set of expectations that are not being met. At the same time, people project their own assumptions and meanings onto what is going on,

15. U. Krieger, 'Noise—A Definition', presentation at the conference *Noise and the Possibility of the Future*, Los Angeles, 6–7 March 2015.

16. Prado Casanova, 'Noise and Morphogenesis'.

but without having any clear identifiable referents. There is confusion, but at the same time there is concentration and a continual attempt at resolution.

However, this is only the first layer of estrangement, which takes place at the experiential level. The deeper level of aliena-tion, the *externalising alienation* evoked above, cannot be directly perceived in full at the individual level. The experience of unease or disturbance is required to render estrangement perceptible and cognitively accessible, then, but it is not itself estrangement: it is more like the *estrangement of estrange-ment* as condition of de-estrangement. This is the function of externalising alienation. If there is tension (because noise is producing this critical potential or, even further, is calling into question our tools for criticality), this is because the safety mechanisms that allow us to 'get it' are not working. Different logics are in play. As such, different participants will think dif-ferently about what is going on, since by definition there is no possible consensus that can be used to describe the situation of noise. Even if some might be able to extract and understand something out of this confusion, they cannot have a full picture in so far as a strange openness injects unpredictable elements which displace and push aside certain expectations. It is impor-tant to note that this tension disallows the type of total subjec-tive experience sometimes referred to by noise practitioners and audiences: you can't just 'immerse yourself' in what you are perceiving, because there is a friction between the reality that you experience and your efforts to cognitively address it.

In my own practice of improvising with the concert situation, I observe that social interaction occurs easily if the performers don't use instruments. Instead, through generic gestures avail-able to all, such as speech or movements in the space, I have found that it is possible to generate unprecedented reactions

from both audience and performers. It's no longer a matter of an interaction anticipated by a musician or director beforehand (as in Brecht's case), but of elements put in place in order to generate the unexpected: in order to produce a tension in everybody involved, including the performers themselves, thus prompting them to address the situation consciously.

The precondition for producing tension is a suspension of the contract and consensual presupposition between audience and performer. If this tension occurs, we do not relate to each other according to the terms of this consensus, because the elements necessary to constitute it have been removed. In this sense, the situation *ungrounds* itself. It forces everyone involved to think, without their having a totally prescribed role or task, and in this process a collective self-consciousness emerges. We lose the ability to relate either to ourselves or to each other as established selves or liberal individuals, and this forces participants to think about their relations to one another without prefiguration—no longer the impoverished sociality of the consumer nor that of the emancipated spectator, but a suspension of clear-cut roles, where people become able to experience and explore their own conditioning, their unfreedom. This, then, is what I refer to as externalising alienation: producing estrangement while simultaneously incorporating the process of decipherment of what is strange into the experience of noise. This inevitably goes beyond a mere aesthetic experience, because it undermines certain assumptions of what experience as such is, and what you are as a receiver of aesthetic experience.

While Brecht would have it that the contradictions staged in the drama reflect those of capitalism, here what is brought onto the 'stage' is the social dissonance that emerges out of the contradictions in our self-understanding which are themselves

a result from our engagement in capitalist relations. Confusion permeates this self-understanding, and participants are welcome to share this confusion, which is not part of a drama but fully a part of real life. Then we can together understand better how these contradictions are reflected at the level of capitalist totality. Your role as auditor cannot be taken for granted, and to this extent capitalist socialisation is undermined: you are not just consuming something—you are a *part* of it. Through enforced participation, where you are not consulted in advance, you are reminded that you are not a sovereign individual, that you do not have a choice to remain neutral, that you're not free.

This experience stands in contrast to our lives in the money economy where you are always 'free' to negotiate your situation in capital—but only in proportion to your economic power. As Marx shows us, the condition of my freedom is the condition of everyone's freedom. Under capitalism, instead, my freedom seems instead to be purchased at the expense of others. My ability to consume comes at the cost of others being obliged to produce goods under terrible circumstances.

Of course, this systemic alienation cannot be negated just by discursive participation or by making noise together. The structural and systemic exploitation present in the contemporary world means there is no possibility for a kind of immediate negation within the whole network of mediations, and there is no immediate negation of mediation as such. And yet the promise and expectation of such negation is something endemic to noise practices. *False immediacy has been too present in noise and in free improvisation.* In order to question this immediacy, we first need to think about the conditions of our experience, not as indeterminate thinking but as determinate thinking, and in doing so, unmask the modernist 'shock of the new'. Secondly, we need to analyse the specific presuppositions of the concert

frame in order to find a specific point to focus on, and noise can be this focus because it is precisely that which we have no control over—that which calls the conditions of experience into question: 'What am I witnessing?' 'How do I behave, given the suspension of the audience-performer relation?' 'How do we relate to each other once we are no longer passively consuming?'. Thirdly and finally, we need to interconnect the first two points and strive to move beyond the concert frame, toward the capitalist social relation.

Leaving the House of Safety

In the concerts that I have been involved in where this kind of tension is produced, I have seen some reassure themselves of their individual agency through some kind of reassertion of themselves. In some cases they try to reconcile themselves with the experience by treating it as a prank or a joke, reestablishing normality as if they cannot even tolerate having to think about what is happening and why it is happening. In my experience, when tension is produced it can go in two directions: (1) People reassert themselves, their knowledge and their authority, pretending to be clever by making a joke or behaving as if they have seen it all before. This attitude tends to kill the tension. (2) People follow the tension. When this happens, a certain honesty emerges in which individual contributions become part of a collective rational agency engaged with trying to make sense of the situation, on the understanding that there is some undecipherable noise going on.

Usually, both of these responses are present at once to some degree, and the interaction between them generates a meta-tension which we could say is in itself unexpected and unusual, and which in turn generates an additional sense of estrangement among the participants where nobody feels

really reassured, but sometimes there is enough trust to feel encouraged to share doubts and insecurities.

Certain techniques can help increase tension and estrangement, including: spiking space (organising the furniture in unconventional ways), introducing a 'human sampler' (sampling and repeating things that have been said in the space), glitching the voice (malfunctioning discourse), anti-social realism (collapsing the impotence of changing the social conventions in the performance space onto the impotence to change reality in the general sense), ungrounding the situation (tearing apart these social conventions), going fragile (sharing deep insecurities and doubts), and daring together (doing the ungrounding collectively).[17] For example, at the last performance at the festival *Kill Your Timid Notion* produced by Arika in Dundee in 28 February 2010, I performed a concert called *Unstable, Fragile but Daring Together* with Emma Hedditch, Howard Slater, Anthony Iles, Liam Casey, and Laurie Pitt. For this concert we had set up the space without a stage and with no clear or specific viewpoint. We had a microphone each, and we had built what we called the 'House of Safety'—a space where we could go if the atmosphere became too dense, overwhelming, or intense. We began by talking about our thoughts and feelings at that moment, thinking out loud, and slowly the audience began to interact, reflecting on the aspects of this situation that were unclear. In particular, one woman said that it was the first time that she had spoken in public, and was trying to work out what this was about. At some point, one of us had to go into the House of Safety because the dense atmosphere became too much. After a few minutes, a member of the audience asked

17. For a list of these and other techniques as used in the *Social Dissonance* score, see the Score, below.

why this person was in the House of Safety. The other members explained, and at some point members of the audience started to shout his name as a sign of encouragement to come out. After a while this person left the House of Safety, the audience clapped him for doing so, and he raised his fist in the air, as if making the most heroic anti-gesture possible. The absurdity of the situation stayed with me for ages, simply because of the way one of the participants exposed their own fragility, and the spontaneous collective support of the audience—something that does not often happen in real life. And of course because, as noise, the experience was not easily recognisable.

For some people this was relaxing, for others it was like being inside a pressure cooker; some mentioned that it seemed like a therapy session. For Barry Esson, one of the organisers, it was a noise concert:

> It produced a Noise concert. In that it engendered a sense of peril—people were genuinely nervous, hesitant and affected by the situation, and made uneasy by it (which is to say that a self-created situation obliged them to act in ways that put them at risk); the group presented something within a specific context (a music festival, to which people had paid to come, with certain expectations—for entertainment, for provocation, who knows...) which was in stark contrast to what was expected and which focused on the all too often overlooked and unwanted remainder of music today—its foundational ideology, its social mechanics, its relationship to its situation. It took the force of thought of Noise seriously, and applied it afresh.[18]

18. B. Esson, 'A Simple but Complicated Being Together', in Mattin and A. Iles (eds.), *Unconstituted Praxis* (A Coruña: CAC Brétigny/Taumaturgia, 2012). In this text Esson also explains the concept of *force of thought*, taken from the work of philosopher François Laruelle: 'The point at which Noise is boiled

The concert generated tension. And once we have identified that there is tension, then we try to gauge its critical potential. Even considered in its purely sonic varieties, noise can be transformative precisely because it makes you connect to other aspects of reality that are not necessarily sonic. In doing so, the historical specificity of this particular situation comes to the fore. It is in the socialisation process of this deciphering that I see the potential of noise understood as a device.

Three Levels of Awareness

There are three levels at which we can gauge the awareness that noise can produce: *awareness*, *awareness as*, and *awareness through*.[19]

(1) *Awareness*. The most phenomenological approach to noise, this would be noise understood as an absolute immersion in sound required of the listener. It's not surprising that those who adopt this approach often implicitly endorse a very strong individualism, as is the case, for example, with Francisco Lopez[20] or VOMIR. In fact, this connection between noise as absolute autonomy and individualist politics is clear in VOMIR's *NOISE WALL MANIFESTO*: The individual no longer has any alternative but to completely reject contemporary life as promoted and

down to a radical core concept; the unique point at which it meets and offers something to reality.'

19. This triadic understanding of the potential of noise comes from a conversation with Ray Brassier in May 2015.

20. As can be gathered from his bio, where he describes what he is trying to produce as 'transcendental listening, freed from the imperatives of knowledge and open to sensory and spiritual expansion'. F. Lopez, 'Biography', <http://www.franciscolopez.net/>.

preached. The only free behaviour that remains resides in noise, withdrawal, and a refusal to capitulate to manipulation, socialisation, and entertainment.[21] This approach is the most problematic precisely because it is the most aestheticised, and implies the agency of the individual based on what we have defined as phantom subjectivity.

(2) *Awareness as*. In the second type of awareness, the context is taken into account: you have a map of the context in which you can situate yourself as a constructed self. This already provides a sense of distance, removing the audience from a total immersion in sound. A couple of examples come to mind here: Firstly, Cage's *4'33"*: even though Cage wants to deal with sounds just as sounds in themselves, the piece functions to makes the audience question what music is, and disrupts traditional value judgments; the audience has to question themselves and their roles (are they producers or/and perceivers of sound?). Secondly, the extreme vocals of Junko, which sonically trigger the most disturbing imaginary situations, like somebody being tortured in the most horrific way, while her delivery is as neutral as can be, avoiding all of the clichés of noise—overt aggression, references to serial killers or concentration camps, or shows of pure expression presented as acts of freedom. Junko's work produces a rift between knowing and feeling because it makes it impossible to reconcile your cognitive abilities to deal with how it makes you feel. The noise involved in such cases no longer relates just to sound, but involves other aspects

21. VOMIR, 'HNW MANIFESTO', <http://www.reclusoir.com/vomir-hnw-manifesto/>.

that have to do with the context, the historical reception of the material, and our conditioned abilities to deal with it.

(3) *Awareness through*. This last level is the most transformative, because it makes you reconsider your relationship not only with the context, but with the mechanisms you have at your disposal in order to deal with what is happening and connect it to a wider social context—and also the social forms and dynamics that mediate those available mechanisms, i.e. those described by Marx, but also those described by Sellars and Metzinger. Inevitably, this would not just be about aesthetic experience, but about questioning in practice what experience is and how it is produced; but more importantly, how the subject of experience is produced. It would not only force conception against sensation (as in the case of Junko), but would also force a process of objectification in which you would have to see yourself from a third-person point of view, because the means to feel and see yourself as an individual are being undermined. For example, your status as an audience member or performer is not totally given, and therefore previously established positions give way to conditions that are not yet describable—but without falling into the fetishism of the singularity of a unique experience.

By exposing the objectification of the social subject of class antagonism necessary for understanding how selfhood has been established, another form of objectification appears, along with possible new forms of sociability. This would be a depersonalisation which subjectivates in terms of class.[22] The socialisation of

22. Ray Brassier, private conversation, 6 July 2020. See also Lukács, 'Antinomies of Bourgeois Thought', in *History and Class Consciousness*.

noise-as-device can help generate the externalising alienation necessary to expose the complex relation between alienation from above and alienation from below.

Why is it important to try to socialise the estrangement effect of noise in this way? Here we must take into account that in the contemporary world both formalist and noise strategies are being recuperated for pernicious purposes. Anthony Iles discusses how, in order to 'encourage' the cognitive 'development' of students and promote better information acquisition, the UK government has used some of the techniques developed by the Russian formalists in order to improve their adaptive capacity:

> The recent reforms of Higher and Primary Education in the United Kingdom have implemented [...] a 'formal aesthetics of behavioral psychology'—a troubling rearming and deployment of formalist techniques to the ends of producing an automatic subject appropriate to crisis capitalism's instrumental needs.[23]

Noise is also now being used in the battlefield, in torture, and in cities to disperse demonstrations. James Parker describes how the use of sonic cannons such as the LRAD 500X-RE (the model that appears to have been present at the 2014 Ferguson unrest, but has also been used in Gaza and elsewhere) slips through juridical loopholes—very helpfully for governments, as they cannot be held responsible for the damage caused, given that there is no physical impact which can be proven to have caused it. In another perverse example of recuperation, as Parker reports, the band Skinny Puppy is trying stop the

23. A. Iles, 'Studying Unfreedom: Viktor Shklovsky's Critique of the Political Economy of Art', *Rab-Rab Journal for Political and Formal Inquiries in Art* B:2 (2015), 72, 74.

US Government from using their music for torture.[24] These examples are of course only the most perverse forms of the negative critical potential of noise. However, my argument here is that there is a negative critical potential in noise which can push our thinking and our perception to points where we no longer know what 'our' means. This approach to noise moves against the absolutisation of experience as a reservoir for agency. To enable this, a socialisation of the alienating effects of noise through collective rational understanding would be necessary. To use noise as a device would be to use its alienating potential to produce strange experiences that make us question ourselves as subjects. Inversely, anything that reaffirms you as subject ('I get it', 'I like it', or even 'I hate it') would not be noise-as-device. Noise-as-device is to be contrasted with noise-as-taste, which cannot expand beyond the mere 'experiencing self' and the first form of awareness described above. The important thing here is to identify whether noise has an estrangement effect—and at the point where it ceases to have this alienating effect, to recharge its critical negative potential constantly so as to prevent it becoming a parody of itself in the worst sense.

IMPROVISATION AFTER BRECHT

In setting up new artistic principles and working out new methods of representation we must start with the compelling demands of a changing epoch; the necessity and the possibility of remodelling

24. J. Parker, 'Towards a Jurisprudence of Sonic Warfare', presentation at *Liquid Architecture* festival, Melbourne, 11 September 2014. Thanks to James Parker for sending me his material and Danni Zuvela and Joel Stern for alerting me to it.

society loom ahead. All incidents between men must be noted, and
everything must be seen from a social point of view. Among other
effects that a new theater will need for its social criticism and its
historical reporting of completed transformations is the A-effect.

Bertolt Brecht, *On Theater*

Historically, free improvisation developed as a way to break away
from the traditional constraints of music making. The guitarist
Derek Bayley expressed it neatly: 'What's unique about this area
is the freedom to do what the fuck you like. I've tried it in other
areas of music, you can't do it.'[25] As a practitioner, however, I
have always had the feeling that improvisation relied on certain
assumptions in regard to the understanding of the individual,
assumptions which I found problematic and liberal: In short, *I'll
let you do what you want if you let me do what I want*. I came
to understand that there were hidden rules that you were not
supposed to break, certain assumptions like this one that could
not be undermined. Even if in the sixties and seventies free
improvisation was very much connected with certain political
movements, as in the US with the black liberation movement
and in Europe with anti-war and anti-consumer-culture move-
ments, today its claims about freedom seem to come from a
more individualist perspective and to be employed for musical
purposes. To cite a couple of examples:

> Part of the point of having all this space is to have the freedom that
> I think this music requires. I think improvised music should be fun-
> damentally free music and about having different possibilities—and

25. B. Watson, *Derek Bailey and the Story of Free Improvisation* (London:
Verso, 2004).

I think you start with the space. I want to create as much place and as much freedom as possible.

I would say it's a mixture: it is freedom but at the same time you always have the parameters to deal with, the relationships, the context, the environment. It's about how you negotiate your freedom within that context. Just because you've got to negotiate doesn't mean it's not freedom. It is freedom. The freedom is there, this little spark that's in you that makes anything seem possible. That's the freedom, not the chains. I've always thought I could be in jail and I would be free. That's a particular conception of freedom perhaps—it's not pure but it is freedom.[26]

As a way to question this specific understanding of freedom, I would like to bring a contemporary understanding of Brecht's *Verfremdungseffekt* into the sphere of free improvisation. The A-effect, alienation effect, defamiliarisation effect, V-effect, or, in the original German, *Verfremdungseffekt*, is perhaps the most powerful technique developed by Bertolt Brecht. He started to use the term in the mid-thirties, after a visit to Moscow, probably having been introduced to it by Viktor Tretiakov, who was himself influenced by Shklovsky's concept of *Ostranenia*. Interestingly enough, John Willets, in his collection of Brecht's writing, decided to translate it as 'alienation effect'. However, as both Fredric Jameson and Sean Carney point out,[27] *Ver-*

26. Xavier Charles and Ross Lambert respectively, quoted in B. Denzler and J.-L. Guionnet (eds.), *The Practice of Musical Improvisation* (New York: Bloomsbury, 2020), 19, 94.

27. Jameson emphasises the problem of Willet's translation as follows: '[W]hat is misleading about his translation (through the volume just mentioned) [...] of *Verfremdungseffekt* as "alienation effect". [is that] the Marxian concept we identify as "alienation" is [...] *Entfremdung* in German, so that his one had

fremdung is not *Entfremdung* (the term used by Marx, usually rendered as 'alienation')[28]. The prefix *ver-* has a set of different connotations in German, including 'removing, vanishing, misleading, negating, resulting, reinforcing'.[29]

Brecht's Techniques

Brecht's *Verfremdungseffekt* is intended as a counter to Aristotelian theatre, which is based on empathy:

better be rendered "estrangement" in keeping with its Russian ancestor (*ostranenia*, "making strange") [...] despite some support for the more aesthetic term "defamiliarization".' F. Jameson, *Brecht and Method* (London: Verso, 2011), 107. Carney, following Jameson's commentary, writes of how '[i]n his editorial notes in *Brecht on Theater*, John Willets gives every indication that he knows that *Verfremdung* is not *Entfremdung*; the fact that he translates *Verfremdung* into "alienation" anyway remains an intriguing puzzle, especially considering Willet's insightful connection of *Verfremdung* to Brecht's purported inspiration, Victor Shlovsky's concept of the *ostranenia*.' S. Carney, *Brecht and Critical Theory* (London: Routledge, 2005), 788.

28. Andrew Chitty gives a precise account of Marx's uses of *Entfremdung* and *Entäußerung* in regard to what in English is usually translated as 'alienation' or 'estrangement': see above, 49–50.

29. Carney continues his analysis of the confusion with emphasis on the prefix *ver-*: 'In his analysis of Brecht's linguistic turns, Rainer Nägele observes the uses to which Brecht puts the prefix *ver-*, and finds a Freudian strategy: "The German prefix *ver-* imposes here, as usual, its Freudian slips on the verb. Meaningless in itself, it twists verbs vertiginously and displaces agents. It is one of the morphemes of the discourse of modernity"' (citing R. Nägele, *Theater, Theory, Speculation: Walter Benjamin and the Scenes of Modernity* [Baltimore, MD: Johns Hopkins University Press, 1991], 147). Carney adds that, '[o]n Freud's part, the prefix *ver-* provides him with the central defence mechanisms of the psyche: *Verdrängung* (repression), *Verleugnung* (disavowal), *Verneinung* (negation), and *Verwerfung* (foreclosure). Brecht's *Verfremdung* is a cousin to these terms. Although *Verfremdung* cannot be entirely understood as any of these psychic events, I do think that it can be illuminated by reference to another Freudian concept (although one not nearly so important for Freud himself, who sees it almost exclusively in aesthetic terms): the *Unheimlich*.' Carney, *Brecht and Critical Theory*, 789.

> The efforts in question were directed to playing in such a way that the audience was hindered from simply identifying itself with the characters in the play. Acceptance or rejection of their actions and utterances was meant to take place on a conscious plane, instead of, as hitherto, in the audience's subconscious.[30]

One of the most important techniques for Brecht is the breaking of the fourth wall between audience and stage, so that the audience knows that they are being perceived, and therefore become participants in the play.[31] The question of participation has been dealt with in happenings, living theatre, relational aesthetics, socially engaged art, and postdramatic theatre, and its unsettling or disorientating potential has undoubtedly been dulled by repetition and familiarity. Can this technique be reimagined in such a way as to reactivate its original subversive charge? The suggestion here is that we do so by replacing the drama or representational setting with our real situation, and the characters with our self-representations, taking our own personas as material for improvisation. In doing so, the relationship between inside and outside blurs, and, since there is no plot outside of our own representation, the disorientation happens at every moment and within our own self-conception. Other techniques employed in Brecht's epic theatre include

30. B. Brecht, 'Alienation Effects in Chinese Acting', in J. Willett (ed., tr.) *Brecht on Theater: The Development of an Aesthetic* (London and New York: Bloomsbury, third edition 2015), 91.

31. Brecht, criticising opera, writes: 'Why do they have so little interest in their own affairs once they step outside their own four walls? Why is there no discussion? And the answer: nothing can be expected of discussion. A discussion of the current form of society, even if it concerned only its least significant parts, would immediately and uncontrollably entail an absolute threat to this very form of society.' Brecht, *Brecht on Theater*, 69.

characters using third-person speech for an actress in order to produce estrangement between the character and audience. Very much conscious of the historical nature of theatre, Brecht heavily criticised bourgeois theatre for presenting the spectator and characters as neutral ahistorical subjects:

> The bourgeois theater emphasized the timelessness of its objects. Its representation of people is bound by the alleged 'eternally human'. Its story is arranged in such a way as to create 'universal' situations that allow Man with a capital M to express himself: man of every period of every colour.[32]

Brecht instead emphasised the particularities and details of encounters so as to encourage a historical awareness of the particular social and political constraints that shape a subject:

> But for the historiciding theater everything is different. The theater concentrates entirely on whatever in this perfectly everyday event is remarkable, particular and demanding inquiry.[33]

Another technique he introduces is the use of moments when characters are presented with different options for the direction of the remainder of the play, as a way to show that things are not stable and could be otherwise. *Gestus* is another powerful tool that has to do with the body and physical expressions:

> Brecht places into an intersubjective relationship the traditional understanding of gestures, facial expression and speech intonation. Together attitude and gestus represents analytical concepts that

32. Brecht, *Brecht on Theater*, 156.

33. Ibid., 97.

enable the actor to separate into single gestures social actions and appearances, and contrast them with one another, indicating how meaning can be established, named or produced in a consistent way by the actor on stage.[34]

A very important aspect here is the radical minimalism of experience that Brecht demands of both audience and actors—'a reduction of action and gesture alike to the very minimum of decision as such, within a situation itself reduced to the most minimal machine for choosing'.[35] According to Walter Benjamin, Brecht also incorporated forms of disruption into his theatre similar to the types of editing made possible by the new technologies of radio and cinema, e.g. cutting out time by splicing, editing, and montage. Disruption or interruption, in general, is a crucial term for understanding the importance of *Verfremdungseffekt*:

> Epic theatre, then, does not reproduce conditions but, rather, reveals them. This uncovering of conditions is brought about through processes being interrupted.[36]

What new forms of playing with time could we envisage in the era of social media, where we are constantly engaged in editing and representing ourselves? Where our choices expand drastically, but increasingly are also monitored, analysed, and

34. M. Silberman, S. Giles and T. Khan, 'General Introduction', in *Brecht on Theater*, 12.

35. Jameson, *Brecht*, 77.

36. W. Benjamin, 'What is Epic Theater? [First Version]', in *Understanding Brecht*, tr. A. Bostock (London and New York: Verso, 1998), 4–5.

controlled? According to Benjamin, 'The art of the epic theater consists in producing not empathy but astonishment':

> In a word: instead of identifying with the protagonist, the audience should learn to feel astonished at the circumstances under which he functions. The task of the epic theater, according to Brecht, is less the development of the action than the representation of situations. 'Representation' [*Darstellung*] here does not mean 'reproduction' as the theoreticians of Naturalism understood it. Rather, the truly important thing is to discover the situations for the first time. (One might equally well say 'defamiliarize' them.) This discovery (or defamiliarization) of situations is fostered through interruption of the action.[37]

We might say that, today, what generates astonishment is reality itself, but this kind of astonishment is something we cannot get hold of easily because, as we explored in the first chapter, this reality produces forms of spectral objectivity that render its complexity opaque. Externalising alienation would serve to engineer this astonishment in the audience/participant, but without crude didacticism (agitprop etc).[38] The generative confusion created in this way inevitably suspends our usual self-conception and opens up space for a questioning in which we try to connect our self-representation with the representation of reality as produced by capital. This is a challenge precisely

37. Ibid., 18.

38. For a problematic film that may exemplify this kind of bad didacticism (critique as conspiracy theory) mentioned above see Adam Curtis's *Hypernormalisation* (2016), <https://www.youtube.com/watch?v=-fny99f8amM>. For an understanding of the uses of astonishment and estrangement in contemporary military warfare see John Boyd's *Discourse of Winning and Losing*, <http://danford.net/boyd/>.

because capital's extremity consists in controlling modes of representation and determining responses to them. As Steve Giles points out, Brecht was heavily influenced by Marx's *Thesis on Feuerbach*:

> Brecht quotes Marx's sixth 'Thesis on Feuerbach' according to which the human essence must be construed as the 'ensemble of all societal relations': 'Likewise, human beings—flesh and blood human beings—can only be comprehended via the processes in and through which they are constituted.'[39]

In today's reality these social forms are nested within technologies. For the latter we can add cables, networks, financial systems, algorithms and so on. How do we comprehend the processes in which we are constituted, how can we understand our own alienation? Grasping how social forms ultimately determine these processes requires an understanding of our self-determination in relation to these technologies and in relation to one another. For our purposes—taking externalising alienation as questioning in practice what constitutes subjectivity—the notion of *Verfremdung*, with its suggestion of estranging and defamiliarising qualities. remains helpful. It helps us to understand alienation beyond its common usage to denote the existential feeling of a separation from the social, forcing us to address forms of social displacement which then in turn must be negotiated. If we take improvisation as a starting point, but read it through the notion of *Verfremdung*, this forces us to reconsider both what freedom is, and who are the subjects of freedom.

39. S. Giles, 'Introduction to Brecht', in Brecht, *Brecht on Theater*, 16.

All of the different levels of alienation we are dealing with here—such as labour, language, the unconscious, technology, and selfhood—are to a large degree determined by capitalist relations. When we try to assess and understand these forms of alienation, this understanding is also tainted by our self conception, which in turn is shaped by ideology. Having said that, we can use ourselves as material for improvisation and, through the *Verfremdungseffekt* and thinking-out-loud together, we can explore the social dissonance that emerges from our determination by capitalist social relations and our capacity for self-determination: freedom beyond the self.

Elizabeth Wright argued in 1989 that under postmodernism the *Verfremdungseffekt* has been rendered obsolete because of the constant and ubiquitous use of these types of effects— a claim that may be even more valid today in the post-Trump era.[40] I would argue that the device is far from exhausted, how- ever, even if forms of distancing through critique are obsolete because they presume a form of objectivity that we no longer have, while other positions such as 'criticality' claim to supercede critique by undoing the 'dichotomies of "insides" and "outsides" through numerous emergent categories such as rhizomatics, folds, singularities, etc. that collapse such binarities and replace them with a complex multi-inhabitation'.[41]

I would say that we need an acceleration of the *Verfrem- dungseffekt*: we need to go beyond its theatrical threshold into a critical exposition of our 'real' selves as characters of the living theatre of a society in which increasingly we are performing a

40. E. Wright, *Postmodern Brecht: A Re-Presentation* (London: Routledge, 1989), 96.

41. I. Rogoff, 'From Criticism to Critique to Criticality', <http://eipcp.net/ transversal/0806/rogoff1/en>.

curated and self-conscious portrayal of ourselves. As Jameson points out, Brecht was already dismantling the idea of selfhood:

> In fact, I think that Brecht's positions are better read not as a refusal of identification but, rather, as the consequences to be drawn from the fact that such a thing never existed in the first place. In which case, 'third-person acting', the quoting of a character's expressions of feeling and emotion, is the result of a radical absence of the self, or at least a coming to terms with the realisation that what we call our 'self' is itself an object for consciousness, not our consciousness itself: it is a foreign body within an impersonal consciousness, which we try to manipulate in such a way as to lend some warmth and personalisation to the matter. The simplest models of identification are therefore rendered meaningless by this situation, in which, at best, in a Lacanian complexity, two self-objects entertain a complex and mediated relationship with one another across the gaps of isolated consciousness.[42]

As we can see, this is a very important supplement to Metzinger's discussion of the self as neurobiological model.

The *Verfremdungseffekt* then is a way of exploring alienation, of generating forms of displacement in which the projection of ourselves confronts glimpses of objectivity and, in doing so, helps us to reconfigure our own self-conception. In the previous two chapters, we have seen how our self-conception is distorted at three levels:

(1) At the suprapersonal level, through the exchange relation (Marx).

42. Jameson, *Brecht*, 68.

(2) At the intrapersonal level, through the neurobiological mechanisms that generate the self-model (Metzinger).

(3) At the conceptual level, through our social interaction (Sellars).

The objectivity we are trying to achieve, then, must take all three levels into consideration in order to grasp the broader implications of our self-conception. Externalising alienation pushes the *Verfremdungseffekt* into improvisation as a way for us to explore our own subjective constitution. Capitalism, as we know, thrives on 'self-empowerment' and, when it can, produces smooth social outlets for these identity models so as to let the workforce go on with business as usual. Within this process of individual subjectivation, a generalised form of fragmentation makes it difficult for us to gain perspective, to gain an overview.

Externalising alienation counters this by exploring social dissonance, reopening a problematic conception of ourselves and of truth by attempting to gain an overview, however incomplete. Today, experiments using virtual reality to explore embodiment are yielding striking results which can also be useful to question self-conception.[43] Having said that, we can also explore forms of embodiment by placing experience in a constant *Verfremdungseffekt* by using externalising alienation so as to gain awareness of its possibilities and conditionings. The *Social Dissonance* score tries to do this by making the passing of time rough and problematic, a constant negotiation of our self-positioning. But once we use externalising alienation as a way to deploy the *Verfremdungseffekt* directly in our subjectivity,

43. See examples on the website of the VERE (Virtual Embodiment and Robotic Re-Embodiment) research project, <http://www.vere.eventlab-ub.org/>.

we enter another form of mediation which has to do with the unconscious and the psychoanalytical realm.

Constituted and Constitutive Alienation

The most powerful recent reading of alienation simultaneously through Marxism and psychoanalysis is offered by Samo Tomšič in *The Capitalist Unconscious: Marx and Lacan*.[44] Tomšič points out how Marx did not envisage life without alienation, because

> [i]f his critique of fetishism would not move from the physiology of vision to the materialist lessons of religion, the inversion would simply repeat his pre-critical and humanist reading of alienation and thereby overlook the break between alienation as an imaginary reflection and alienation as a structural operation. The point is to show that human relations exist in the way in which they are distorted. There are no human relations without distortion.[45]

Social dissonance is this distortion as manifested in capitalist relations. Elsewhere Tomšič indicates the connection between alienation and revolution, pointing out that Marx did not think the latter as the overcoming of the former, but conceived alienation itself as a structural transformation of the existing mode of production:

44. Nadia Bou Ali, in her text 'The Fantasy of Subsumption?', juxtaposes Tomšič's theory with the Communisation theory offered by Théorie Communiste and Endnotes, and develops a compelling critique. It was thanks to her that I was able to understand the powerful account of alienation provided by Tomšič's work. N.B. Ali, 'The Fantasy of Subsumption? Labour-Power and the Capitalist Unconscious', in Mattin and Iles (eds.), *Abolishing Capitalist Totality*.

45. S. Tomšič, *The Capitalist Unconscious: Marx and Lacan* (London: Verso, 2015).

In distinction to these attempts to abolish alienation, which really do deserve to be called utopian, Marx's critique of political economy contains an effort to think alienation not only as reproduction of the relations of production but also as a structural transformation of the existing mode of production. We cannot overlook that the double meaning of the term 'revolution' is at stake here, the scientific (circular movement of astronomic bodies) and the political (subversion of the given social order).[46]

As Tomšič points out, the belief that we can live an unmediated life, or maintain an unsplit, conflict-free ego, or consciousness is one aspect of the mystification produced under capitalism. He goes on to makes a distinction between two types of alienation: *constituted alienation* and a second, deeper form, *constitutive alienation*.

Constituted alienation emerges from commodity fetishism, which follows from the misperception of the relation between the appearance of value and the structure that causes this appearance.[47] Commodity fetishism is the 'immediate' capitalist form of social relation, and assumes the phantasmatic form of relations between commodities. Constituted alienation is also the production of the asymmetrical relation between the subject and the other, which still concerns the 'cognitive' misperception of commodities and functions as a mask or a mystification of the constitutive alienation. It is clearly what we have defined as phantom subjectivity.

Constitutive alienation is a more fundamental form of alienation and is equivalent to structure.[48] Tomšič brings the psycho-

46. Ibid., 61.

47. Ibid., 105.

48. Ibid.

analytic real into a critique of political economy and constitutive alienation is the meeting points of these two realms. Therefore constitutive alienation distorts every immediate relation between humans and the production of the split ego: It is the production of capitalist subjectivity qua labour-power but it is not just that. It contains an inner redoubling, it is a form of becoming (*werden* in the Hegelian sense) which has a productive force in regard to subjectivity, but also has the negative determination from capitalist social relations. Labour-power designates the capitalist appropriation of the subject of the signifier, its transformation in accordance with the commodity form. In other words, value represents the labour-power contained in each object that carries value, but it can only represent it in commodity exchange, that is, for another value. But labour-power is simply the subject. It is Marx's name for the subject.[49] Because it is constitutive, it is irreducible to capitalist forms of alienation, but it is also a surplus, a negative extra that cannot be fully reconciled. Constitutive alienation concerns the fact that this reinstated image is modified in relation to the reality that it reflects:

> There is also no doubt that constitutive alienation does not address solely the alienation of the subject but above all the alienation of the Other: it makes the Other appear in its split, incompleteness, contradiction and therefore inexistence. The correlate of this inexistence is the existence of the subject, the actual agency of the revolutionary process, which, however, does not assume the position of knowledge but the place of truth.[50]

49. Ibid., 63.

50. Ibid., 61.

According to Tomšič, capitalism generates false forms of universalism because it has 'rooted its politics on the hypothetical existence of the Other (the Market and other economic abstractions), the strong ego of a fictitious economic subject (the narcissism of private interest) and social segregation'. Previous forms of communism failed to deal with 'how the political consequences of inexistence, alienation and universality look in practice'. This suggests a new grounding for any future politics: because there is a social entity, the proletariat, which articulates a universal demand for change in the name of all (being the social embodiment of a universal subjective position), this very enunciation grounds politics on the link between inexistence, alienation, and universality. So far we had only a fake liberal abstract universal subject— which has been rightly criticised by feminism, decolonial, and Marxist projects. The current disenchantment with liberalism, where more and more people are realising its phantom qualities and limitations, brings with it a lot of resentment. The question is how we deal with it.[51] Dealing with the asociality of our contemporary conditions may lead to ugly situations, but taking it personally or using it for our own personal benefit is certainly the wrong way to go. Nonetheless there is a conversation to be had here about cruelty.

Social Sadism in a Sadistic Society

In a recent text, Ana Teixeira Pinto and Kerstin Stakemeier coin the term 'social sadism' for art practices that exercise cruelty upon others in the name of freedom. According to them, these practices are expressions from a narcissistic wound that come from a white male privileged position that is being radically questioned today. The artists they mention use irony in order

51. Ibid.

to ridicule particular targets in acts of transgression justified as free speech. Pinto and Stakemeier identify this ironic nihilism employed by social sadism as the existential philosophy of the alt-right, and see its function as being 'to recover the totalizing dimension of white eschatology (now simply negativised), and to devalue calls to redress injustice, ultimately reaffirming the color line'.[52] Some of the artists mentioned are well-known male historical figures such as Martin Kippenberger, Santiago Sierra, and Artur Żmijewski, but the authors also target young contemporary artist such as Mathieu Malouf, Dana Schutz, and the 2018 Athens Biennale, entitled *Anti* (curated by Stefanie Hessler, Kostis Stafylakis and Poka-Yio). Importantly, this text examines certain practices that have been defined as 'cutting-edge' but which, within the current political climate, can be seen as politically extremely dubious. As Pinto and Stakemeier articulate, this has to do with the implosion of a liberalism that is demonstrating that it is unable to meet its promises:

> Liberalism was always (mis)construed as a horizon of open poten-
> tial by the subjects it manufactured. As a direct consequence of
> these failed promises, it also produced and reproduced its own
> inner differentials, and along with it, a great many illiberalized
> lives, dispossessed and decapitalized within the very horizon of
> possessive individuation liberalism necessitated. The mediation
> of this gap between aspirational subjecthood and material sub-
> jection has been the primary task of education, culture, and art.[53]

52. A.T. Pinto and K. Stakemeier, 'A Brief Glossary of Social Sadism', *Texte zur Kunst* 116 (December 2019), <https://www.textezurkunst.de/116/ein-kurzes-glossar-zum-sozialen-sadismus/>.

53. Ibid.

Pinto and Stakemeier go on to describe the privilege of the
artists mentioned above,

> subjects whose rationality, according to Robert Hullot-Kentor, 'ascertains truth only in the achievement of the separation of knowledge from its object', thereby declaring themselves no longer responsible for the violence they inflict. This (self-)dehumaniz-ing core of modern humanism created a subject whose isolation is at once a function of his privilege and unsettled by it, whose bloated yet jittery self-representation bristles with something like a paranoia of possession, haunted by the fear of being rendered indistinguishable from its objects.[54]

Admittedly, social dissonance as a concept and *Social Disso-nance* as a score are also a result of these failed promises of liberalism, and the interpretation of the score tries to reveal and make public all the repercussions of this dissonance. However, this dissonance is far more structural and that its prevalence goes beyond the work of the artists that Pinto and Stakemeier mention. In the text they praise the practices of self-abolition of Pier Paolo Pasolini and Georges Bataille with Acéphale as 'a self-transgression measured not by its effect on others but by the limit encountered in the process of self-abolition', insisting that these 'historical transgressive practices were directed very pointedly against the brutalizing cultures of modern domination and their colonial core'.[55]

So far, my experience is that interpretation of the *Social Dis-sonance* score brings fragility to the artist and the interpreters precisely because its material is our assumptions about how we

54. Ibid.

55. Ibid.

conceive ourselves—which means a radical self-questioning in front of the participating public. No doubt this has sometimes generated difficult situations which were not anticipated. At the beginning, out of inexperience, interpretations of *Social Dissonance* could possibly have been seen as some form of live 'trolling'. Later on they became far more focused on systematically exploring social dissonance. The experience of this dissonance felt collective, and this was necessary in order to be able to deal with the consequences not from established and reinforced positions but from the position of understanding that a different form of subjectivation is needed, even though it is clearly not going to be possible to generate it only through art practices and critical texts. This might therefore be seen as a non-heroic version of self-abolition where, through externalising alienation, an estrangement of estrangement is produced: a *Verfremdungseffekt* that disrupts simple awareness and experience of estrangement because it exposes the noise in the social relations underlying such experience. This could help us to connect the consequences of social dissonance with our self-reproduction as commodities in the class relation.

Externalising Alienation as a Constituting Praxis

Constituted alienation produces the phantom subjectivity that makes you believe that, as an individual, you are already a subject and that you can overcome alienation; it promises the possibility of unmediated life. It also functions as a mask or a mystification of constitutive alienation, which structures our being and our conception of ourselves as capitalist subjects. Previously I have worked with the concept of 'unconstituted praxis' in relation to improvisation, as a praxis of pure mediality, of means without an end, 'a praxis which is not finally constituted, not complete, yet has no end outside itself. Its effect

depends on interaction: the participation of others [...]'.[56] From the perspective of the above account of constitutive alienation, we can see how this notion is problematic because it presupposes a possibility of nonmediation which is precisely an illusion produced by constituted alienation. I would therefore, as a corrective, like to propose the term *constituting praxis*, in the sense of a praxis whose focus is on identifying and addressing the different forms of alienation by which we are conditioned and constituted.

Here we need to explain how Marx's concept of freedom differs from Kant's and Sellars's. For Sellars, freedom is to be taken as an act of self-determination (without any necessity for selves to be invoked) through subjection to a rule that transforms the previous forms of conditioning that are to be overcome and, in the process, *becomes* the subject—indeed, it is this process itself that is the subject:

> The 'oneself' that subjects itself to the rule is the anonymous agent of the act. To be subjected is to act in conformity with a rule that applies indiscriminately to anyone and everyone. One does not bind one's self to the rule; the subject is the act's acting upon itself, its self-determination. The act is the only subject. It remains faceless.[57]

However, under capitalism, this anonymous agent is determined by existing social conditions, which means that in order to generate its freedom a revolution would be required.

56. Mattin, *Unconstituted Praxis*.

57. R. Brassier, 'Unfree Improvisation/Compulsive Freedom', text for a performance with Mattin at *Arika* festival episode 4, 'Freedom is a Constant Struggle', 21 April 2013, Tramway, Glasgow, <http://www.mattin.org/essays/unfree_improvisation-compulsive_freedom.html>.

Social dissonance therefore cannot be overcome since the I/We relation is tainted by the impossibility of being actualised under capitalism. This is why the philosophical idea of freedom as autonomy remains contradictory. On the one hand, at the level of consciousness it appears possible, while on the material level it cannot be properly realised. Of course, it is from this very contradiction that social dissonance emerges.

Externalising alienation as a constituting praxis takes the norms and rules of its conditioning, reassessing their necessities for the interest of a goal—you cannot abolish all norms and rules, as freedom is a cultural achievement, which means that it is norm- and rule-governed. The question is not how to access freedom, but, starting from a situation of constraint, which mediations are most intimately involved in a norm of freedom. This procedure produces an awareness of social mechanisms while taking into account the irreducible negativity that traverses social and subjective reality.

Contemporary capitalism wants you to deal with alienation individually by believing that you can overcome it. The proposal here is to deal with it collectively, acknowledging both the fallacy of the individual as a juridical figure under capitalism and the mystification of the promise of unalienated life. And to do this knowing that to deal with it collectively is to articulate or effectuate this contradiction; i.e. to affirm that therein lies the only viable (non-mystificatory/non-metaphysical) idea of freedom. However, we need to take into account that this freedom remains constitutively blocked by the social totality until a revolution is achieved.

Externalising alienation, then, recognises the inexistence and impossibility of reconciliation and takes these as its starting point. It then addresses alienation understood as a contradictory process which on the one hand determines us, but on

the other can be constitutive of freedom. Constituting praxis in its most minimal form tries to get hold of this contradictory process via a constant reassessment and testing of the *Verfremdungseffekt* in improvisation, through the interpretation of the *Social Dissonance* score. In this score we constantly deal with the contradiction between 'I' and 'We', between constituted alienation and constitutive alienation, and with their relation to capital and class.

As a way to deal with their interconnection, we treat externalisation as that process which sublates phantom subjectivity and its reified estranged qualities. With the terms externalisation (*Entäußerung*) and estrangement (*Entfremdung*) we have the dialectical character of alienation: while externalisation is constitutive of freedom—as the splitting process between subject and substance that cannot be properly objectified (we could even say that this is the kernel of living noise)—estrangement is constitutive of unfreedom as part of the objectication process (the subsumption of labour under capital).

Externalising alienation is a constituting praxis in so far as it takes social dissonance and tries to understand its relation to structural alienation by slowly and carefully articulating the difficult relation between alienation from above and alienation from below. By understanding that our subjectivity is not given, externalising alienation engages in an irreversible process leaving behind established notions of selfhood and encountering noise in different registers (cognitive, experiential, and psychological). It necessarily involves a process of improvisation so as slowly to expose the different points of mediation, the intricate articulation between spectral objectivity and phantom subjectivity.

CONCLUSION:
BREAKING THE INNER
FOURTH WALL

If Brecht wanted to break the fourth wall—the imaginary wall between actors and audience which keeps the latter, as observers, from realising that they are active members of the theatrical experience trying to make sense of what is going on—I am instead interested in breaking the inner fourth wall:[1] the self-perception that we as individuals are stable selves and the belief that we are already subjects with agency. Breaking this inner fourth wall implies exposing the performance of self as a historically specific and social reifying process. But doing so also opens us up to unknowns that we may not be ready to explore.

In a time when noise and unpredictability are radically undermining core Enlightenment values such as autonomy, reason, agency, and freedom, we seem to prefer to accept ideological prisons constructed out of bad totalities over confronting this noise head-on. However, the current intellectual landscape is a claustrophobic one, a spectral objectivity without exit in which an overarching narrative cocoons us negatively in an impotent present haunted by a catastrophic future. Examples of this outlook would be Mark Fisher's 'capitalist realism', which takes as its maxim Žižek and Jameson's dictum that 'it is easier to imagine the end of the world than the end of capitalism', the notion that capitalism has taken over all aspects of life without remainder through a process of real subsumption, or some of the current discussions on Planetarity, the Anthropocene, and Globality. To believe that there is no outside to capitalism or that capitalism is total is to negate all things and practices that are not yet valorised, quantified, or comprehended. Negating or obviating these generates a conceptual idealisation along with its fulfilment, simply because one cannot deal with noise that is not yet understood.

1. Thanks to Lisa Rosendahl for suggesting this expression while describing my practice.

However, there is also potentiality in noise. We still need living noise to be explored, but in order to do this we first need to understand how we are already embedded in and constituted through different forms of noise—from the mental noise that we usually take to be 'personal' to general noise in regard to our limited knowledge. Facing noise and uncertainty means exposing processes of reification, understanding them, and transforming them, all in the knowledge that our tools are limited, distorted, and probably inadequate. This is why it is necessary to constantly turn these tools inside out, to externalise them in order to get a better grasp of reification. If we had a granular view of the reifying processes, as in a microscope with a temporal dimension that made it possible to identify all the elements happening in practice, then we would be able to much better discern and understand its effects. For this we need far more precise concepts that can deal with the reifying dynamic. We pretend to understand the whirlwind that we are in, standing still surrounded by these ideological inner walls, believing that they will keep us safe. But these walls are not going to protect us, and will be destroyed by changing material conditions. Better that we dismantle them rather than see them taken away from us, producing resentment, confusion, and desperation in the process. To break the inner fourth wall means to open up the mental state of noise to general noise, and to understand its connections and consequences.

We have seen how the complex interrelation between alienation from above and alienation from below produces a phantom subjectivity: we as individuals take for granted two different forms of transparency based in two different processes of reification (value production and selfhood), but these produce further noise that we don't seem to want to acknowledge. The reifications arising from spectral objectivity and phantom

subjectivity produce a condensation of selfhood, a personifi-cation that tries at all costs to avoid exhibiting its porous, frag-ile, and unstable character. This self condensed from the two forms of alienation in its liberal form is no longer able to hold together, because the material and historical conditions that made it possible are disappearing. It is not surprising that we see increasing problems with mental health, with disintegrating interiorities that cannot manage to keep up the appearance of maintaining the inner fourth wall.

To break the inner fourth wall means being open to recon-sidering what the subject/object relationship is, in a world full of noise. In this book, through the conceptual lens of aliena-tion, I have developed the theory of social dissonance, which concerns the contemporary problematic of the conflation of the individual with the self and the self with the subject. Out of this conflation there emerges a discrepancy between how we understand ourselves—with the notion of the individual being increasingly reinforced—and the way that we are socially deter-mined by capitalism—through technologies and ideologies that have made the classic idea of the subject as bearer of an origi-nary freedom or of a capacity for self-determination increasingly difficult to reconcile with the actuality of social conditions. In the process, I aimed to expose the illusory qualities of selfhood and the problematic belief in the individual as a juridical notion implying inalienable rights. The political stakes of this research lie in exploring the difficulty of coming together—a symptom of ongoing fragmentation—a difficulty which in turn directs us toward the barriers we confront in the apprehension and transformation of things at the structural level.

The book was written at a moment when democracy is showing signs of clear and irreconcilable contradictions—namely, the progressive co-optation of its historical forms by

economic interests. At the same time, we are left without any clear idea of any future for alternative ways of being together. This has resulted in a right-wing backlash in which ideas that were thought to be buried—ideas of ossified ethnic identity and the militarised national state—have made a merciless return. My point of entry into this complex of factors was the experimental music scenes of noise and improvisation, whose relevance as a research object lies in their exemplary status as shining beacons of the general weakness in our understanding of freedom as a starting point of the political. In improvisation, the notion of freedom has been taken to be related to the expression of the self, often in collective environments. Improvisation attempted to break with previous norms of musicmaking, without acknowledging the norms to which freedom is subject, or that the self is a form of mystification. Noise has historically dealt in transgression and alienation, but their effects are temporally limited and today seem exhausted.

There is a common element in these practices which I have attacked: the phenomenological approach to sound, which presupposes ownership of experience. Hence I have attempted to bring about a historical awareness of alienation through the incorporation of contemporary empirical analysis into the philosophical development of this category. In doing so I sought to map out new approaches for dealing with alienation that rely neither on the reactionary romantic discourse of de-alienation nor the overly optimistic approach of accelerationist currents. It is here that I developed proposals for the negative critical potential of 'noise' beyond the phenomenological connotations of the term; not only for aesthetic purposes, but also for the exploration of social dissonance: understanding the interrelation between how we understand ourselves and what we could be, and the mystification that is produced between the

gaps in these understandings. The exploration of alienation in different registers has helped us to understand the different levels at which we are determined: *alienation from above* and *alienation from below*.

There is a complex interrelation between these two, and our ability to grasp them is limited. The concept of alienation forces us to ask: What it is that is being alienated? What is producing it? And what can be done about it? In doing so, the discourse presented here connects directly with modern critical theories of subjectivity i.e. theories of the subject that question the theological tutelage of agency and freedom through the embrace of modern scientific developments. In doing so we encounter what Freud called the three 'narcissistic wounds':

> Copernicus had demonstrated that the earth is not the centre of the universe; Darwin, that the human being is a product of natural selection, emerging through the same blind material processes as every other creature; finally, psychoanalysis was to undermine our impression that we are masters of our own consciousness and destiny—unconscious processes beyond our perception and control steer our relation to the world and to ourselves.[2]

Marx supplemented these with yet another 'wound' by explicating the intricacies of the capitalist mode of production, which produces mystification in its attempt to colonise all aspects of reality, from the environment to our subjectivity.

The wounds incurred by Marxism, Darwinism, and psychoanalysis are then drastically broadened by current neuroscientific research carried out by thinkers such as Thomas Metzinger,

2. R. Mackay, 'Introduction: Three Figures of Contingency', in R. Mackay (ed.), *The Medium of Contingency* (Falmouth: Urbanomic, 2015), 1–10: 2–3.

which detail the illusionary qualities of selfhood. It is imperative to deal with these new disenchantments as a way to gain agency, i.e. an ability to understand the rules that we are subject to, and thus to be able to act upon them and change them, and through such action to become non-narcissistic subjects. As we have said: there is no freedom in a normative vacuum. The belief in unmediated expression and unalienated life is a form of fetishism that needs to be eradicated. Accepting alienation as a constitutive part of subjectivity reminds us of the constant wounds that we will have to confront.

The *Social Dissonance* score deals with these narcissistic wounds, digging into them like crows feasting on the corpses of neoliberal bodies, however alive they might seem to be.

THE SCORE

Listen carefully.

The audience is your instrument, play it in order to practically understand how we are generally instrumentalised.

Prepare the audience with concepts, questions and movements as a way to explore the dissonance that exists between the individual narcissism that capitalism promotes and our social capacity; between how we conceive ourselves as free individuals with agency and the way that we are socially determined by capitalist relations, technology and ideology.

Reflect on the I/We relation while defining social dissonance.

Help the collective subject to emerge.

AGAINST THE FLOW:
NOTES FOR INTERPRETERS

In interpreting the Social Dissonance score, interpreters shift the ground of the audience, making them unsure of where they are, and making it difficult for them to reorientate themselves. In the midst of this 'performance', everything feels like a struggle. Nothing is easy. This difficulty focuses participants on every detail of what is going on in the room. The passing of time is made uncomfortable. The notion of performativity becomes very apparent in Social Dissonance *because every movement has meaning and can contribute to the flow of time, either smoothing it out or disrupting it. The devices suggested below serve to make the passing of time rough, unstable, and discontinuous.*

Once we feel comfortable, we generate a kind of cosy atmosphere based on common denominators, on consensus. The consensus reached in this way is a bland form that functions to prohibit self-questioning. In order to counter this, the interpreters use improvisation and various specific devices to undo the cosy elements and to constantly generate the feeling that things could be otherwise.

There is an invitation to participate, but this is a partial invitation in the sense that the interpreters all have previous knowledge of what has happened before, during the concert. There is also another connected factor that distances the interpreters from the audience, and this has to do with the confidence they gain through the process. This confidence begins to be reflected in the pace, their ability to perceive what is happening, and their ability to act quickly. After more than a month of interpreting the score, some things became clear: the importance of stating the situation so that the audience can choose to stay or leave; the fact that the audience's

willingness to interact and the way they want to be played depends on the confidence of the players; and the possibility for things to open up once you break with the consensus on what is 'supposed' to be happening.

Some stereotypes appear constantly, such as the idea that forming a circle is a necessary beginning for the collective subject, or the way in which confident people are often willing to speak, but their body language reveals where this confidence comes from (they are already used to being seen and behaving in public, which also has to do with their degree of education, or of intellectual development).`

The point is to really dig into the unfamiliar, into estrangement, while we reflect upon how we conceive ourselves. In opposition to Brecht, in Social Dissonance *there is no plot other than ourselves.*

Because both the background and foreground are unstable, any element can really become central, the same as any other. The atmosphere should be set for anything unexpected to happen as part of the improvisation, without the need to get into unnecessary provocations.

And then there is the transparency of body language: it's amazing how much you can read people by the way they dress and how they move in space. Sitting down, for example, is like generating your own fortress. If you let people sit down, it's as if you are letting them be themselves and giving them reassurance. As an interpreter of Social Dissonance, *you don't want to give them reassurance, you want them to be confused so that they reveal themselves without presenting themselves, without pretending or taking up a position. The materiality of the public, their decisions, their acceptances, produces a fragility that provides room to breathe for elements that are usually*

not perceived; the way that we curate and present ourselves, how our confidence is built, the acceptance and rejection of stereotypes, and how we position ourselves in regard to different themes. Building trust, using trust as material. Speed, how things are going, being taken along a path by somebody else. An early decision can have weird consequences later on; people feel the room, generating different forms of perception, which is connected to how we feel in a certain space. Place the emphasis on different senses, go from one to another. Zombie play: people enable others to follow: if everybody does the same, it's likely that people will follow. People usually don't like to stand out. The interpreters give roles to people, people adopt them and do something with them. People get to know each other very quickly, so they feel comfortable with each other, but then the interpreters cut this through an abrupt decision or separation. This is what I call 'editing the room': people have to constantly reassess the conditions they are in and how they are interrelated. There are rules, but some are not visible, one can only understand them by daring to challenge them.

The interpreters need to play with danger, fear, and disruption as a way of editing flows so that the projection of oneself, how one makes oneself comfortable, and how one portrays oneself to others all become visible. As outlined below, we have developed numerous devices to counter self-expression.

It is very difficult to transpose the theoretical ideas directly into the score, and one has to look very careful into the thread that is being developed through time in order to see things that keep repeating themselves and coming back. However, the interpretation of the score generates a constructive confusion which disrupts the flow of how we generally perform 'ourselves'—or at the very least, we become aware of this self-representation and self-understanding as a 'performance'.

PROJECT DESCRIPTION FOR DOCUMENTA 14

Four people will perform a text-based score during the whole 163 days of documenta 14. The performance will be streamed through the web and documented on archive.org. The score will deal with generic qualities or gestures in which the notion of instrumentalisation will be played against that of the instrument.

The players will use the audience as instruments, similarly to how players in improvisation play their instruments in unconventional ways or against the grain. By doing this, the concert hopes to expose the normative and instrumental qualities of our behaviours in the exhibition space, but also in everyday life (the porous qualities of this score and the form of interaction will certainly server to constantly undermine the autonomy of the score and the situation).

For this score, some strategies from experimental music will be reappropriated, shifting the emphasis from the sonic to the social. Let's take as an example the notion of 'prepared piano' where objects are placed inside the piano as a way to generate different forms of resonance and percussive qualities. Instead, for Social Dissonance, *the players will prepare the audience not with objects but with concepts, questions, and gestures.*

The players will use some of these techniques or devices as a way of setting the situation into motion. The roles of the players and of the audience are not fixed and will be interchangeable, constituting a different form of interaction based in improvisation where the roles will not be clear cut.

The separation of Athens and Kassel, as part of the performance, will be a form of alienation and therefore a crucial element in the project. When the exhibition takes place on both sides, two of the players will go to Kassel and from there both sides will continue performing the score and interacting

which each other through the livestream, which will be pro-
jected (Athens in Kassel and Kassel in Athens).

CALL FOR INTERPRETERS

Documenta was founded in the German city of Kassel in the
1950s and since its debut in 1955, Documenta (and the city of
Kassel as a whole) has welcomed thousands of artists and cul-
tural practitioners from across the world. Please check http://
www.documenta14.de/en/ for more information.

Each Documenta is a unique endeavour, and the defining
feature of documenta 14 will be its twofold structure: the exhi-
bition will take place in two cities concurrently, Athens (where
documenta 14 will open in April 2017) and its traditional home
Kassel (where the exhibition will open in June 2017). Within this
overarching structure, a small number of primary themes and/or
topics will be addressed by way of artworks and artistic projects.

Social Dissonance is an instructional score with four inter-
preters for an extended concert that will happen throughout
the course of documenta 14 both in Athens and in Kassel.
However, for the concert the emphasis will shift from the
sonic to the social.

Social Dissonance will explore the discrepancy that exists
between the narcissist individualism that capitalism promotes
and our social capacity. This dissonance emerges from the idea
that we have of ourselves—as free individuals with agency—
and how the notion of the self as agent is being dismantled by
science, politics, and technology. Alienation and estrangement
are crucial concepts to reveal this dissonance. The interpreters
will play the audience as their instrument as a way to explore
how we are usually exploited in capitalist relations, but also,
more concretely, by the expectations of viewers of the exhi-
bition. In order to do this, the interpreters will use techniques

that are usually used in experimental music such as 'prepared piano', but instead of preparing the audience with objects they will use concepts, questions, and movements.

The concert will start on the 4th of April in Athens and then from the 10th of June in Kassel. Between the 10th of June and the 16th of July the concert will be performed both in Athens and Kassel (two interpreters in each location).

This extended concert will be streamed live on the internet via an application called Periscope, and then archived on archive.org

We are looking for interpreters to perform an instructional score called Social Dissonance, initiated by Mattin, every day for 163 days. You will be asked to play the audience as an instrument through questions and movements and to engage in an ongoing collective thinking process. This project is not about acting or performing but rather is a way to explore the social dissonance mentioned above. No musical knowledge is necessary.

Therefore, we are looking for people to interpret this score who are interested in performative situations, politics, and theory. They should be interested in investigating how our subjectivity is produced under capitalist relations, and more specifically the role of art in this process, and in exploring the possibility of generating a more social type of subjectivity through rational and performative means. Besides the above, the candidate needs to have technical abilities to deal with mobiles, projectors, and uploading material to the internet.

If you are interested, then please send a short letter of motivation and CV to Eleni Riga <riga@documenta.de> and Carlota Gomez <gomez@documenta.de>.

There will be a preparatory workshop between the 20th and 27th of March, it will be held in Athens Music School and it will last six hours each day.

The performers will have co-authorship of this piece. However, the material generated will have an Anti-Copyright note meaning that anybody would be able to do whatever they want with it.

STARTING SUGGESTIONS

First Moves

What we have seen is that it is very important to get the audience from the very beginning. If you let them be comfortable in beginning, they will make the space their own, which often means that they normalise the atmosphere—especially if they sit down. For this reason it's important to have strong first moves which push the interpreters and the audience into new situations.

- *Ask them for their wallets and go through them in public.*
- *Film specific parts of their bodies while projecting the internet stream.*
- *Eliminate physical distance: staring at the audience, being very close to them, kissing them, a firm handshake.*
- *Leader/Follower: put people into couples and tell one 'You are a follower' and the other 'You are a leader'; the follower is blinded and they need to follow the leader.*
- *Circle everybody: ask them, are you performing a role or do you think you are truly yourself?*
- *Dream sharing.*
- *Start with simple categorising (age, sex, work...) and slowly get very personal.*
- *Ask everybody what they think is the most urgent problem in the world, then ask what we can do now about it?*

Second Moves:

· *Vulnerability: ask about insecure thoughts.*

· *Voting: to stop the performance, to make music, to change the direction...*

· *Ask and separate people depending on whether they are pro- or anti-revolution.*

· *Ask them to show their social media accounts and project them in the room and talk collectively about a member of the audience's self-presentation. If Brecht was bringing editing techniques from radio and film into his epic theatre, here we edit the room by bringing social media logic (adding as friends, very quickly, by look or on the basis of the info given about yourself).*

· *Ask people to perform their idea of freedom.*

· *Ask: Are you all right now?*

LINKS

· *Periscope live stream:*

Athens: <http://www.periscope.tv/socialdissonanc>

Kassel: <http://www.periscope.tv/socialdissonan1>

· *YouTube channel with all documentation:*

<https://youtube.com/channel/UCZN3mZD45YnZjD27prGoMjw>

· *Documentation also available at archive.org: search 'Social Dissonance' to get direct links.*

DEVICES

Agrammatical Form of Sentences: change the grammatical structure of sentences.

Amplified Perfection: be as focused as possible and feel the room.

Analysing Behaviours: describe how somebody is behaving or how the audience is behaving.

Anti-Social Realism: collapsing the impotent inability to change the social conventions in the performance space into the impotent inability to change reality in the general sense.

Audience Behaviour: behave as if you are a member of the audience

Check In: express your feelings at that precise moment.

Check Out: synthesise and reflect upon what has happened.

Chicken: when you are scared, start behaving like a chicken.

Collect Subjects: then discuss them, then direct them toward the specific point.

Daring Together: doing the ungrounding collectively.

Emotional Toilet: dump all your miseries in public.

Exposing Accents: in relation to class, for example.

Exposing Stereotypical Gender Behaviours.

Forcing the Lapsus: trying to force a lapsus in your speech or in somebody else's speech.

Glitching Voice: malfunctioning discourse.

Going Crazy: act in a way that feels the most abnormal to you.

Going Fragile: sharing deep insecurities and doubts.

Hic et Nunc/Aestheticising: act now—don't think just do—and then straight away reflect.

House of Safety: place where people can go in order to feel comfortable; from there you can also use a microphone to confess in the most honest possible way.

Human Sampler: sampling and repeating things that have been said in the space.

Licking Ears: ask somebody if it is okay to lick their ear and lick them if they agree.

Mapping Social Conventions: explicitly saying what the expectations of people are.

Articulate Tension: try to articulate in language the tension in the room and measure it.

Lecture: when somebody if behaving like a teacher or a professor start repating the word 'lecture' while clapping.

Not About You: when somebody is trying to show off, the interpreters sing, 'It's not about you'.

Open-Source Subjectivity: reveal what you are and how you think you are constructed in different ways.

Projecting Thoughts: saying aloud what you think other people are thinking.

Pronoun Exchange: change the pronoun when you want to say something (instead of I, you, and so on).

Report: when somebody moves their hand close to your ear, give a report of how you perceive the situation.

Spacing Language Through Time or Though People: somebody starts a sentence and other people continue collectively the sentence(s).

Spiking Space: organise the furniture in unconventional ways.

Squirrel: when you don't know what to do, pretend to be a squirrel.

Stealing Private Speaking: ask questions privately to a member of the audience and then share the answers publicly.

Stop the Clock: behave like a statue that is frozen in time.

Talking-As-One: the whole group speaks as if you were one person.

The Lacanian Stop: when the atmosphere is very dense and we reach the most interesting point, we stop for three minutes.

Thermometer: measure tension, ask by moving your head quickly up: left hand 1–5 private situations, right hand 1–5 general rooms, both hands 5, Lacanian stop.

Ungrounding the Situation: tear apart these social conventions.

STILLS FROM VIDEO DOCUMENTATION (ATHENS)

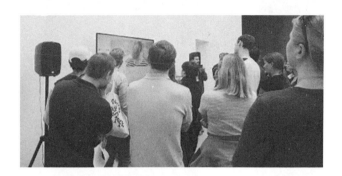

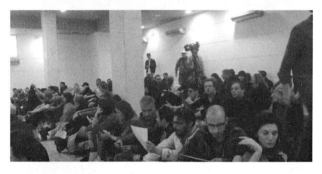

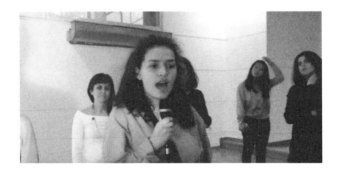

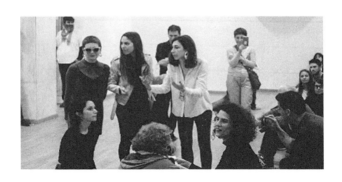

This book is dedicated to Carlos Artiach, who encouraged me to pursue this research early on, and to Eleni Zervou, Ioannis Sarris, Danai Liodaki, Smaragda Nitsopoulou, and Dafni Krazoudi, for performing an impossible score.

Special thanks to Ray Brassier for his extreme generosity and intellectual motivation, friendship, willingness to help with this project and the foreword, Josu Rekalde for always being there and helping whenever it was necessary, Robin Mackay for his patience and amazing editing, Miguel and Patricia for great friendship, the cover, and the hand, Noah Brehmer for extensive proofreading, Iñigo Eguillor for translations and support over the years, Cristina Gomez Barrio and Marina Vishmidt for the reports and extensive feedback, Anthony Iles for great friendship and long discussions, Noé Cornago, Maria José Martinez de Pison, Eleni Riga, Aziza Harmel, Carlota Gomez, Paul B. Preciado and the team at documenta14. Thanks to Dania Burger for the great and helpful curtain installation at *Social Dissonance* in Kassel.

I can never thank enough Pierre Bal-Blanc, who invited me to participate in documenta14 to score *Social Dissonance*, and trusted in the project all the way.

Very special thanks to Lisa Rosendahl and Odita for constant support and for bearing my long absences, and to Blanca Oraa, Bea Artiach, and Jaime Artiach for their encouragement.

Thanks to Abject Subject Ensemble (Faranaz Hatam, Colin Hacklander and Sacha Kahir), Acción Cultural Española (AC/E), Denise Luna Acevedo, Gabriela Acha, Mario Aguiriano, Peio Aguirre, Nadia Bou Ali, American University of Beirut Department of Philosophy, Ygor Anario, Jonathan Anderson, Henrik Andersson, Sepake Angiama, Daphni Antoniou, Ibon Aramberri,

ACKNOWLEDGEMENTS

Arika, Malin Arnel, Mirene Arsanios, Elisa Arteta, Artiatx, AusArt, Armen Avanessian, Lendl Barcelos, BICAR, Elena Biserna, Jacob Blumenfeld, Selma Boskailo, Sezgin Boynik, Anders Bryngelsson, Bulegoa, Clare Butcher, Cafe Oto, Jack Callahan, Eduarda Camargo, Lucio Capece, J.-P. Caron, Liam Casey, Andrei Chitu, Ron Clark, Alexandra Collins, Communist Reading Group (Andrei Chitu, Reid Kotlas, Timothy Treciokas, Raviv S. and Leena G.), Christoph Cox, Alex Cruse, Bill Dietz, Discoteca Flaming Star, Endnotes, Eremuak, Annika Eriksson, Octavian Esanu, Xabier Erkizia, Barry Esson, Oier Etxeberria, Etxepare Basque Institute, Exploratorium Berlin, Marcelo Expósito, Loy Fankbonner, Filipe Felizardo, Matheus Ferreira, Festival Caja Negra (Mendoza), Richard Fletcher's Minus Plato blog, platform and persona (2012–2022), Jarrod Fowler, Tim Goldie, Gabriel Gonzaga, Gabriel Hensche, Ryu Hankil, Angela Harutyun, Em Hedditch, Fielding Hope, Candice Hopkins, Helen Hughes, Enrike Hurtado, Ikersoinu, Kunsthochschule Kassel, Miren Jaio, Yan Jun, Moe Kamura, Sami Khatib, Seth Kim-Cohen, Dimitra Kotouza, Anabelle Lacroix, Heimo Lattner, Marysia Lewandowska, Tobi Maier, Martí Manen, Jon Mantxi, Bryony McIntyre, Mathias Maschat, Michele Masucci, Andrew McLellan, Noel Meek, Giacomo Mercuriali, Markus Miessen, Jan Darius Monazahian, Muskauer (Jumana Manna, Natascha Sadr Haghighian, Karolin Meunier, Ute Waldhausen, Haytham El-Wardany), Reza Negarestani, Loty Negarti, Warren Neidich, The New Centre for Research and Practice, Katerina Nikou, Noise Research Unit (Martina Raponi, Cecile Malaspina, Inigo Wilkins, Sonia De Jager and Miguel Prado), noiserr, Pawel Nowożycki, Okela, Pan Pan Kolektiva (Agnès Pe, José Luis Espejo), James Parker, Laurie Pitt, Rafael Pedroso, Eddie Prévost, Judy Radul, Lucy Railton, Patricia Reed, Héctor Rey, Matana Roberts, Pedro Rocha, Irit Rogoff, Marina Rosenfeld, Walik Sadek, Arnau Sala, Matthieu Saladin, Mohammed

Salemy, Eric Schmid, Cathleen Schuster and Marcel Dickhage, Martin Schüttler, María Seco, Lina Selander, Signal Festival (Brussels), Cássia Siqueira, Howard Slater, Koyuki Smith, Labor Sonor, Jorgina Stamogianni, Joel Stern, Monika Szewczyk, Tabakalera, Anne Tallentire, Rebecka Thor, TIER Space, Samo Tomšič, Tractora, Ultimate Leisure Workers' Club, Taku Unami, University of the Basque Country Faculty of Fine Arts, Emma Vallejo, Leire Vergara, Niamh Vlahakis, Hong-Kai Wang, XING (Silvia and Daniele), Dan Young, Danni Zuvela, and everybody who took part in *Social Dissonance*.

Earlier versions of parts of the book were delivered as talks on various occasions: Part of the first chapter was first delivered at the Art History Department, American University of Beirut on 7 November 2014, 'Noise as Device' at the conference *Noise and the Possibility of the Future* organised by Warren Neidich at the Goethe Institute in Los Angeles on 7 March 2015 (and published in *RAB-RAB: Journal for Political and Formal Inquiries in Art* issue 02 , volume B, 91-100), the introduction at *Continuous Verb* festival at the National Museum of Contemporary Art, Seoul on 29 October 2016. Parts of the second chapter were presented at BICAR, T-Marbouta Library, Beirut on 2 December 2016, at *Phenomenology and the Framework of Givenness* Winter School with Ray Brassier at University of Tübingen on 23 February 2017, and at the Historical Materialism conference, American University of Beirut, on 10 March 2017. A version of 'Improvisation After Brecht' was delivered at Petersburg Art space, Berlin on 28 April 2019 as part of a concert with Lucy Railton. An earlier version of the conclusion was published in English and Spanish in *eremuak #4* in 2017.

BIBLIOGRAPHY

Ali, Nadia Bou. 'The Fantasy of Subsumption? Labour-Power and the Capitalist Unconscious', in *Abolishing Capitalist Totality: What is To Be Done under Real Subsumption?* eds A. Iles and Mattin, Berlin: Archive Books, forthcoming.

Althusser, Louis. 'Lenin and Philosophy', in *Lenin and Philosophy and Other Essays*, tr. B. Brewster. New York: Monthly Review Press, 2001.

—— *The Humanist Controversy and Other Writings (1966–1977)*, tr. G. M. Goshgarian. London and New York: Verso, 2003.

Arthur, Chris. 'Notes on TC's First Letter', *Chris Arthur vs Theorie Communiste on alienation*, <https://libcom.org/library/on-theorie-communiste>.

Attali, Jacques. *Noise: The Political Economy of Music*, tr. B. Massumi. Minneapolis: University of Minnesota Press, 1984.

Aufheben. 'Decadence: The Theory of Decline or the Decline of Theory? Part 1', *Aufheben* 2 (1993).

—— 'Decadence: The Theory of Decline or the Decline of Theory? Part 2', *Aufheben* 3 (1994).

—— 'Decadence: The Theory of Decline or the Decline of Theory? Part 3', *Aufheben* 4 (1995).

—— 'Communist Theory—Beyond the Ultra-Left', *Aufheben* 11 (2003), <https://libcom.org/book/export/html/1736>.

Austin, J.L. *How to Do Things with Words*. Oxford: Oxford University Press, 1976.

Benjamin, W. 'What is Epic Theater? [First Version]', in *Understanding Brecht*, tr. A. Bostock. London/New York: Verso, 1998.

Bordiga, Amadeo. 'The Democratic Principle', *Rassegena Communista* (February 1922), <https://www.marxists.org/archive/bordiga/works/1922/democratic-principle.htm>.

Bouveresse, Jacques. *Le Mythe de l'intériorité: expérience, significa-tion et langage privé chez Wittgenstein*. Paris: Minuit, 1976.

Boyd, John. *Discourse of Winning and Losing*, <http://danford.net/boyd/>.

Braidotti, Rosi. *The Posthuman*. Cambridge: Polity Press, 2013.

——— 'Conclusion: The Residual Spirituality in Critical Theory: A Case for Affirmative Postsecular Politics' in R. Braidotti et al (eds.), *Transformations of Religion and the Public Sphere: Postsecular Publics*. Basingstoke: Palgrave, 2014.

Brassier, Ray. 'The View from Nowhere', *Identities: Journal for Politics, Gender and Culture* 8:2 (2011), 7–23.

——— 'Nominalism, Naturalism, and Materialism: Sellars's Critical Ontology', in *Contemporary Philosophical Naturalism and Its Implications*, eds B. Bashour and H.D. Muller, New York: Rout-ledge, 2013, 101–14.

——— 'Unfree Improvisation/Compulsive Freedom' (2013), <http://www.mattin.org/essays/unfree_improvisation-compulsive_free-dom.html>.

——— 'The Metaphysics of Sensation: Psychological Nominalism and the Reality of Consciousness', in *Wilfrid Sellars, Idealism, and Realism: Understanding Psychological Nominalism*, ed P.J. Reider. London: Bloomsbury Academic, 2017, 59–82.

——— 'Concrete-in-Thought, Concrete-in-Act: Marx, Materialism and the Exchange Abstraction'. *Crisis and Critique* 5:1 (2018), 110–29. <https://crisiscritique.org/2018h/brassier-v1.pdf>.

——— 'Against an Aesthetics of Noise'. Interview by Bram Leven. *nY*, 2019. <https://www.ny-web.be/artikels/against-aesthetics-noise/>.

—— 'Strange Sameness: Hegel Marx and the Logic of Estrange-
ment'. *Angelaki* 24:1 (2019), 98–105.

—— 'The Human: From Subversion to Compulsion', *Foreign Objekt*,
<https://www.foreignobjekt.com/post/ray-brassier-posthuman-
pragmatism-selecting-power-the-human-from-subversion-to-
compulsion>.

—— 'Adorno: The Affinity of Fatality and Freedom', lecture pre-
sented at the workshop 'Critical Theory and Psychoanalysis',
American University in Cairo, 13–14 September 2019.

—— 'Abolition and Aufhebung: Reply to Dimitra Kotouza', in *Abolish-
ing Capitalist Totality: What is To Be Done under Real Subsump-
tion?* eds A. Iles and Mattin, Berlin: Archive Books, forthcoming.

—— and T. Metzinger. 'A Special Form of Darkness' (conversa-
tion), *Okolice*, <https://iokolice.wordpress.com/2014/12/03/
a-special-form-of-darkness/>.

Brecht, Bertolt. *Brecht on Theater: The Development of an Aesthetic*,
eds M. Silberman, S. Giles and T. Kuhn. Third Edition. London/
New York: Blomsbury, 2015.

Cage, John. 'John Cage's Lecture "Indeterminacy" 5'00" to 6'00"', *Die
Reihe* 5 (1961).

—— 'Experimental Music', in *Silence: Lectures and* Writings. Middle-
town, CT: Wesleyan University Press, 1973.

—— *Anarchy: New York City–January 1988*. Middle-town, CT:
Wesleyan University Press, 1988.

Callari, Antonio and D. F. Ruccio. *Postmodern Materialism and the
Future of Marxist Theory: Essays in the Althusserian Tradition.*
Hanover, NH and London: Wesleyan University Press, 1996.

Camatte, Jacques. *The Wandering of Humanity*, tr. F. Perlman. Detroit:
Black & Red, 1975.

—— *Capital and Community: The Results of the Immediate Process
of Production and the Economic Work of* Marx, tr. D. Brown.
London: Unpopular Books, 1988. <https://www.marxists.org/
archive/camatte/capcom/ch05.htm>.

BIBLIOGRAPHY

Carney, Sean. *Brecht and Critical Theory: Dialectics and Contemporary Aesthetics*. London: Routledge, 2005.

Centre for Research in Modern European Philosophy (Kingston University), 'Phenomenology' (article), *Concept and Form*, <http://cahiers.kingston.ac.uk/concepts/phenomenology.html>.

Chitty, Andrew. 'Review of Sean Sayers, *Marx and Alienation: Essays on Hegelian Themes*', *Marx & Philosophy Society*, <https://marxandphilosophy.org.uk/reviews/7864_marx-and-alienation-review-by-andrew-chitty/>.

Chitu, Andrei. 'Stirner, Marx and the Unreal Totality', in *Abolishing Capitalist Totality: What is To Be Done under Real Subsumption?* eds A. Iles and Mattin, Berlin: Archive Books, forthcoming.

cleverpanda1. 'an explanation of Max Stirner memes for the clueless. [read this shit before looking at the memes, seriously you will be left clueless]', Reddit, 23 April 2019. <https://www.reddit.com/r/fullegoism/comments/bgkwh6/an_explanation_of_max_stirner_memes_for_the/>.

Curtis, Adam, dir. *HyperNormalisation*. London: BBC, 2016.

D'Amato, David S. 'Egoism in Rand and Stirner', *libertarianism.org*, <https://www.libertarianism.org/columns/egoism-rand-stirner>.

Debord, Guy. 'Report on the Construction of Situations and on the International Situationist Tendencies Conditions of Organization and Action' (1957), tr. K. Knabb, <http://www.cddc.vt.edu/sionline/si/report.html>.

———— *The Society of the Spectacle* (1967), <https://www.marxists.org/reference/archive/debord/society.htm>.

Dematteis, Philip Breed. *Individuality and the Social Organism: The Controversy between Max Stirner and Karl Marx*. New York: Revisionist Press, 1976.

Denzler, Bertrand and Jean-Luc Guionnet (eds.). *The Practice of Musical Improvisation: Dialogues with Contemporary Musical Improvisers*. Bloomsbury: New York, 2020.

Derrida, Jacques. *Specters of Marx: The State of the Debt, the Work of Mourning and the New International*, tr. Peggy Kamuf. Abingdon and New York: Routledge, 2006.

Endnotes Collective. 'Communisation and Value-Form Theory', <https://endnotes.org.uk/issues/2/en/endnotes-communisation -and-value-form-theory>.

——— 'A History of Separation: The Rise and Fall of the Workers' Movement, 1883–1982', *Endnotes 4: Unity In Separation* (2015), <https://libcom.org/files/Endnotes%204.pdf>, 70–85.

Fanon, Franz. *Black Skin White Masks*, tr. C.L. Markmann. London: Pluto, 1986.

Festinger, Leon. *A Theory of Cognitive Dissonance*. Stanford, CA: Stanford University Press, 1957.

Feuerbach, Ludwig. *The Essence of Christianity*, tr. G. Eliot. Walnut, CA: MSAC Philosophy Group, 2008.

Habermas, Jürgen. 'The Language Game of Responsible Agency and the Problem of Free Will: How Can Epistemic Dualism be Reconciled with Ontological Monism?', *Philosophical Explorations* 10.I (2008), 13–50.

Hegel, G.W.F. *Science of Logic*, tr. A.V. Miller. Atlantic Highlands, NJ: Humanities Press, 1969..

Heinrich, Michael. 'Invaders from Marx: On the Uses of Marxian Theory, and the Difficulties of a Contemporary Reading', *Left Curve* 31 (2007). <http://www.oekonomiekritik.de/205Invaders.htm>.

Heinrich, Michael. *An Introduction to the Three Volumes of Karl Marx's Capital*. New York: Monthly Review Press, 2012.

——— 'Value, Fetishism and Impersonal Domination' (lecture). Filmed 5 March 5 2014 at MaMa, Zagreb. <https://www.youtube.com/watch?v=TsblBQoJkqI>.

Hunter, E.C., M. Sierra, and A.S. David, 'The Epidemiology of Depersonalisation and Derealisation. A Systematic Review', *Soc. Psychiatry Psychiatr. Epidemiol.* 39:1 (January 2004): 9–18. doi: 10.1007/s00127-004-0701-4. PMID: 15022041.

Husserl, Edmund. *Ideas 1*, tr. D.O. Dahlstrom. Indianapolis: Hackett, 2014.

Iles, Anthony. 'Studying Unfreedom: Viktor Shklovsky's Critique of the Political Economy of Art', *Rab-Rab Journal for Political and Formal Inquiries in Art* B:2 (2015), 55–76.

―――― and Mattin (eds.). *Abolishing Capitalist Totality: What is To Be Done under Real Subsumption?* Berlin: Archive Books, forthcoming.

Jameson, Fredric. *The Prison-House of Language: A Critical Account of Structuralism and Russian Formalism*. Princeton, NJ: Princeton University Press, 1972.

―――― *Late Marxism: Adorno, or, the Persistence of the Dialectic*. London and New York: Verso, 1990.

―――― *Brecht and Method*. London: Verso, 2011.

Jappe, Anselm. *Guy Debord*. Berkeley, CA: University of California Press, 1993.

Kahn, Douglas. *Noise Water Meat: A History of Sound in the Arts*. Cambridge, MA and London: MIT Press, 1999.

Kant, Immanuel. 'The Good Will', *The Fundamental Principles of the Metaphysics of Morals* (1785), <http://fs2.american.edu/dfagel/www/Kantgoodwill.html>.

Khatib, Sami. '"Sensuous Supra-Sensuous": The Aesthetics of Real Abstraction', in *Aesthetic Marx*, eds S. Gandesha and J.F. Hartle. London: Bloomsbury Academic, 2017.

Kim-Cohen, Seth. *In the Blink of an Ear: Toward a Non-cochlear Sonic Art*. London: Bloomsbury, 2009.

Krieger, Ulrich. 'Noise—A Definition' (presentation), *Noise and the Possibility of the Future*, Los Angeles, 6–7 March 2015.

Laboria Cuboniks. 'Xenofeminism: A Politics for Alienation', <http://www. laboriacuboniks.net>.

Lopez, Francisco. 'Biography', <http:// www.franciscolopez.net/>.

Losurdo, Domenico. *Liberalism: A Counter-History*, tr. G. Elliott. London: Verso, 2011.

Lukács, Georg. *History and Class Consciousness*, tr. R. Livingstone. London: Merlin Press, 1971. <https://www.marxists.org/ebooks/lukacs/history_and_class_consciousness_georg_lukacs.pdf>.

Mackay, Robin. 'Introduction: Three Figures of Contingency', in R. Mackay (ed.), *The Medium of Contingency* (Falmouth: Urbanomic, 2015).

—— and A. Avanessian (eds.). *#Accelerate: The Accelerationist Reader.* Falmouth and Berlin: Urbanomic and Merve, 2014

Malaspina, Cecile. *An Epistemology of Noise: From Information Entropy to Normative Uncertainty.* London: Bloomsbury, 2018.

Marx, Karl. *Grundrisse: Foundations of the Critique of Political Economy (Rough Draft)*, tr. M. Nicolaus. London: Penguin, 1976.

—— 'Contribution to the Critique of Political Economy' (1859), tr. Y. Sdobnikov, in *Marx & Engels Collected Works Vol 29: Marx:1857-1861.* London: Lawrence & Wishart, 1987.

—— *Capital: A Critique of Political Economy, Volume One*, tr. B. Fowkes. London: Penguin, 1990.

—— *Capital: A Critique of Political Economy, Volume Three*, tr. D. Fernbach. London: Penguin, 1991.

—— *Economic and Philosophic Manuscripts of 1844.* Moscow: Progress Publishers, 1959. Online edition edited by A. Blunden, *Marxist.org*, 2000. <https://www.marxists.org/archive/marx/works/1844/manuscripts/comm.htm>.

—— and F. Engels, *The German Ideology.* New York: Prometheus, 1998.

Mattin, and A. Iles (eds.), *Unconstituted Praxis.* A Coruña: CAC Brétigny/Taumaturgia, 2012. <https://www.taumaturgia.com/unconstituted_praxis.pdf>

McDowell, John. 'Conceptual Capacities in Perception', in *Kreativität*, ed G. Abel. Berlin: Felix Meiner Verlag, 2006.

Merchant, Brian. 'Fully Automated Luxury Communism', *The Guardian*, 18 March 2015, <https://www.theguardian.com/sustainable-business/2015/mar/18/fully-automated-luxury-communism-robots-employment>.

Metzinger, Thomas. *Being No One: The Self-Model Theory of Subjectivity*. Cambridge, MA: MIT Press, 2004.

Monal, Isabel. 'Ser genérico, esencia genérica en el joven Marx', *Crítica Marxista* 1:16 (2003), 96–108.

Nägele, Rainer. *Theater, Theory, Speculation: Walter Benjamin and the Scenes of Modernity*. Baltimore, MD: Johns Hopkins University Press, 1991.

Negarestani, Reza. *Intelligence and Spirit*. Falmouth and New York: Urbanomic/Sequence Press, 2018.

Negri, Antonio. *Marx Beyond Marx: Lessons on the Grundrisse*, tr. H. Cleaver, M. Ryan, and M. Viano. South Hadley, MA: Bergin and Garvey, 1984.

O'Sullivan, Simon. 'The Missing Subject of Accelerationism', *Mute*, <http://www.metamute.org/editorial/articles/missing-subject-accelerationism>.

Parker, James E.K. 'Towards a Jurisprudence of Sonic Warfare' (lecture), *Liquid Architecture Festival*, Melbourne, 11 September 2014.

Pinto, Ana Teixeira. 'Artwashing NRx and the Alt-Right'. *Texte zur Kunst* 106 (June 2017), 153–70.

Pinto, Ana Teixeira and K. Stakemeier. 'A Brief Glossary of Social Sadism', *Texte zur Kunst* 116 (December 2019). <https://www.textezurkunst.de/116/ein-kurzes-glossar-zum-sozialen-sadismus/>.

Prado Casanova, Miguel. 'Schelling's Positive Account of Noise: On the Problem of Entropy, Negentropy and Anti-entropy', unpublished paper, 2015.

——— 'Noise and Synthetic Biology: How to Deal with Stochasticity?', *NanoEthics* 14: (2020), 113–22.

———— 'Noise and Morphogenesis: Uncertainty, Randomness and Control', PhD thesis, University of the West of England, 2021.

Preciado, Paul B. 'The Parliament of Bodies: Communism Will Be the Collective Management of Alienation' (lecture), <https://www.documenta14.de/en/calendar/24799/communism-will-be-the-collective-management-of-alienation>.

Raponi, Martina. 'The Authority of Taste. Mattin and Theses on Noise', *Digicult*, <http://www.digicult.it/news/authority-taste-mattin-theses-noise/>.

Redtwister. 'Who Are We', <https://libcom.org/library/who-are-we>.

Rogoff, Irit. 'From Criticism to Critique to Criticality', *Transversal*, <http://eipcp.net/transversal/0806/rogoff1/en>.

Ross, Alexander Reid. 'EGOMANIA! A Response to My Critics on the Post-Left', *IWW Environmental Unionism Caucus,* <https://ecology.iww.org/texts/AlexanderReidRoss/Egomania>.

Saenz De Sicilia, Andrés. 'History, System and Subsumption', in *Abolishing Capitalist Totality: What is To Be Done under Real Subsumption?* eds A. Iles and Mattin, Berlin: Archive Books, forthcoming.

Sands, Steven, and J.J. Ratey. 'The Concept of Noise'. *Psychiatry* 49:4 (November 1986), 290–97.

Schwartz, Hillel. 'Hillel Schwartz Interview' *Sonic Acts*, <https://vimeo.com/113593758>.

Sellars, Wilfrid. 'A Note on Awareness As', Wilfrid S. Sellars Papers, University of Pittsburgh, Box 35, Folder 4, <https://digital.library.pitt.edu/islandora/ object/pitt%3A31735062220151/viewer>.

———— 'Meaning as Functional Classification (A Perspective on the Relation of Syntax to Semantics)', *Synthese* 27: 3/4 (August 1974), 417–37.

———— 'The Lever of Archimedes', *The Monist* 64:1 (January 1981), 3–36.

———— *Empiricism and the Philosophy of Mind*. Cambridge, MA: Harvard University Press, 1997.

———— 'Language as Thought and As Communication', in *In the Space of Reasons*, eds K. Scharp and R.B. Brandom. Cambridge, MA and London: Harvard University Press, 2007, 57–80.

Sève, Lucien. 'To Begin with the Ends', tr. C. Shames, <https://www.marxists.org/archive/seve/lucien_seve.htm>.

Shklovsky, Viktor. 'Art as Technique', in *Russian Formalist Criticism: Four Essays*, eds L.T. Lemon and M.J. Reis. Lincoln, NE: University of Nebraska Press, 1965, 3–24.

Skempton, Simon. *Alienation after Derrida*. London: Continuum, 2010.

Sohn-Rethel, Alfred. *Intellectual and Manual Labour: A Critique of Epistemology*. London: Macmillan, 1978.

Srnicek, Nick. 'Nick Srnicek—17/08/2016' (lecture). Filmed on 17 August 2016 at *Ars Industrialis*, Épineuil-le-Fleuriel. <https://www.youtube.com/watch?v=YxT59gmXDLDI>.

Stirner, Max. *The Ego and Its Own*, tr. S. Byington. Cambridge: Cambridge University Press, 1995.

Striphas, Ted. 'Algorithmic Culture. "Culture Now Has Two Audiences: People and Machines"; A Conversation with Ted Striphash', *medium.com*, <https://medium.com/futurists-views/algorithmic-culture-culture-now-has-two-audiences-people-and-machines-2bdaa404f643>.

Théorie Communiste. 'Self-organisation is the first act of revolution it then becomes an obstacle which the revolution has to overcome', tr. Redtwister, <https://libcom.org/library/self-organisation-is-the-first-act-of-the-revolution-it-then-becomes-an-obstacle-which-the-revolution-has-to-overcome>.

———— 'A propos du texte "Sur la decadence" de "Aufheben"', including French translation of Aufheben, 'Decadence: The Theory of Decline or the Decline of Theory?', in *Théorie Communiste* 15 (1999), <https://libcom.org/files/TC15.pdf>.

———— 'Real Subsumption and the Contradiction between the Proletariat and Capital', in *Abolishing Capitalist Totality: What is To Be Done under Real Subsumption?* eds A. Iles and Mattin, Berlin: Archive Books, forthcoming.

Tomšič, Samo. *The Capitalist Unconscious: Marx and Lacan*. London: Verso, 2015.

———— *The Labour of Enjoyment: Towards a Critique of Libidinal Economy*. Berlin: August Verlag, 2019

VERE (Virtual Embodiment and Robotic Re-Embodiment), <http://www.vere.eventlab-ub.org/>.

VOMIR, 'HNw MANIFESTO', <http://www.decimationsociale.com/app/download/5795218093/Manifeste+du+Mur+Bruitiste.pdf>.

Watson, Ben. *Derek Bailey and the Story of Free Improvisation*. London: Verso, 2004.

Wilkins, Inigo. *Irreversible Noise*. Falmouth: Urbanomic, forthcoming.

Wright, Elizabeth. *Postmodern Brecht: A Re-Presentation*. London: Routledge, 1989.

Wynter, Sylvia. 'Towards the Sociogenic Principle: Fanon, the Puzzle of Conscious Experience of "Identity" and What It's Like To Be "Black"', in *National Identity and Sociopolitical Change: Latin America Between Marginalization and Integration*, ed M. Durán-Cogan and A. Gómez-Moriana. Minneapolis: University of Minnesota Press, 1999.

Zahavi, Dan. 'Being Someone', *Psyche* 11:5 (June 2005), 1–20.

Žižek, Slavoj. *Living in the End Times*. London and New York: Verso, 2010.

INDEX